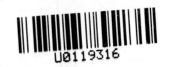
畫好國畫⑫

張大千　畫

張大千繪著
高嶺梅主編

Chinese Painting
by Chang Da-chien

Chinese Painting
by Chang Da-chien

Publisher: Ho Kung-shang
Published by ART Book Co., Ltd.

First Edition: 1988
All Right Reserved

Address: NO. 18, LANE 283, ROOSEVELT ROAD, SEC. 3,
TAIPEI, TAIWAN, R.O.C.
TEL: (02) 2362-0578 • 2362-9769
FAX: (02) 2362-3594

Price: US
Printed in Taiwan

附1　櫻桃芭蕉　Cherry and Plantain

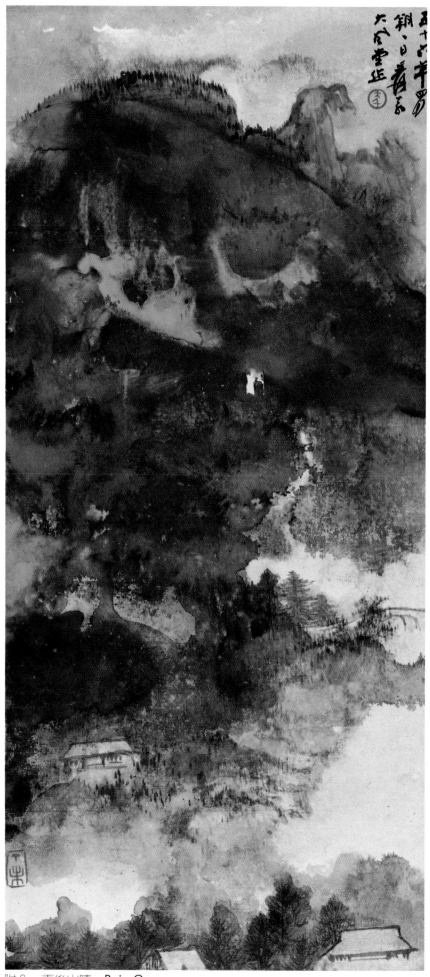

附2　雨後山晴　Rain Over

張大千　畫

Chinese Painting
by Chang Da-chien

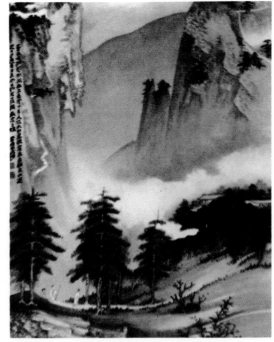

附3　雨晴巫峽　Rain Over Wu Dale

記大千居士　　　　　　　　　　　高嶺梅

　　大千居士是中國當代的大藝術家，他不但畫得好，書法也極好，並且對於文章詩詞的造詣也很高。他的作品的技巧與思想的融合，到了化境，自古到今難有這樣子的全才。

　　他生平事蹟，也是多采多姿，說來帶點傳奇性。少年時，他曾做過和尚，又被土匪綁去做師爺；廿多歲便蓄著一把大鬍子，至今儼然成了他特有的標誌。一八九九年（民國前十三年）陽曆五月十日舊曆四月一日他生在中國四川省內江縣。父諱懷忠，母曾氏諱友貞，是一個詩禮傳家的舊家庭。兄弟十人，他排行第八，從小就愛繪畫。母親是當時知名的女畫家。他的二哥名澤，字善子，別號虎痴，享有大名，是畫虎專家。其實善子對人物山水花卉，無一不精，大千也是從他受益的。先天賦與他繪畫的天才，在這藝術環境中培養成長起來。他九歲學畫，十二歲就能畫出花鳥人物山水一手好畫，見者稱爲神童。他的二位老師，一位是湖南衡陽曾農髯先生，諱熙；一位是江西臨川李梅庵先生，諱瑞清，都是著名的文藝家。農髯先生，從有蹟象的啓示，說他是黑猿轉生的，因此替他起名曰蝯，字季蝯（蝯卽古文猿字）。這好像是神話，但他自己似乎也默認，所以他特別喜歡養猿，現在在他巴西的摩詰山園，就養了有十幾隻之多。有人說他：「富可敵國，貧無立錐」，這比喩一點不錯。他收藏不少的名蹟，而自己的畫，就等於有價證券，朋友們說他雙手像鈔票機器一般，那麼應該說他很有錢吧，但有時他會窮得連買米的錢也沒有，原因是他賦性豪邁，慷慨好義幫朋友的忙，常傾囊相贈，見心愛的名迹，有傾家蕩產求得的魄力，如此安得不時窮時富呢？大千藝事的造詣，是他那絕頂的聰明和非凡的豪氣融合而成的，據我所知道的，他之有今天的成就，主要的是有兩點：第一，是觀賞與臨摹古人的傑作，而能融會貫通自我創造，若干年來，所有過目的古畫，也不知有若干幅，他對於其他事從不放在心上，記憶力好像專注在書畫，記憶與鑒定的能力，委實驚人，祗要一看畫頭，立刻可以斷定這畫的眞僞，舊時看過沒有，若干年前曾在某處看過，有什麼題跋印鑑，打開畫看，果然絲毫不爽。每遇有實在好的畫，沒有現錢也要千方百計的買下來，寢食與用，手不釋卷的去讀它，一定要參悟出古人的用心處。因此他的大風堂收藏豐富，確有幾百年來所罕見的東西，所印行大風堂名迹四集，已成爲世界各博物館列爲必要的參考品。第二，他不辭艱險與勞苦的遊覽名山大川，以實情實景來作繪畫的藍本。他平生遍遊五岳，三次作黃山絕頂之行，行萬里路，讀萬卷書，養成他胸襟的曠達，加上本身的稟賦及古代名家畫派的綜合，於是滙爲他自己獨特的一派。所以他作畫有一種磅礴之氣湧現紙上，古人所謂「外師造化，中得心源」，他確實地做到達到這至高的境界。一九四一年，他不遠千里去西北荒僻的戈壁裡，住在敦煌石窟中二年零七個月之久。他發現那些壁畫都是北朝，隋唐，五代，兩宋時代的寶物，以前國人不注意的。他臨摹了幾百幅精釆的作品回來，所以他畫人物仕女，確實受了壁畫的影響，明顯的轉變了作風。由於他發現了這偉大的藝術之宮，於是敦煌壁畫才受到普遍的重視。一般人說敦煌壁畫是受了印度的影響，勝利後他就特地趕到印度去參觀，看看到底是敦煌受印度的影響，還是我們的文化在唐宋時代已遠播到國外去？他始終精進不懈地忠於藝術，而不辭辛苦跋涉，在阿堅達住了三個月，他斷定敦煌壁畫祗用佛教故事，不受印度影響，完全是我國傳統畫法，與漢代武梁祠孝堂山及四川之漢墓壁畫爲一系，就拿這件事來講，他有極崇高的成就，決非偶然的。

　　這些年來，世界風雲日亟，大千的行踪也就飄泊無定。一九四九他曾住印度大吉嶺年餘，一九五二年又全家由香港遷阿根廷，後來到巴西，在摩詰買了一個荒園才算安頓下來。同時，因鑑於中國藝術的未爲世人瞭解，他才毅然以文化使者自任，足跡走遍南北美及歐洲各國，把臨摹敦煌的畫及自己的作品，先後在印度新德里，海德拉把（卽阿堅塔所在的一邦），日本東京，南美阿根廷，法國巴黎舉行展覽。尤其是在巴黎近代美術館的展出，由法國政府機構非常隆重主辦，轟動了整個歐洲。一九五七年紐約世界美術協會，公舉張大千爲當代第一畫家，贈他金質獎章，這項榮譽，國人在外國尚屬第一人，第一次，可不說是國家的光榮麼？

　　大千每到一處，總是高朋滿座，向他請益的人很多，他的天性旣豪爽好客，又兼健談，無論晨昏晦明，祗要他話匣子一開，在座的人聽了沒有不樂而忘倦，神爲之王。雖然他生平最怕的是公開演講—以前在中央大學做教授的時候，也聲明避免尋常授課方式—其實他的口才挺好，上下古今沒有不歷歷如數家珍，又風趣，又幽默，尤其對於幾十年來在藝術上所有寶貴的經驗，獨創的見解，他往往能道人所未道，發人所未發，簡直就像洩漏了天機一般似的。現在我將他平日所說關於繪畫的話紀錄下來，所畫的畫收集起來，編成一套有系統有價值的「張大千畫」問世，這本書包括他的畫論畫法畫範：張大千他是不願意將自己的畫法作爲楷模的，他曾說畫無定法，更無所謂用筆，任你翻來翻去都是前人做過的了。我想這是他的客氣吧！中國的繪畫藝術，具有獨特的風格，至高的水準，是我們綿延數千年民族優秀的傳統，不可不把它特別珍重，發揚光大，今日像大千這樣的人，在他身上儼然是負著繼往開來，歷史偉大的任務，不但替國家民族爭取光榮，抑且對我們子孫後代，都將得其深遠的影響，應該是毫無疑問的。我們相信，大千的畫是不朽的，而他的畫法是必傳的。

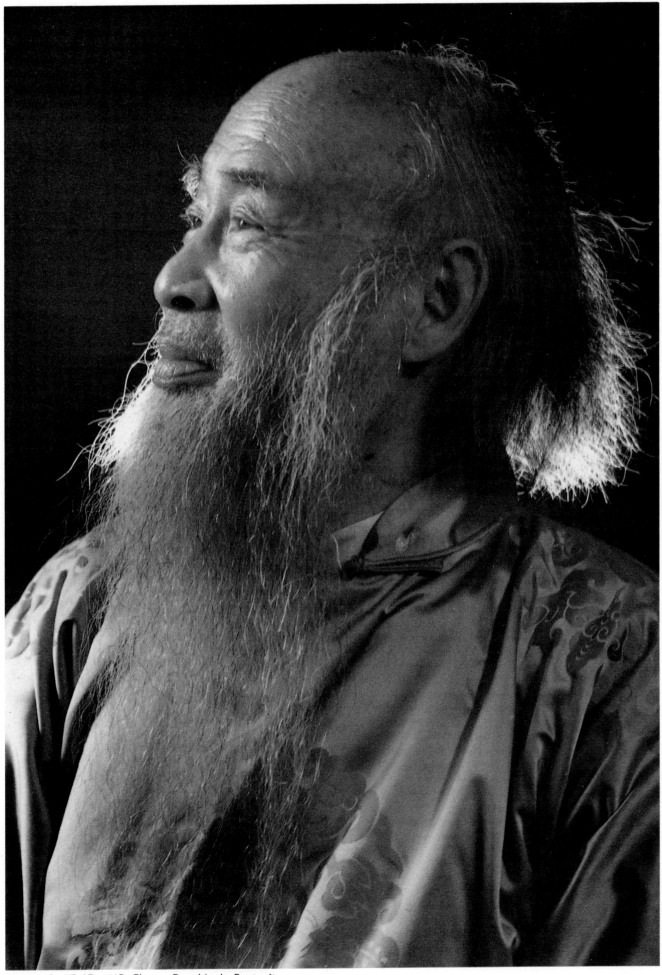

附4　大千像　MR Chang Da-chien's Portrait

Notes on Chang Da-Chien

General recognized as the Picasso of China today, Chang Da-chien is not only a great painter, a master calligraphist, but an accomplished poet and man-of-letters in his own right. His works reflect a fusion of technique and intellect that has reached the state of sublimation. Few and far between are geniuses of so many parts in the history of Chinese art.

The story of his life is as coloured and strange as a romance. At the age of eighteen, he was kidnapped by a gang of bandits and pressed into their service as a secretary. Three years later he became a Buddhist monk but left the monastery shortly afterwards and for good, and grew a long beard which has since become a familiar emblem of his person.

He was born at Neichiang in the Province of Szechuan on May 10th, 1899. His father was Chang Huai-chung and his mother Yu-cheng, a daughter from the House of Tseng and a noted painter of her time. Their mansion was an old-fashioned one, long founded in the classical tradition of the Odes and the Rites. The eighth of their ten sons, Chang Da-chien showed an aptitude for painting in his childhood. His late elder brother Tze (known too by the courtesy name Shan-tzu, or the poetic name Hu Chih), was a tiger painter of great fame but was also proficient in painting human figures, landscapes, flowers and plants. Of Tze's instruction the younger brother often availed himself.

Endowed with the gift of painting and brought up in an artistic environment, little Da-chien started to wield the brush at the age of ten. At twelve, he could paint flowers, birds, human figures and landscapes with such proficiency that those who saw him at work invariably proclaimed him a prodigy. He studied under tow masters, Tseng Hsi (alias Tseng Nung-jan) of Hengyang, Hunan, and Li Jui-ching (alias Li Mei-an) of Lingchuan, Kiangsi, both being scholar-artists of great renown. From a spiritual revelation, the master Tseng asserted that his talented pupil was a black gibbon in his last incarnation, whereupon he gave him the praenomen Yuan (which in the ancient script is equivalent to the character yuan for gibbon in the modern Chinese script) and the courtesy name Chi-yuan. Though this sounds like a myth, its truth seems to have been tacitly acknowledged by Da-chien and further supported by his lasting passion for breeding gibbons in later years. At present he still keeps more than a dozen

of the little South-east Asian apes at his Mogi Das Garden in Brazil.

He is "rich enough to vie with a kingdom", someone has pertinently observed, "yet so poor as to have no ground to stand a awl thereon." This, though a hyperbole, is not far from the truth; For apart from the priceless masterpieces of Chinese painting in his private collection, his own paintings are almost as negotiable as bonds and shares and his hands have often been likened by his friends to a banknotes press. Yet, in spite of these mines of wealth, he is sometimes so hard up that he does not even have money to buy his daily rice! The reason is: he is recklessly prodigal by nature. Generous and compassionate as a knight-errant, he often empties his purse to help a friend in distress. Should he take a fancy to a masterpiece, he would not hesitate to purchase it at any cost, even if it might cause the downfall of his house and forfeiture of his property. This being the case, it is small wonder that he is somttimes affluent and sometimes out of pocket.

Chang Da-chien's artistic attainment bespeaks a happy union of his extraordinary genius and spiritual greatness. As far as I know, his accomplishments up-to-date are mainly attributable to two factors: First, he has thoroughly digested and absorbed the ancient masterpieces through tireless studying and copying, yet he is able to create a distinct style of his own. No one knows how many examples of the old masters he has pored over in years past. He never takes the sordid realities of life to heart; his amazing acumen and retentive memory seem to be exclusively reserved for calligraphy and paintings. When unrolling a scroll, he can tell at a cursory glance whether the painting is authentic or not. If he happens to have seen it befire, he can recall not only the time and place of the occasion, but the inscriptions and appreciative notes on it as well as the seals used by the artist and the connoisseurs, respectively, to the minutest detail without a slip of memory. Whenever he comes accross a really good piece of painting, he will buy it through thick and thin, even if he does not have a single penny at hand. He will be with it night and day, whether sleeping or having his meals, and study it without respite till he has discovered the secret of the master mind that caused its creation. That accounts for the richness of his Ta Feng Tang collection, in which there are some ancient masterpieces that have remained in obscurity for many centuries.

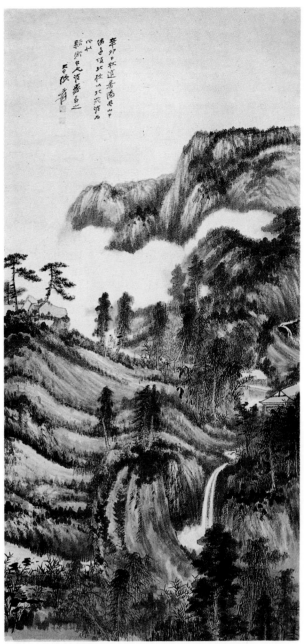

附5　北投山頂　Summit of Pei-tou Mount

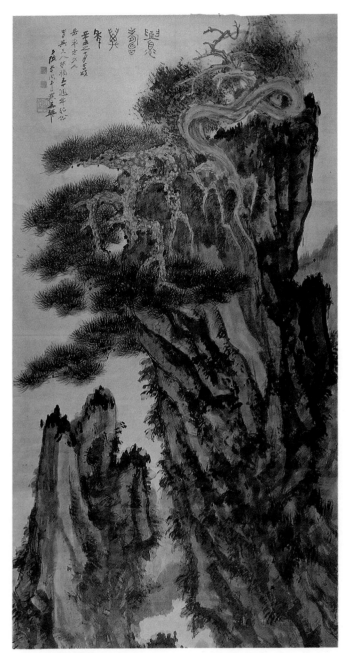

附6　嵩壽萬年　Longevity

The four albums of the masterpieces in the collection recently published by him have already taken a permanent place on the reference shelves of libraries all over the world.

Next, in his life time he has paid visits to the Five Sacred Mountains of China, climbed to the peak of the scenic Huang Shan three times, travelled myriads of miles and read myriads of books. His psychical estate, having thus been enriched and widened, joins forces with his inborn genius and the heritage of the ancient masters to shape out a unique school of his own. That is why there is an atmosphere of greatness about his painting that looms large over the paper. The ancients say, "Sit at the feet of the Creator without and draw on the psychical source within." This supreme state he has undoubtedly attained.

Twenty years ago he travelled thousands of miles to the Gobi Desert in Northwest China and lived in the Tun Huang Caves for two years and seven months. He perceived that the frescoes in these caves were a great art treasure dating from the Six Dynasties to the Sung Dynasty (roughly from the 4th century to the 14th century), unnoticed and unsung by his compatriots for centuries. Before he went home, he made several hundred copies of the best murals, the potent influence of which has since been reflected in the conspicuous change of style in his portrayal of human figures and classical ladies. In consequence of his discovery, the nation has awakened to the great importance of those long neglected paintings. Some people have contended that the Tun Huang frescoes were under the influence of the art of ancient India. To find out for himself whether that theory was correct or whether Chinese art had

exerted its influence upon Central Asia in the T'ang and Sung Dynasties, he made a special trip to India after the conclusion of World War II and studied the ancient Indian art at Ajunta for three months. Finally he arrived at the conclusion that the Tun Huang murals merely used Buddhist themes without submitting to Indian influence and that their technique, being essentially that of traditional Chinese paintings, was of the same category as that of the engravings on the stone tomb walls at Wu Liang Ssu, Hsiao T'ang Shan and in Szechuan. Even if one takes this alone into consideration, it is obvious that his high artistic attainment is no accident.

In recent years, growing tension in the international situation has cast him adrift. In 1949 he stayed at Darjeeling on the north-eastern border of India for more than one year. Three years later, he took his family from Hong Kong to Argentina, then away to Sao Paulo, Brazil, where he bought a farm at Mogi Das and settled down. Meanwhile, in view of the fact that Chinese art is little known to the outside world, he has taken upon himself the task of a non-official cultural envoy to many countries in Europe and the America. At New Delhi, Hyderabad (the Indian province to which Ajunta belongs), Tokyo, Argentina, and Paris, he has exhibited his paintings together with the copies he made of the Tun Huang murals. Under the auspices of Salon National de Paris, the exhibition held at Musee d'Art Moderne de la Ville de Paris in 1956 with a ceremonious opening has left a lasting impression in Europe. In 1957 the International Council of Fine Arts of New York elected him the best painter of the year and awarded him a gold medal—an honour never before accorded to a Chinese artist abroad.

His magnetic character draws friends and those who crave for his instruction to his crowded parlour wherever he may go. Large-hearted and hospitable, he is also endowed with the "gift of the gab" which enables him to keep his guests fascinated and in high spirits as long as the flow of his words continues. But he is averse to public speaking, so much so that when he was offered the chair of Chinese Art at the National Central University of Nanking in 1936, he made a point of dispensing with the practice of giving his lectures in the classroom. In reality, he is not only eloquent in speech but has a keen sense of humour and an inexhaustible store of interesting anecdotes about the ancients as well as our contemporaries. With the invaluable experience of a life-time devoted to art and an independent view of his own, he can say what is unsaid by others and explain what seems inexpressible, as though he had access to the top secret of the Muses.

For years I have collected his paintings and recorded his discourses on Chinese painting. On the basis of those, I now endeavour to compile a book with a view to giving a systematic exposition of the priceless technique of the master. On his part he is rather disinclined to have such a publication and he contends that there is no fixed technique of painting, nor the so-called method of mastering the brush, and that whichever way one may turn it has been trodden by someone before. I am inclined to think that he is just being too modest.

The Chinese art of painting has a unique style of its own and the highest level of attainment. Being a part of the great cultural heritage of the Chinese nation through thousands of years, it deserves to be preserved with special care and advanced till it becomes more glorious than ever. It is on the shoulders of men like Chang Da-chien that there falls the historic task of keeping up with the past and blazing a new path for posterity. There is not a shadow of doubt that he will continue to win honours for our country and our people and exert far-reaching influence upon our children and our more distant offspring. We firmly believe that Chang Da-chien's paintings are immortal and that this book will continue to be read as long as his technique inspires interest.

Kao Ling Mei.

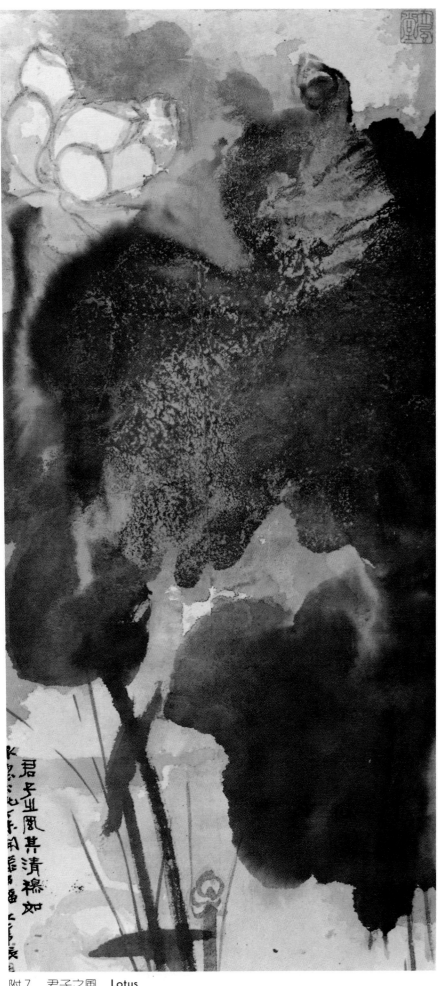

附7　君子之風　Lotus

畫說

張大千

　　有人以爲畫畫是很艱難的，又說要生來有繪畫的天才，我覺得不然。我以爲祇要自己有興趣，找到一條正路，又肯用功，自然而然就會成功的。從前的人說，「三分人事七分天」，這句話我卻絕端反對。我以爲應該反過來說，「七分人事三分天」纔對；就是說任你天分如何好，不用功是不行的。世上所謂神童，大概到了成年以後就默默無聞了。這是什麼緣故呢？祇因大家一捧加之父母一寵，便忘乎其形，自以爲了不起，從此再不用功。不進則退，乃是自然趨勢，你叫他如何得成功呢？在我個人的意思，要畫畫首先要從勾摹古人名跡入手，把線條練習好，寫字也是一樣；要先習雙勾，跟著便學習寫生。寫生首先要了解物理，觀察物態，體會物情，必須要一寫再寫，寫到沒有錯誤爲止。

　　在我的想像中，作畫跟本無中西之分，初學時如此，到最後達到最高境界也是如此。雖可能有點不同的地方，那是地域的風俗的習慣的以及工具的不同，在畫面上纔起了分別。

　　還有，用色的觀點，西畫是色與光不可分開來用的，色來襯光，光來顯色，爲表達物體的深度與立體，更用陰影來襯托。中國畫是光與色分開來用的，需要用光就用光，不需用時便撤了不用，至於陰陽向背全靠線條的起伏轉折來表現，而水墨和寫意，又爲我國獨特的畫法，不畫陰影。中國古代的藝術家，早認爲陰影有妨畫面的美，所以中國畫傳統下來，除以線條的起伏轉折表現陰陽向背，又以色來襯托。這也好像近代的人像藝術攝影中的高白調，沒有陰影，但也自然有立體與美的感覺，理論是一樣的。近代西畫趨向抽象，馬蒂斯，畢加索都自己說是受了中國畫的影響而改變的。我親見了畢氏用毛筆水墨練習的中國畫有五冊之多，每冊約三四十頁，且承他贈了一幅所畫的西班牙牧神。所以我說中國畫與西洋畫，不應有太大距離的分別。一個人能將西畫的長處溶化到中國畫裏面來，看起來完全是國畫的神韻，不留絲毫西畫的外貌，這定要有絕頂聰明的天才同非常勤苦的用功，纔能有此成就，稍一不愼，便走入魔道了。

　　中國畫常常被不了解畫的人批評說，沒有透視。其實中國畫何嘗沒有透視？它的透視是從四方上下各方面著取的，現在抽象畫不過得其一斑。如古人所說的下面幾句話，就是十足的透視抽象的理論。他說「遠山無皴」。遠山爲何無皴呢？因爲人的目力不能達到，就等於攝影過遠，空氣間有一種霧層，自然看不見山上的脉絡，當然用不著皴了。「遠水無波」，江河遠遠望去，那裏還看得見波紋呢？「遠人無目」，也是一樣的；距離遠了，五官當然辨不清楚了，這是自然的道理。所謂透視，就是自然，不是死板板的。從前沒有發明攝影，但是中國畫理早已發明這些極合攝影的原理。何以見得呢？譬如畫遠的景物，色調一定是淺的，

同時也是輕輕淡淡，模模糊糊的，這就是用來表現遠的；如果畫近景，樓台殿閣，就一定畫得清清楚楚，色調深濃，一看就如到了眼前一樣。石濤還有一種獨特的技能，他有時反過來將近景畫得模糊而虛，將遠景畫得清楚而實。這等於攝影機的焦點，對在遠處，更像我們眼睛注視遠方，近處就顯得不清楚了。這是「最高」現代科學的物理透視，他能用在畫上，而又能表現出來，眞是了不起的。所以中國畫的抽象，既合物理，而又要包含著美的因素。講到以美爲基點，表現的時候就該利用不同的角度，畫家可以從每種角度，或從流動地位的眼光下，產生靈感，幾方面的角度下，集成美的構圖。這種理論，現代的人或已能夠明白，但古人中就有不懂得這個道理的。宋人沈存中就批評李成所畫的樓閣，都是掀屋角。怎樣叫掀屋角呢？他說從上向下的角度看起來，看到屋頂，就不會看到屋簷，李成的畫，既具屋脊又見斗拱，頗不合理。粗粗看來，這個道理好像是對的，仔細一想就知道不對了；因爲畫既以美爲主點，李成用鳥瞰的方法，俯看到屋脊，並且拿飛動的角度，仰而看到屋簷斗拱，就一刹那的印象，將腦中所留屋脊與屋簷的美感併合爲一，於是就畫出來了。況且中國建築，屋脊的美、斗拱的美都是絕藝，非兼用俯仰的透視不能傳其全貌啊！

　　畫家自身便認爲是上帝，有創造萬物的特權本領。畫中要它下雨就可以下雨，要出太陽就可以出太陽；造化在我手裡，不爲萬物所驅使；這裡缺少一個山峯，便加上一個山峯，那裡該刪去一堆亂石，就刪去一堆亂石，心中有個神仙境界，就可以畫出一個神仙境界。這就是科學家所謂的改造自然，也就是古人所說的「筆補造化天無功」。總之，畫家可以在畫中創造另一個天地，要如何去畫，就如何去畫；有時要表現現實，有時也不能太顧現實，這種取捨，全憑自己的思想。何以如此？簡畧地說，大祇畫一東西，不應當求太像，也不應當故意求不像；求它像，當然不如攝影，如求它不像，那又何必畫它呢？所以一定要在像和不像之間，得到超物的天趣，方算是藝術。正是古人所謂遺貌取神，又等於說我筆底下所創造的新天地，叫識者一看自然會辨認得出來；我看到眞美的就畫下來，不美的就拋棄了它。談到眞美，當然不單指物的形態，是要悟到物的神韻。這可引證王摩詰兩句話，「畫中有詩，詩中有畫」。「畫是無聲的詩，詩是有聲的畫」，怎樣能達到這個境界呢？就是說要意在筆先，心靈一觸，就能跟著筆墨表露在紙上。所以說「形成於未畫之先」，「神留於既畫之後」。近代有極多物事，爲古代所沒有，並非都不能入畫，祇要用你的靈感與思想，不變更原理而得其神態，畫得含有古意而又不落俗套，這就算藝術了。

　　作畫要怎樣才得精通？總括來講，首重在勾勒，次

則寫生,其次才到寫意。不論畫花卉翎毛,山水人物,總要了解理、情、態三事。先要著手臨摹,觀審名作,不論今古,眼觀手臨,切忌偏愛;人各有所長,都應該採取,但每人筆觸天生有不同的地方,故不可專學一人,又不可單就自己的筆路去追求,要憑理智聰慧來採取名作的精神,又要能轉變它。老師教學生也應當如此,告訴他繪畫的方法,由他自去追討,不可叫他固守師法,然後立意創作,這樣纔可以成為獨立的畫家。所以唐宋人所傳的作品,不要題款,給人一看就可知道這是某人的作品,看他片楮寸縑就可以代表他個人啊!

古人所謂讀萬卷書行萬里路,這是什麼意思呢?因為見聞廣博,要從實地觀察得來,不只單靠書本,兩者要相輔而行的。名山大川,熟於心中,胸中有了丘壑,下筆自然有所依據。要經歷得多纔有所獲,山水如此,其他花卉人物禽畜都是一樣。

遊歷不但是繪畫資料的源泉,並且可以窺探宇宙萬物的全貌,養成廣潤的心胸,所以行萬里路是必須的。

一個成功的畫家,畫的技能已達到化境,也就沒有固定的畫法能夠拘束他,限制他。所謂「俯拾萬物」,「從心所欲」,畫得熟練了,何必墨守成規呢?但初學的人,仍以循規蹈矩,按步就班為是。古人畫人物,

多數以漁樵耕讀為對象,這是象徵士大夫歸隱後的清高生活,不是以這四種為謀生道路,後人不知此意,畫得愁眉苦臉,大有靠此為生,孜孜為利的樣子,全無精神寄託之意,豈不可笑!梅蘭菊竹,各有身份,代表與者受者的風骨性格,又是花卉畫法的祖宗,想不到現在竟成了陳言鑑套!現在就我個人學畫的經驗畧寫幾點在下面與大家研究:

(一)臨摹　勾勒線條來求規矩法度。

(二)寫生　了解物理,觀察物態,體會物情。

(三)立意　人物,故實,山水,花卉,雖小景要有大寄託。

(四)創境　自出新意,力去陳腐。

(五)求雅　讀書養性,擺脫塵俗。

(六)求骨氣,去廢筆。

(七)佈局為次,氣韻為先。

(八)遺貌取神,不背原理。

(九)筆放心閒,不得矜才使氣。

(十)揣摹前人要能脫胎換骨,不可因襲盜竊。

(十一)傳情記事　如寫蔡琰歸漢,楊妃病齒,溢浦秋風等圖。

(十二)大結構　如穆天子傳,屈子離騷,唐文皇便橋會盟,郭汾陽單騎見虜等圖。

附8　長臂猿　Gibbon

On The Art of Painting

Some people, apparently considering painting as a very difficult art, contend that a painter must be born with the genius for his calling. I do not think so. For so long as a man takes an interest in painting, success will come his way as a matter of course, provided that he follows the right path and plies his study with assiduity. The proverb says, "Three parts of human endeavour plus seven parts of Providence." This tenet, However, is quite opposite to my way of thinking. I deem it far more likely to put it the other way round, that is to say, "Seven parts of human endeavour plus three parts of Providence." In other words, however talented a painter may be, he will come to no good without industry. Most of the so-called child prodigies have turned out to be nonentities when they came of age. Why is it? The answer is: they have been pampered by their parents and extolled to the skies by everyone so much that they forget themselves and, having grown swollen-headed with conceit, no longer devote themselves to their work. Since it is common sense that retrogression begins where progress leaves off, how then can they expect to succeed?

In my opinion, the painter should commence with copying the old masters, as is the practice with the calligraphers, with a view to acquiring the mastery of line. First, he must do exercises in the contour method, next in life study. The latter requires thorough understanding of the nature of the subject, close observation of its manner and attitude, and identification of oneself with its feelings. One must practise and practise again, if necessary, till one makes no technical errors.

As far as I can see, there is no rigid line of demarcation between Chinese painting and Western painting, whether in the initial approach or in the highest ultimate attainment. Whatever difference there is in the form of representation, it is a mere result of the regional divergence in custom and usage and in the media and materials of the painter.

Of course, there is also a difference in the application of colour. In Western painting, light and colour are not used separately; colour sets off light and light brings out colour. Apart from that, shading is added to achieve depth and three-dimensional effect. In Chinese painting, light and colour are employed apart and light comes in only when it is called for. The different aspects of light and shade, or front and back, find expression in the rise and fall or the turn and twist of the lines. In unique Chinese paintings in ink monochrome or in the impressionistic style, shading is dispensed with altogether. Ancient Chinese painters long ago considered shading detrimental to the graphic beauty of the picture as a whole. This is why, apart from the brush-stroke, Chinese paintings also rely on colour for enhancing the contrast between light and shade. In principle, this is similar to the modern photographic study of human figures in high key, which produces aesthetic three-dimensional effects without the assistance of shadows.

The trend of modern Western painting has been in the direction of the abstract. Both Matisse and Picasso confess that they have changed their modes of expression under the influence of Chinese paintings. I have seen with my own eyes no less than five albums of Picasso's experiment in Chinese painting with brush and ink, each containing some forty sheets of paper. One of these is The Pastoral God, which he has presented to me as a souvenir.

In the light of this new trend, it does not make sense that a wide gulf should still have existed between the Chinese painting and the Western painting. However, it is difficult to instil the merits of Western art into a Chinese painting without compromising its inherent character and betraying some trace of the Western touch. This can only be achieved by a genius of the highest intelligence who will apply himself to the task with extraordinary care and industry, for the slightest negligence may defeat the purpose of his pursuit.

Chinese painting has often been pooh-poohed by unappreciative critics for its want of perspective. In reality, Chinese painting is not innocent of the visual aspect of dimension in space; only, the Chinese point of view may shift from one direction to another, as the painters of some modern schools show, instead of from one fixed point. The dicta of the ancients quoted in the following may represent the Chinese theory of perspective:

"Distant hills have no wrinkes." Why is that so? Because neither the human eyes, nor the camera lens, can see the rugged contour of the distant hills through the softening atmosphere in space. Hence, it is quite unnecessary to paint any wrinkle.

"Distant waters have no waves." For the same reason, it is impossible to see the ripples or billows on distant rivers and lakes.

"Distant men have no eyes." The same principle applies to human figures. It is common sense that at a distance facial features are indiscernible.

Perspective, I take it, is what things look like in nature under a certain condition, not just a set of hard and fast rules. Centuries ago, long before the invention of the camera, Chinese theorists of art

had laid down those principles which, curiously enough, are in agreement with the elements of modern photography. For instance, in a distant scene, the colour is invariably in the light tone and its outlines are soft, vague and a little blurred. This is the Chinese artist's technique for suggesting distance. In case of a near scene, the detail of a building must needs be distinct and sharp and their colours in deep tone, as though they were right in front of one's eyes.

Shih T'so sometimes employs a special technique whereby he reverses the usual practice by giving things in the foreground a blurred ethereal look while making the objects in the distance appear clear-cut and solid. That is tantamount to setting the camera focus on infinity or riveting one's eyes on something remote, so that the objects at close quarters are out of focus. It is truly wonderful of Shih T'ao to be able to anticipate in his paintings the modern scientific perspective of the focus and give it an aesthetic interpretation. Chinese impressionism is, therefore, both in accord with the principles of physics and compatible with the elements of aesthetics.

On the basis of aesthetics, sometimes it takes a different angle to give expression to beauty. Theoretically speaking, the painter may derive inspiration from every possbile angle, or from a mobile point of view, or paint an artistic composite picture from several different points of view. Such a theory, though quite comprehensible to the modern man, was inconceivable to some of our ancients. For instance, the great Sung Dynasty critic Shen Kua is known to have stigmatized the buildings painted by Li Cheng for their "upturned roof-corners". With the premise that looking down from a high point, one may see the roof but not the inside of the eaves, he maintains that Li's painting does not stand to reason because it shows the roof ridge as well as the bracket system under the eaves. Superficially, Shen's criticism seems to be pertinent, but in retrospect he has obviously barked up the wrong tree. For in painting, aesthetics is the thing. Li Cheng not only sees the ridge of the roof from a bird's-eye view but has swooped down to take in the bracket system under the eaves. In his painting he has successfully combined the first impression of the roof with the second impression of the bracket and eaves into an aesthetically blended picture. The Chinese architecture is noted for the exceptional beauty of its roof and its bracket system. It is quite impossible to paint both without recourse to blending the upward and downward perspectives.

The painter is the deity of his one world, invested with the prerogative to creat whatever he please. In his paintings, he may play the part of the Creator and cause it to rain or the sun to shine, wihtout being dictated to by any force in existence. He may conjure up a peak or get rid of a pile of unsightly rocks, as he sees fit. If he conceives a domain of genii and fairies, he is at liberty to put it into form and colour. He may, as the scientists advocate, "bring about improvement upon Nature," or as the ancients say, "let the brush amend Nature without the auspices of the Providence." Generally speaking, the painter may create a world on the paper and paint it in whatever way he likes. Sometimes it is desirable to reflect the realities, sometimes it is expedient to leave realistic considerations out of mind; the choice being entirely at his discretion. In short, when painting a picture the painter should neither seek to be too life-like nor wilfuly strive for unlikeness. If faithfulness be the criterion, painting is at a disadvantage in comparison with photography. If it is unlikeness that the painter aims at, why then should he paint the subject at all?

So, the true artist must try to bring out, between likeness and unlikeness, the extramundane charm of nature. That is what the ancients mean by "to capture the spirit at the expense of appearance." In other words, the world of the painter's creation should be such that the initiated shall be able to recognize its identity at one glance. The artist sees what is truly beautiful and paints it, while rejecting what is not beautiful. Speaking of true beauty, it does not dwell solely in the outward form of things but must be appreciated through its spiritual vitality. This may be coupled with the famous dictum of the eminent T'ang Dynasty poet-painter Wang Wei: "In a picture there should be poetry, in a poem there should be a picture." For painting is poetry unsung, and poetry is painting set to music. To attain such a transcendent state, it is imperative to conceive the picture before manipulating the brush, so that as soon as an inspiration sparkles in the painter's psyche, it may take shape on the paper by means of brush and ink. So it is said, "The form is born ahead of the brush-work," and "The spirit dwells in the painting when it is done.

As to the countless new-fangled things of our age which were unknown to the ancients, they are not altogether unpaintable, as some people are inclined to think. There is no reason why they should not become fit themes of art, so long as the painter can do justic to their form and spirit by virtue of his inspiration and intellect, without compromising his aesthetic principles, and so long as his paintings are in keeping with the classical tradition without deviating into the beaten track of vulgarism.

In brief, if a painter wishes to become an

adept, he should first of all master the contour method, next life study, and finally the impressionistic style. Whether he paints flowers, birds, landscapes, or human figures, it is necessary for him to be conversant with their nature, form and feeling. He must begin with copying and studying the work of famed painters of the past and the present. In doing so, he must guard himself against lopsided favouritism; because every great painter has his own particular merit worthy of emulation. But the individual touch of each is different, so the beginner should not imitate only one master, nor imitate only one master, nor follow a course under the unassisted guidance of his own bent. He must emulate the spiritual quality of the old masters and be able to adapt it to his own use, rationally and intelligently. In the same way, a master of painting should teach his pupils. He should impart to them the technique of painting and let them pursue their own courses, till they are mature enough to make independent creations of their own, instead of requiring them to tread in his footsteps. In this way, they may become independent painters in due course of time. That is why one can tell at a glance the authorship of the extent paintings of the T'ang and Sung masters, in the absence of their signatures. For even a fragment of the original painting is eloquent of its creator.

The ancients say, "Read myriads of books and travel myriads of miles." It simply means that knowledge should be obtained from actual observation as well as from books, the two being complementary to each other. If the painter has contemplated the great mountains and rivers of the world till "there are peaks and valleys in his bosom", so to speak, he need have no fear of having to create something with his brush out of the void. The more he sees the more resourceful he will become. It is so with landscapists, so with the painters of flowers, human figures, birds, animals, and the rest.

Travelling may provide the painter with source materials, enable him to see the whole creation in its infinite aspects and broaden his horizon. So it is imperative to travel myriads of miles.

An accomplished painter, having technically attained the state of sublimation, is above the constraint and limitation of any fixed rules and methods. All things in the physical universe are his for the drawing and he can paint as his heart desires. After all, having become a master of painting, why should he be a bond-slave of conventional rules? As for the beginner, however, it is expedient for him to adhere to the rules and proceed according to the proper order.

In painting human figures, the most popular themes of the ancients are angling, fuel-gathering, ploughing and book-reading. These occupations were chosen, not for their being a means of making a living, but for their symbolic significance of the noble way of life befitting a learned mandarin living in retirement. Being ignorant of this underlying meaning, the painters of today often paint the human figures concerned with sordid worry written across their faces, as if they were wretched mercenaries living from hand to mouth, without suggesting the consolation of a tired soul finding sanctuary in a retreat. How absurd!

Of the four noble plants, plum, orchid, chrysanthemum and bamboo, each has its own exalted station, which is symbolic of the integrity and character of the painter or of the one to whom his painting is dedicated. Apart from that, these plants are the prototypes from which the technique of flower painting is derived. How should the ancients know that they would become the hackneyed and much abused themes of the thoughtless painters of today?

In conclusion, let me bring up a few points from my experience as a painter, for the reference of those who are interested:

(1) *Copying.* The beginner should learn the rules and methods by means of mastering the technique of defining the contour lines.

(2) *Life Study.* The painter should understand the nature of his subject, observe its form and attitude, and identify himself with its feelings.

(3) *Conception of Ideas.* Whether it be human figures, stories, landscapes, or flowers and bamboos, there should be a lofty underlying meaning, however insignificant the subject may be.

(4) *Creating the Psychical State.* The painter should strive for new ideas and discard shabby and hackneyed ones.

(5) *Seeking After the Sublime.* The painter should read books, cultivate his nature and remove himself from what is earthly and vulgar.

(6) *Craving for Nobleness of Style and Dispensing with Superfluous Brush-Work.*

(7) *Composition to Play Second Fiddle to Rhythmic Vitality.*

(8) *To Capture the Spirit at the Expense of the Appearance,* so long as it does not go against the fundamental aesthetic principles.

(9) *To Let the Brush be Relaxed and the Heart at Ease,* and to guard against showing off one's own talent and giving rein to one's own temperament.

(10) While emulating the old masters, *One Must Go Through A Metamorphosis,* instead of resorting to duplicating or pirating.

(11) *To Give Expression to a Sentiment by*

Painting an Anecdote, such as The Return of Lady Ts'ai Yen to China, Lady Yang Suffering from a Toothache, Po Chu-yi Listening to the Balloon Guitar on the Ilsunyang River, etc.

(12) *Great Compositions,* such as *King Mo's Travels, Chu Yuan in Exile, The Truce of Pienchiao* between Emperor Tai Tsung of the Tang Dynasty and the Turks, *General Kuo Tzu-yi's Encounter with the Uighur Tribesmen,* etc.

Chang Da-chien

附9　事事如意　May Everything as Wishes

畫梅

　　畫梅須老幹如鐵，枝柯樛曲，才能描寫出它耐寒喜潔的性格。畫枝時須先留好花的位置，如果用水墨，那就拿粗筆澹墨，草草鈎出花的大形輪廓，然後細筆輕鈎，在有意無意之間，才見生動。如果著色，就先用細線條鈎成花瓣，拿淡花青四圍暈它，不用着粉，自然突出紙上，兼有水光月色的妙處，若用臙脂點皴，那就不必用花青烘托。畫梅第一是鈎瓣，第二是花鬚，第三是花蕊，第四是花蒂，這裡面尤其是點蒂，要算最難，正好像顧長康所說的：「傳神寫照，正在阿堵中也。」畫花鈎瓣要圓，所謂圓不是說勻整好像數珠一般，是要蓓蕾繁花，都要有生長的意態，通通完備有欣欣向榮的樣子。花鬚要整齊，所謂整齊，不是說排比如針插針似的，不過表它是不亂的意思。點蕊要跟隨花鬚長短，錯錯落落，這才有風致。點蒂要在瓣與瓣的中間，那種含苞未吐的，尤要包固，才合物的情態，如果胡亂點去，既不合理，更不能叫人觀賞。點時更當加意，花朵有前後左右，向背陰陽，各種不同的姿態，每朵在點蒂時候要顯出生在枝上。老幹上不可以著花，因為無姿態的緣故啊。著色花心用澹草綠，花如填粉，那就用三綠，花鬚用重白粉，花蕊用粉黃點，略用赭石一兩點表示其開放已久了。花蒂用深草綠或二綠，亦可用穠臙脂，如紅梅那就必須用臙脂了。為顯示幹的蒼老，所以不能不點苔蘚鱗皴，表示它經過雪壓霜欺，久歷歲寒，但是它的貞固精神，是超卓絕特的。點時光用焦墨禿穎，依着它的背點去，一定要點圓點，若點尖長形，那就不是樹上的苔，而是地面的草了，更不可作橫點，如山水中樹上所點。待等墨乾後，用淡墨加點一次，比較有生動的氣味，不然那就枯而燥了。如是著色的，那就用草綠加在焦墨上面，或頭二綠也可以，不是全部蓋滿，偶爾留幾點焦墨在上面，也自生動自然。

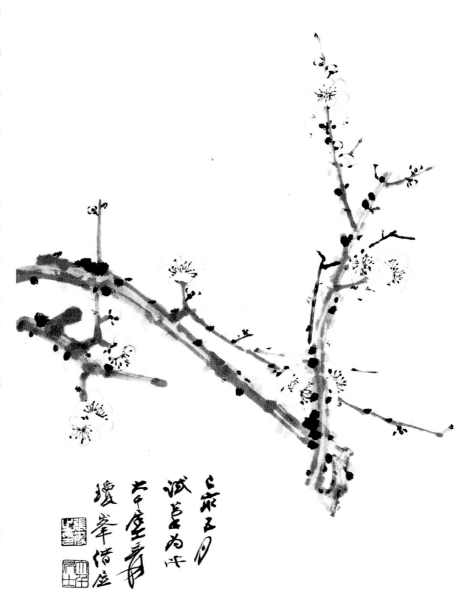

1　墨梅　Plum Blossoms

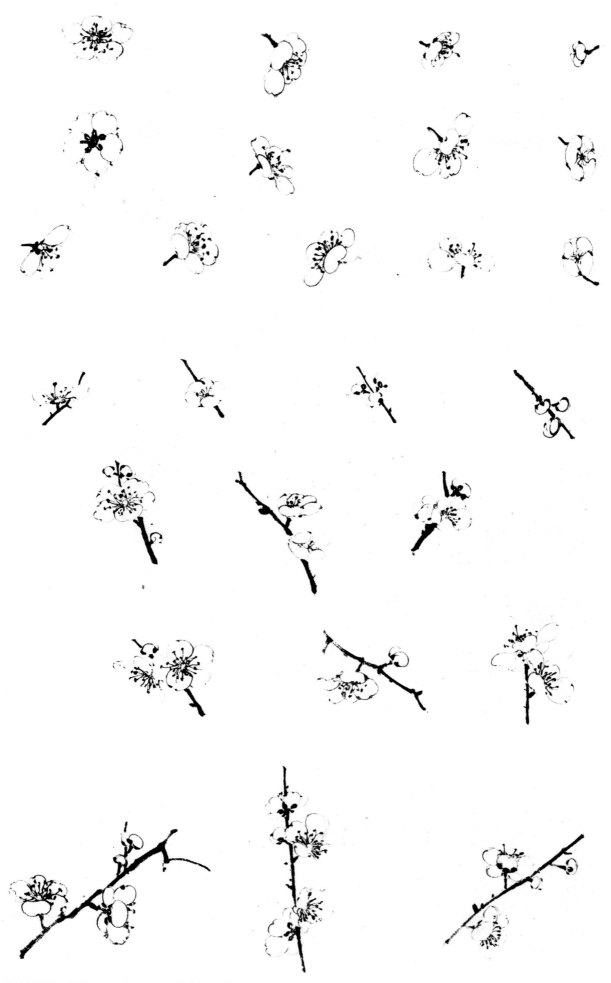

2 梅花各態 Different Aspects of Plum Blossoms

ON PAINTING PLUM BLOSSOMS

To do justice to the sturdiness and chastity of the plum tree — to which these characteristics are traditionally attributed — the artist must paint its rugged stem and gnarled limbs as though they were wrought in iron. While the branches are being drawn, suitable space should be reserved for the blossoms. In an ink monochrome, the artist first makes a rough sketch of the plum blossoms in diluted ink, then executes the detail in light strokes with inspired abandon, in order to achieve rhythmic vitality. In a water-colour, it is best to delineate the petals in thin lines and suffuse the outskirts with a tinge of pale indigo, so that the blossoms will stand out without having to be painted white, and will seem to be bathed in moon-light. The indigo shading will not be necessary, of course, if the petals are to be dabbed with saf-flower red.

The component parts of the plum blossom should be painted in the following order: first, the petals; next, the filaments; then, the pistils; and lastly, the calyxes. Of the four, the last is the most difficult, for it is the very thing, as Ku K'ai-chih (392-467) observes, in which the artist may capture the spirit and essence of his subject.

The contour of the petals should be round, not as uniform and perfect as a cluster of pearls, but in such a vivacious manner that the buds and blossoms alike appear to stir with the gladness of life. The filaments should be done in neat order without suggesting the mechanical symmetry of pins tidily stuck in a pin-cushion. The tiny dots of anthers should be evenly distributed as would befit the varying length of the filaments and thus produce a charming effect. The calyx should be so painted that it either peeps out behind parted petals or firmly embraces a bud, as it does in nature. While working on the calyxes, the artist must carefully study the particular attitude and poise of each blossom and see whether it faces front, back, left or right, whether it is prone or supine, in the light or in the shade, as the case may be. He should see to it, of course, that each calyx indicates the branch to which the blossom is attached, though he must bear in mind that it does not become the stem of a plum tree to wear blossoms in its rugged contour.

In a water-colour, the pistils may be tinged with pale green,

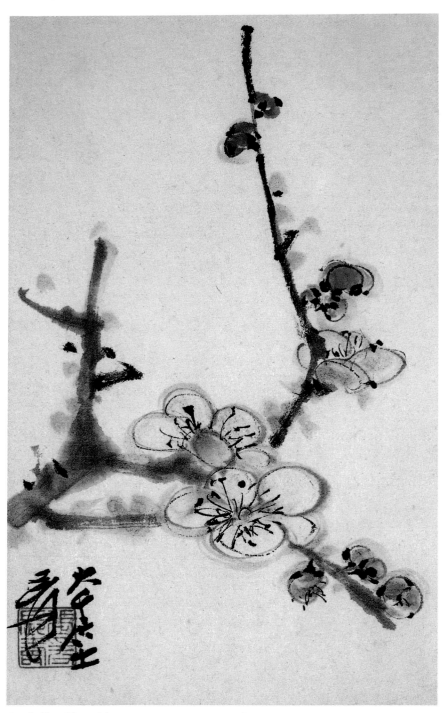

3　梅花　Plum Blossoms

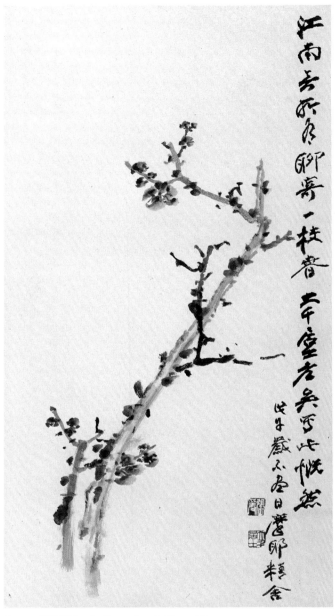

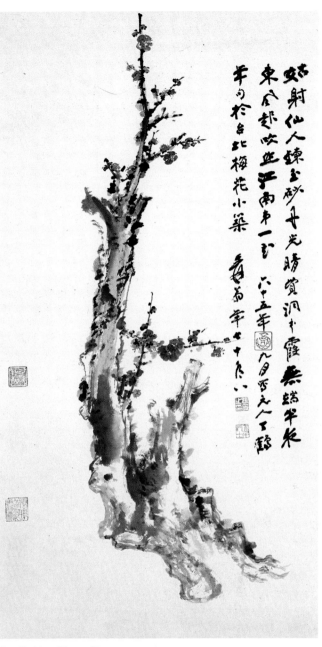

4　一枝春梅　A Branch of Plum Blossoms

5　梅花　Plum Blossoms

or No. 3 green, if the petals are painted in Chinese flake white. The filaments may be painted in heavy white and the anthers in pale yellow. A mellowing blossom may be denoted by a couple of anther-dots in red ochre. The calyxes may be painted in dark green, or No. 2 green. Heavy saf-flower red may be used also, particularly if the plum happens to be of a red species.

Moss must be stippled on the stems to enchance their rugged sturdiness. The presence of scaly and cracked moss-patches implies that the plum has withstood the frost and snow of many winters yet its steadfast spirit remains unbroken and pre-eminent. To do the moss properly, the artist should use the battered point of a brush slightly moistened with "charred ink", i.e., deep black ink, and execute the dots according to the dictates of light and shade. The stipplings should be round instead of being oblong and pointed; otherwise, they would look like patches of grass on the ground rather than those of moss on a tree. Transverse dots such as those representing foliage in a landscape, should also be avoided. As soon as the ink is dry, the dots should be retouched with diluted ink so that they will seem alive, not dry and withered. In water-colour, the painter may retouch the dots either with grass green, or with No. 1 or No. 2 green. But he must refrain from tinging all the dots; for with a few "charred ink" points remaining un-retouched, the picture will look more lively and natural.

畫蘭

　　蘭花幽香清遠，它的香氣能夠暗暗的襲人衣袂。生於深林絕谷，並不因為沒有人欣賞，而不散發它的芬芳，所以稱做幽蘭。那種一榦一朵花者，叫做蘭，幾朵花者叫做蕙。畫時應該用「清」字做要點。如能做到清字境界，便是紙上生香了。

　　畫蘭，撇葉最難，起首二三筆還容易安排，等到要成一叢，那就是大大的難事，稍一點不小心，那就好似茅草亂蓬一般了。

　　畫蘭拿一花做主體，拿三幾撇葉子陪襯它，但：每撇葉子都要有臨風吹着的風致，這才算最好的。如要畫成一叢一叢的，那就應當畫蕙，因為葉子多不易生出姿態，那就要在花枝上面特別注意，要使它枝枝好似要去舞蹈似的。

　　蘭用水墨畫算是最清高，若要用顏色，拿花青撇葉，拿嫩綠敷花，花心稍白，那上面略加上臙脂點或赭石也可，花梗就在嫩葉綠中滲少少的赭石也覺有精神。花瓣可以用汁綠在畫後雙勾，葉子就祇勾中線，使它向背顯出來就可以了。如用水墨那就不宜用勾勒。水墨撇葉在落筆時就要有轉折，花宜於淡，葉宜於濃，花瓣不可取巧，故意表示花的陰影，這一下子倒被俗見所拖累了。

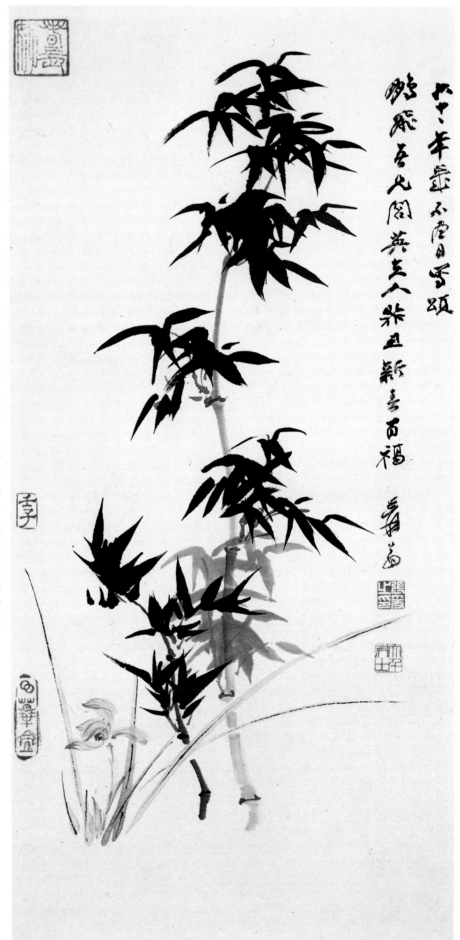

6　蘭竹　Orchid and Bamboo

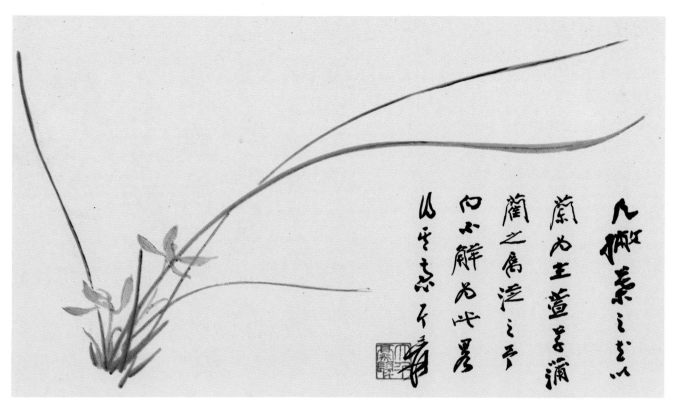

7 蘭 Orchid

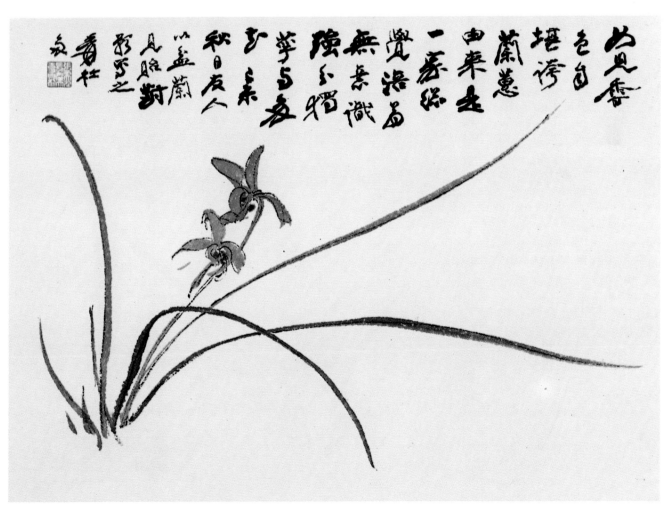

8 蘭花册 Orchid （Album Leaf）

ON PAINTING ORCHIDS.

The Chinese orchid breathes a subtle fragrance, so ethereal yet pervasive that it may steal into one's sleeves almost unnoticed. Though growing in the depth of a virgin forest or a hidden vale, unseen and unappreciated by man, it is content, nevertheless, and its sweetness untempered with sourness. That is why it has come to be called "the recluse orchid". The species that has only one flower on each stalk is known as *lan,* that which bears several is known as *hui.*

Of orchid painting, the concept of ethereality should be the central theme. If the artist can attain this conceptual state, his scroll will naturally savour of the quiet aroma of his subject.

The most difficult part of orchid painting is the execution of the long leaf-strokes. The first two or three blades are quite easy to manage but when they grow into a tuft, the difficulty becomes enormous indeed, and the slightest negligence may turn the whole picture into that of weeds and rushes.

In point of composition, the artist should treat one flower as the principal and support it with three or more blades. No orchid picture is worth the paper it is painted on, unless every leaf shows the gracefulness of being "in the wind," so to speak. If the artist intends to do a thick tuft of orchids, it is advisable to paint the multiflorous *hui,* instead of the single-crested *lan.* As it is a ticklish problem to arrange so many blades into an interesting composition, he must pay the utmost attention to the flowers and charm them till they are on the point of dancing.

It is ideal to portray the orchid in ink monochrome. If the artist prefers water-colour, he may paint the blades in

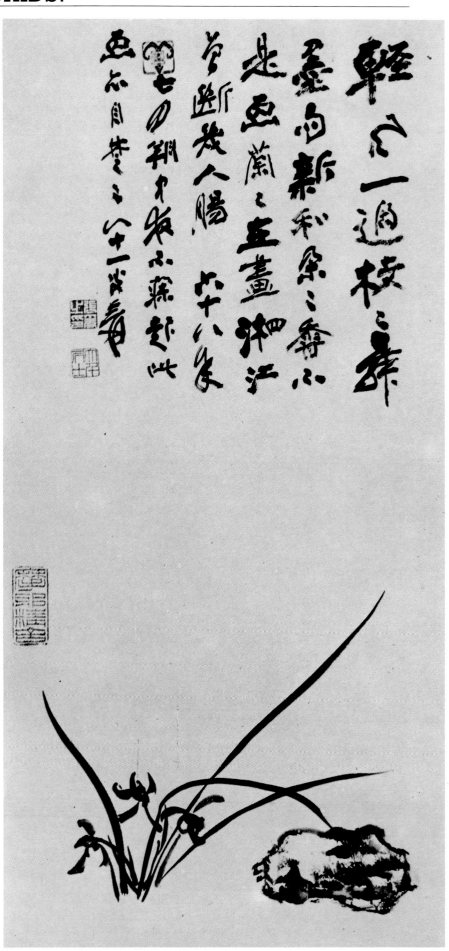

9　蘭石　Orchid and Stone

bright indigo and the flowers in tender green or sap green. The centre of the flower should be a shade paler and be slightly dabbed with saf-flower red or red ochre. The stalk, if painted in tender green with a dash of red ochre, may appear more sprightly.

When the picture is done, if the artist desires to define the contour of the plant, he may merely draw the centre line of the blades to indicate light and shade, and that will do. In ink monochrome, it is not advisable to trace any outline at all, since the bend and curve of each leaf is denoted by the brush-stroke itself, the moment the artist manipulates his brush. Light colour becomes the flower, deep colour the blades. The artist must not tamper with the petals, nor try to shade them and thereby identify himself with vulgar taste.

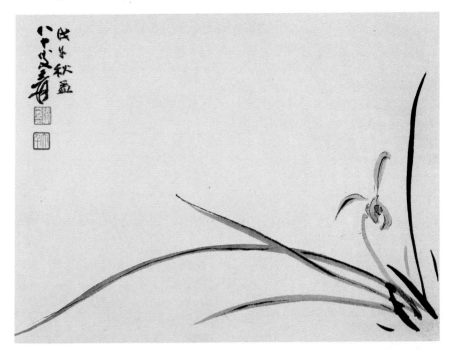

10　幽蘭　Orchid

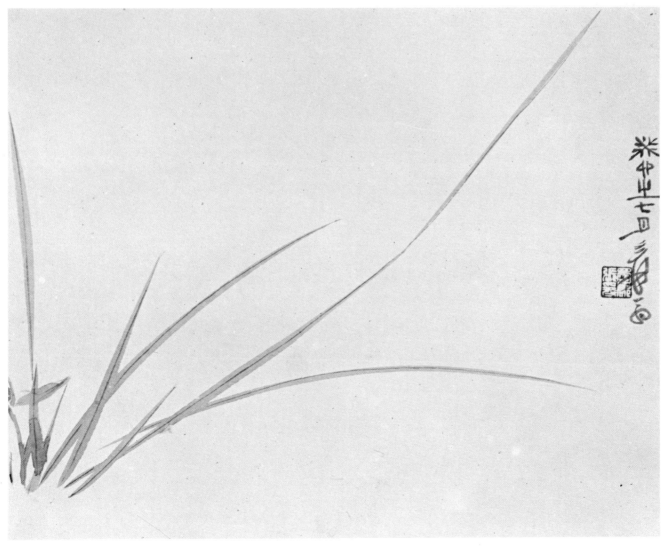

11　蘭香馥郁　Orchid

畫菊

畫菊先畫花瓣，明瞭花朵的組織，花瓣與形成整個花朵的關係。盛開或半開及含苞，都是籍花朵不同的形狀來表現的。花頭正側俯仰，花瓣也要隨着方向而展開，每瓣都要攢心連蒂。菊是凌寒傲霜的，絕無俯仰隨人的姿態，能把它的標格寫出，始稱能事。熟習花形生發方法，再畫牡丹、芍藥等，那就輕而易舉了。畫花瓣要從外面先畫大瓣，用淡墨一層，再用較深的墨畫一層。全花畫好，用淡赭石烘染它，等乾後，用濃墨點花蕊。如果畫複瓣，就不必點蕊。畫菊梗用筆要有頓挫曲折，又要有含挺健的意思。等到花梗畫成，就拿水墨濃澹的筆點葉，但最要疏密得宜，用筆好似捲雲，間或一點飛白。等墨乾透，再就那上面加以淡淡花靑或汁綠，間加

一二筆澹赭，顏色溢出墨葉是不要緊的。勾葉筋可用濃墨，勾時成小字或尖形，不必拘泥，只要看葉的大小疏密，隨意加減就行了。菊的葉尖是帶圓形的，與一般的花葉，俱帶尖形者，是不同的。菊花種類甚繁，花形各各

不同，菊葉也就不一樣，畫時一定要有分別。寫意的，那就不妨從畧；若工筆，則必須加意。從前有人畫百菊圖，花是每種各具一形，而葉俱是一種，這是一個大錯誤。寫意用單瓣為合宜。複瓣只好用在工筆畫上面。

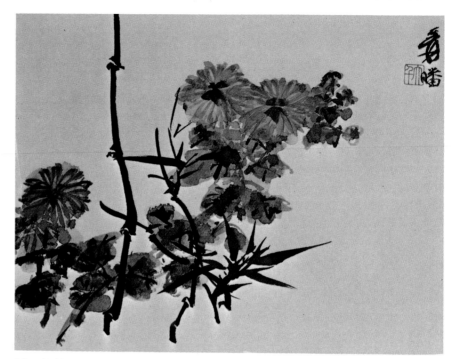

12 竹菊 Bamboo and Chrysanthemum

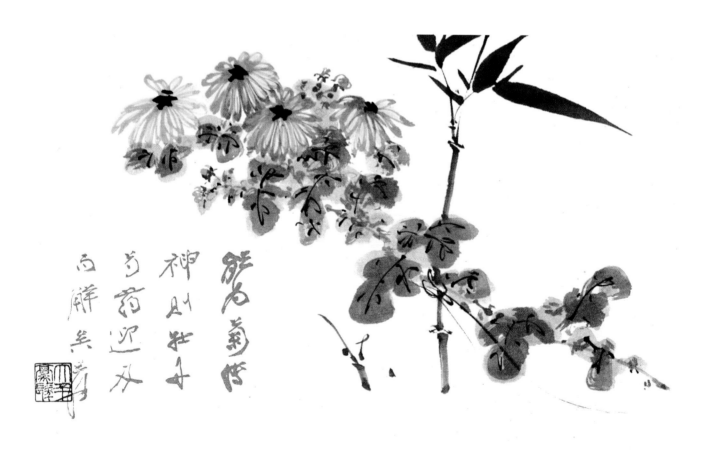

13 菊 Chrysanthemum

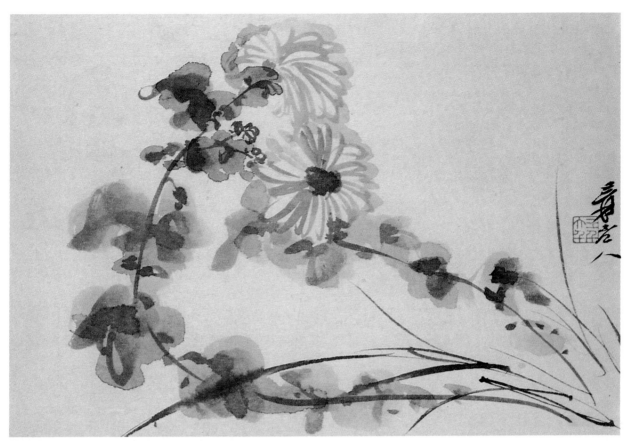

4　菊（冊頁）　Chrysanthemums（Album Leaf）

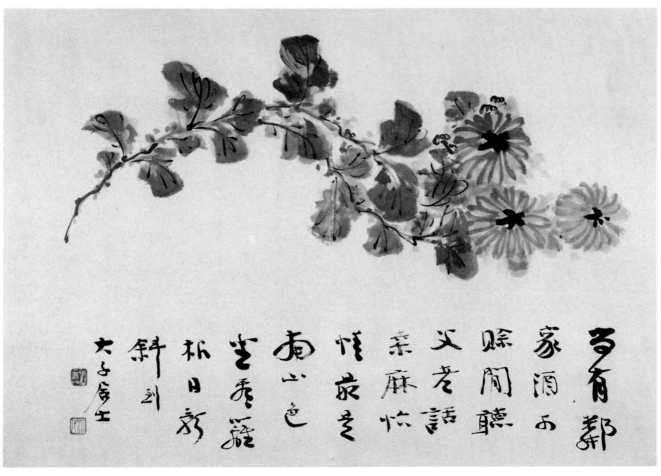

15　秋菊　Chrysanthemums

ON PAINTING CHRYSANTHEMUMS

It is the common practice to paint the petals first. The painter should know the organism of the flower and the form and feature of each individual petal in relation to the whole. The various shapes of the flower indicate whether it is in full bloom, half-open or in the bud. The petals should spread out in the direction compatible with the particular attitude of each flower, whether it faces front, sideways, upwards or downwards; and every petal must converge upon the centre and attach itself to the calyx.

The chrysanthemum, noted for its ability to withstand cold and frost, is not to the manner born of a handmaid. The painter must show his ability to bring out such lofty characters before his painting may be regarded as a work of art. Having mastered the technique of shaping this flower, it should be easy for him to do full justice to the other flowers, such as the peonies.

The long petals on the outer rim are painted first with light ink-washes before the inner layer is done with darker ink. When the flower is completed, a shading of pale red ochre should be applied to it. Wait till it is dry, then stipple the stamens and pistils with heavy ink. In the case of a double flower, the stippling would be unnecessary.

When it comes to painting the stems, the brush-strokes should have modulations and bends and turns, and should give the impression of being erect and sturdy. This done, the painter may proceed to draw the leaves with both light and heavy ink washes.

The leaves should not be too dense, nor too sparse. The brush-strokes should be so executed as if they were clouds rolling out across the firmament, with an occasional comb-like effect. Wait till the ink is thoroughly dry, then wash the leaves over with pale indigo or liquid green and add one or two dabs of light red ochre here and there. It does not matter if the colour washes should overlap the ink base. Dark ink is commonly used to delineate the leaf-veins which may either be shaped like the character　or　, depending on the size and density of the foliage. The painter may do whatever he sees fit, without restraint.

The end of the chrysanthemum leaf is somewhat crescent in shape, instead of being pointed as is that of many other plant leaves. Infinite variety of species has given rise to marked differences in the shape of flowers and leaves alike. The painter will do well to observe such disparities, particularly if he chooses to paint in the elaborate style. If however he belongs to the impressionistic school, he may overlook the distinction with impunity. A long time ago, a certain artist painted a scroll of "One Hundred Chrysanthemums," in which each flower was of a different type but the leaves were all alike.

That, of course, was a great error. In passing, the painter should bear in mind that whereas single flowers suit those who paint in the impressionistic style, the double ones lend themselves only to the elaborate brushwork of the *kung-pi* school.

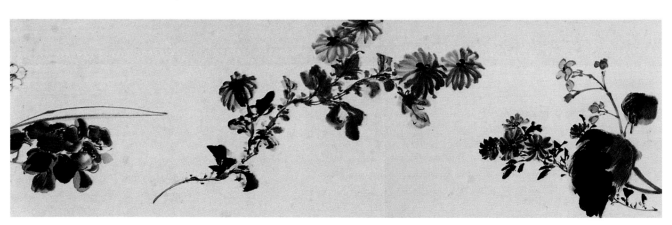

16　仿白陽四季花卉　The Flowers in Four Seasons Immitated from Pai Young

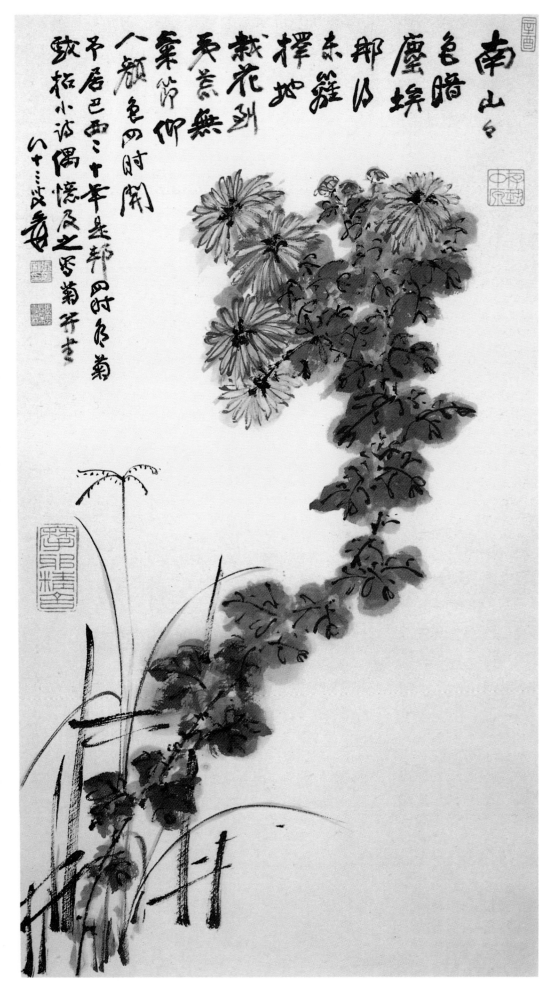

南山白
色暗塵埃
那似東籬
擇地
栽花到
不煮無
氣節仰
人額色四時開
予居巳西三十年是邦四時多菊
致拈小詩偶憶及之寫菊并書
八十三叟每

17 菊 Chrysanthemums

寫竹

古人畫竹稱作寫竹，因為畫竹是等於寫字一樣，用筆要完全合乎書法。書法第一要訣，一定練好永字，因為永字已包括側、勒、努、趯、策、掠、啄、磔八種方法。這些方法都通用於寫竹。竹枝更須用篆書的方法，畫竹葉也要寫成个字，和介字，川字形狀，但必須要用一二筆來破開。古人所說的：「逢个不个，逢介不介，逢川不川。」就是這個道理。畫竹應該先寫竹竿，從上寫下，像字一樣，沒有由下寫上的道理。每一竹節為一段，起筆署重，一搨直下，住筆向左署署一踢就收，一節一節的畫下去，梢頭稍短，漸下漸長，到近根的地方，又慢慢的短下來。待畫完時，然後出枝畫葉，在離開竹節的空處，用濃墨寫一橫道，用筆要從逆勢進去然後翻出來，兩頭放起，叫做點節。竿要上下粗細差不多，切忌兩頭大，中間細，叫做蜂腰鶴膝，是不可以的。講到順勢，直的竹竿必從上到下，這是順筆，如果竹竿倒在右邊，是應該從上而下，或從外向內呢？我以為要是竹竿偏倒在右邊，就要從下或裏向外畫了。這完全是要看情形，順着筆勢的

關係。最後就畫竹葉。竹葉必須生動，決不可將竹安排得如圖案一樣，尤忌部位一樣，必定要非常自然。竹法有雙勾寫意兩種，雙勾那就是用細線條勾成輪廓，然後再填色，這是工筆畫竹，必要充分了解竹的生長狀態和結構，一筆不得苟且，這種可以叫作畫竹。寫意的竹，也要分層次，近的竹在前，要用濃墨，遠的竹在後，要用淡墨，這才能夠分得出前後，明暗的

層次，增加韻味，可是有一點要記着，每一根竹是用濃墨，就全部用濃墨，用淡墨就全部用淡墨，絕不要在一筆上弄巧，兼有濃淡二色，反為不美。竹有風竹，雨竹，晴竹，老竹，新竹，新篁的分別。風竹是要表現竹在風中的姿態，枝葉要隨着風向，作斜橫飄動的狀態，最不易表現者，為竹竿要能夠在風中有彈性動態的感覺。雨竹的枝葉稍下垂，有濕重的意思，老竹

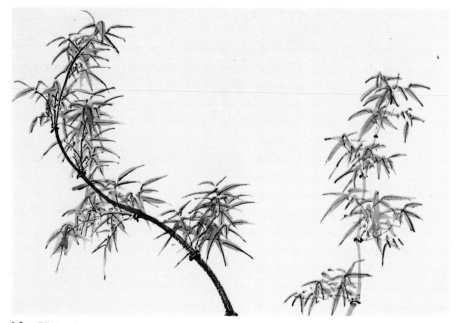

18　翠竹　Bamboo

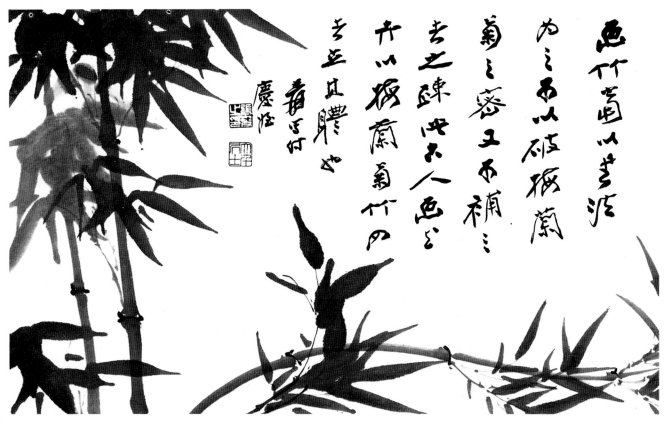

19　竹　Bamboo

是竿粗葉少，新篁乃是竿細枝柔，葉
葉向上。還有在竹節每節上出枝及芽
的問題，往往爲人忽畧，根據實狀，
每一竹節在左發枝，一定在右發芽，
第二節則一定變爲在右發枝，在左發
芽，作畫雖小地方也要注意，如作詩
詞，要字斟句酌。石濤寫竹，昔人稱
其好爲野戰，但是他的生動有風致，
那種縱橫態度實在趕不上。但是我們
不可以去學。畫理嚴明，應該推崇元
朝李息齋算第一人，從他入門，一定
是正宗大路，現在我畧畧舉他的方法
在後面。

畫竹所忌的是「衝天撞地」、「偏重
偏輕」、「對節排竿」、「鼓架勝眼」、
「前枝後葉」。枝葉要在剛勁快利中
求柔軟諧和，柔軟諧和裡而要有剛強
的骨力，在柔婉姿媚裡找求剛強中
正；分開斷開的地方，要有相連相屬
的意思。

墨竹要墨色勻停，下筆平直，兩邊
好似有界限的，自然就會圓正。如果
畫的擁腫，又偏又邪，墨色又不勻，
一些粗，一些細，一些枯，一些濃，
及節空或長或短，斷斷不可犯着這些
毛病。

畫枝各有名目，生葉的地方叫丁香
頭，相合處叫做雀爪，直枝叫做釵股，
從外面畫入的叫做垜疊，從裡面畫出
的叫作迸跳。下筆一定要有遒健，圓
勁，生動的意態，一直連綿下去不斷，
行筆要快要速，不可遲緩。老枝那就
挺然而起來，節大但枯瘦；嫩枝那就
和柔而婉順，節小但是肥滑；葉多那
就枝垂下來，葉少那就枝昂起來；風
枝雨枝也是因爲每類情態的不同，而
隨時變化，不可以拘泥於一個方式。

畫葉下筆要勁利，實按而虛起，一
抹便過，稍微遲留，那就鈍厚不會銛
利了。這是寫竹最難的一關，虧了這
步功夫，那要不能算線墨竹了。在畫
竹方法有所不宜，而應忌的，學者應
當知道，粗枝忌像桃幹，細的忌像柳
枝，第一忌一竿孤立而生，第二忌兩
竿並排並立，第三忌好似叉形，第四
忌好像井字，第五忌好似手指和像蜻
蜓一樣。所有竹的反、正、向、背、
轉、側、低、昂，雨打風翻都各有它
的姿態，但要細心去領會，然後畫出，
才能盡善盡美。

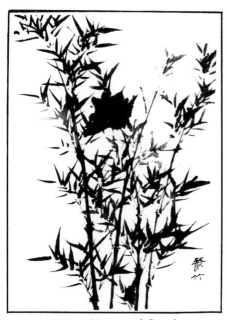

20　叢竹　A Cluster of Bamboo

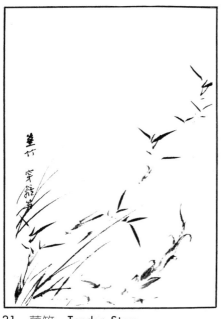

21　莖竹　Tender Stem

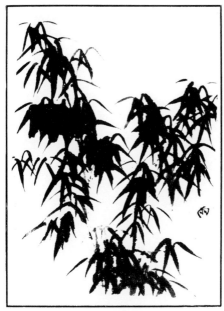

22　雨竹　Rainy Bamboo

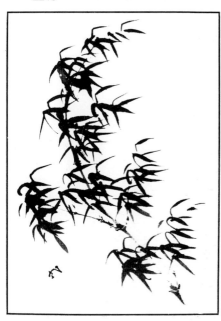

23　風竹　Windy Bamboo

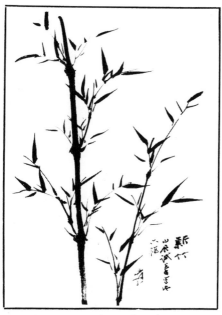

24　新竹　New-born Bamboo

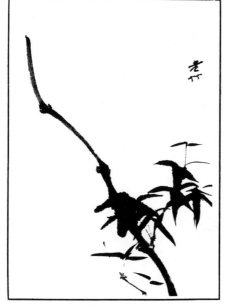

25　老竹　Old Bamboo

ON PAINTING BAMBOO

The ancients often refer to bamboo-painting as "inscribing the bamboo". For the bamboo painter, like the Chinese calligraphist, must execute his brush-work in accordance with the calligraphical technique. The first pre-requisite in Chinese calligraphy is the mastery of the "eight methods" as manifested in the character *yung*, namely, *ts'e,* or the dot; *le,* or the horizontal stroke; *nu,* or the vertical stroke; *ti,* or the hook; *ts'e,* or the up-tilted stroke; *lueh,* or the declining stroke; *cho,* or the pecking stroke; *che,* or the trailing stroke. These eight methods are used concurrently in painting bamboos. To do the bamboo stems, for instance, requires the application of the seal script technique. The leaves should be shaped like the characters , , and , though these patterns should be broken up with one or two non-conforming strokes. As the ancients say, "The pattern should not be a perfect , nor a perfect , nor a perfect ."

The artist generally draws the stem first in a succession of vertical strokes from the top downwards, as in calligraphy, instead of from the bottom upwards. Each segment of the stem is indicated by a node at its base. It should be painted in one straight descending stroke with greater stress at the outset and a slight leftward "kick" of the brush-tip at the end. In this manner the segments are delineated one after another, each slightly longer than the preceding one, till the order is reversed near the root. The stems must be completed before the artist proceeds with the branches and leaves. To "inscribe" the node in the narrow gap between every two segments, he makes a horizontal stroke in heavy ink by starting his brush in the opposite direction, then reversing it abruptly, so that both ends become uptilted. The stem should be of almost even thickness from top to bottom, neither wasp-waisted nor crane-kneed.

As most bamboo stems are upright, the natural direction of the brush-stroke is from the top downwards. If however the stem happens to slant over to the right, should one paint it in the same way, or in the reverse direction? In my opinion, the latter is to be preferred. As there are always exceptions to the general rule, the painter must exercise his own discretion according to the natural impulse of the brush and the special situation in each case.

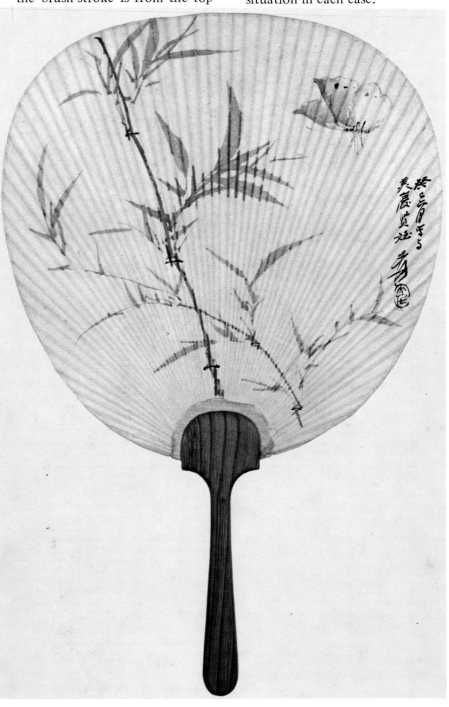

26 蝶竹 Butterfly and Bamboo

The leaves, to be painted last, should be lively and dynamic. Instead of rendering them in the same order as geometrical patterns, particularly in balanced symmetry, the painter should strive to bring about spontaneity.

There are two ways of painting bamboo, namely, the contour method and the impressionistic style. By the former, the artist describes the contour of his subject and fills in with plain colour washes. This is the technique of the elaborate school which requires precision of brushwork and a substantial knowledge of the bamboo's organism and manner of growth. In other words, this is the technique of *painting* the bamboo, as distinguished from that of *inscribing* it.

The technique of inscribing the bamboo in the impressionistic style also requires indication of depth in perspective. Thus, the bamboo in the foreground should be painted in deep black and those in the background in pale grey, in order to enhance the rhythmic vividness by means of the difference in nuance and depth. But the painter must bear in mind: (1) that each bamoo must be painted entirely in one shade, either black or grey, and (2) that the trick of using both heavy and light ink in one single brush-stroke is a proven foolery which one will do well to avoid.

There are distinctions between the old bamboo, the new bamboo and the tender stems as between bamboo in the wind and that in rain or sunshine. To paint *feng chu,* or bamboos in the wind, the artist must give expression to their graceful carriage and show the branches and leaves in motion as they flutter and sway in the direction of the breeze. The most difficult thing to achieve is to let the stems manifest their resilience in the eye of the wind. *Yu chu,* or bamboos in the rain, are denoted by their slightly drooping branches and leaves, which give the impression of being wet and heavy. Thick stems and sparse leaves are the hallmarks of old bamboo, whereas the tender stems are thin and flexible, with uptilted leaves.

The way in which the branches and buds sprout from the node is a point that often escapes the painter's notice. In reality, if a branch shoots out on the lefthand side of a particular node, a bud is invariably to be found on the other side;

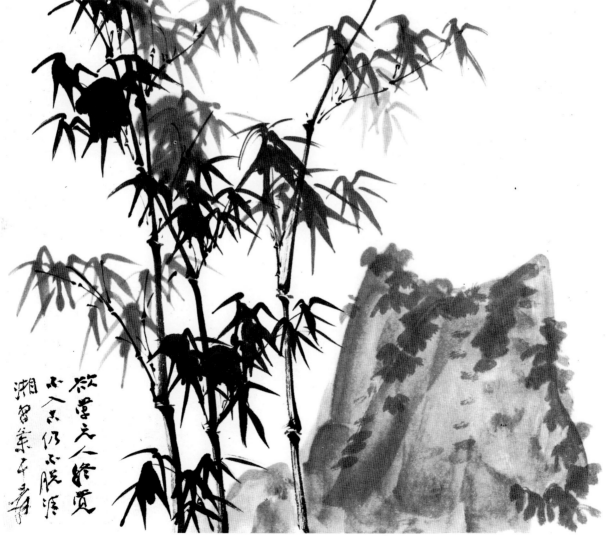

27　石竹　Stone and Bamboo

their relative positions are reversed at the next node. The artist should take due notice of such minute detail just as the poet should ponder over every line and word of his poems. Commenting on the bamboo by Shih Tao (1630-1707), the critics of old say that he has a passion for "combating in the wilderness", i.e., extraordinary composition. But his ink bamboos are so lively and graceful and their style such a riot of beauty that we should never attempt to follow in his footsteps. The beginner can never go astray if he takes the advice of Li Hsi-chai of the Yuan Dynasty, the foremost theorist in bamboo-painting. Let me quote some of this remarks: —

The bamboo painter should avoid such faults as "leaving no margin at the top and bottom of the picture frame," "lopsided composition", "symmetrical parallelism", "criss-cross of several stems at the same point or into a rhomb" and "the presence of a branch in front of its leaves". The branches and leaves should contain flexibility in their sword-like sharpness, strength in their pliability, integrity in their lady-like gentleness, as well as continuity and affinity in the broken-up or parted strokes.

Mo chu, or bamboos in ink monochrome, calls for even-toned brushwork and straight, balanced strokes as if the brush were following sharply defined boundary lines. The painter should never commit such faults as making lumpy, erratic, uneven-toned strokes, so that some are thick and others thin, some shrivelled and others sodden, some node-gaps wide and others narrow.

There are special epithets for various parts of the bamboo. The place where the leaf grows is called "the clove's bud", where the leaves join the branch "the sparrow's claws", the

straight branch "hairpin shaft"; the convergent technique of painting is know as "piling-up", the divergent "jumping-off". The brush work should be executed with vigour and strength, with sustained liveliness, and with expedition instead of slovenliness. The old branches should be erect, with prominent but desapped thin nodes; the tender stems supple and complaisant, with small but smooth round nodes. The branch tends to droop if the leaves are dense, to cock up if sparse. In wind or rain, the bamboo changes its mode according to the dictates of circumstances, instead of clinging to a stereotyped pattern.

When it comes to painting the leaves, the brush-strokes must be steely and sharp. The firm pressure applied to the brush at the start should be gradually released in one swift motion, lest the stroke should become blunt and thick. This is

the bamboo painter's most difficult test. Should he fail to master the technique, his work would be so much labour lost.

In painting bamboos, the painter must bear in mind that the stems should neither be as thick as peach stems nor as thin as willow branches. He must also try to avoid such technical defects as the following: (1) isolation of a single leaf, (2) two leaves parallel to each other, (3) three leaves in a trident-like formation, (4) four leaves crossing one another like the symbol 井, (5) five leaves stretching out like fingers or a spread dragon-fly. Whether facing front or rear, turning upside down or sideways, drooping or uptilted, rain-lashed or wind-swept, the bamboo leaf has its particular manner in each case. The artist must study the subject carefully before he can ever attain perfection.

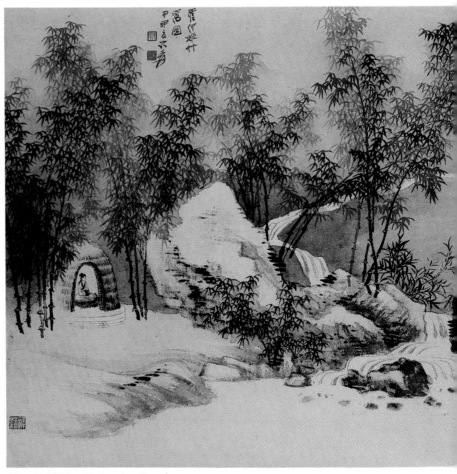

28　竹居圖　Living by Bamboo

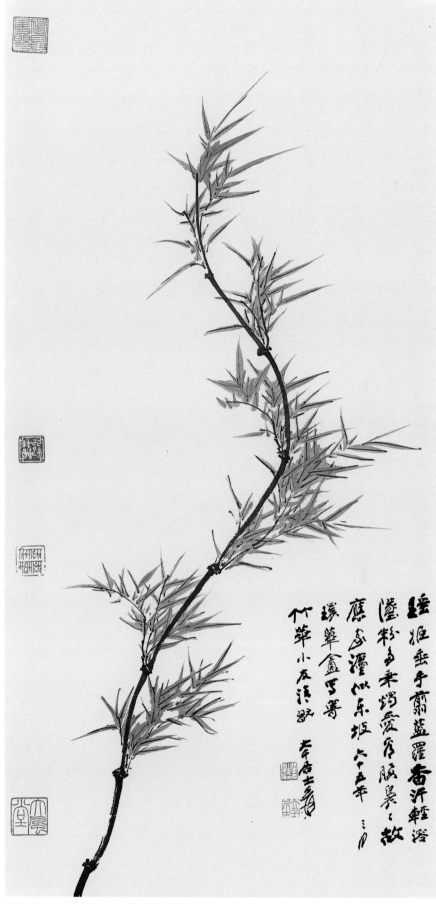

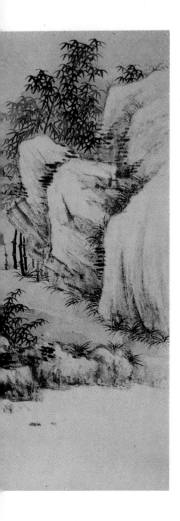

29 鳳尾竹 Phoenixlike Bamboo

花卉

研習花卉，首先要參考一部舊時的書，叫廣羣芳譜。全書祗是文字，沒有一張圖畫，但把各種花卉的形態和特性，說得非常清楚。知道花形容易，知道花的性情就困難，所以這本書是畫花卉應備爲參考的要籍。花卉有木本、草本兩種，這要先弄清楚。花卉當然要推宋人爲第一，畫的花卉境界最高，他們的雙鈎工夫，不是後人所趕得上的。到了元人才擅長寫意（宋末偶亦有之）；到明清，漸至潦草，物理、物情、物態、三點都失掉了，獨有八大山人崛起，超凡入聖，能掩蓋前代古人。花卉不是每一種都能夠入畫，也須選擇；畫家也不是每一個擅長各種花的，能深深的明瞭幾種花木的特性，已經是不容易的事了。體會物理，看某一種花，要由芭萌抽芽，發葉吐花，這些過程中，給我們的印象，能一一傳出。更嚴格的說，要能從發葉子的時候，一看就可以辨出花開出來的顏色，要這樣纔能算得深入裡層，算是花的知己，稱得畫師了。能夠栽種的或能插於瓶盎的，應該搜羅一些，放在身邊，使我們能夠朝夕相處而觀察它們，從而爲它們寫生。冶姿嬌態，和生長的意味，都要完足。用筆要活潑，活潑並不是草率，是要活力和自然。墨色務要明朗，不可模糊不清。選古人的名跡，吸收他們的精粹，這樣不會不成功的。花幹也有一點必須注意的，它是整個花的主體，木要畫得挺拔而且秀發，又不可以太過僵直，草本要有柔脆婀娜的姿態。

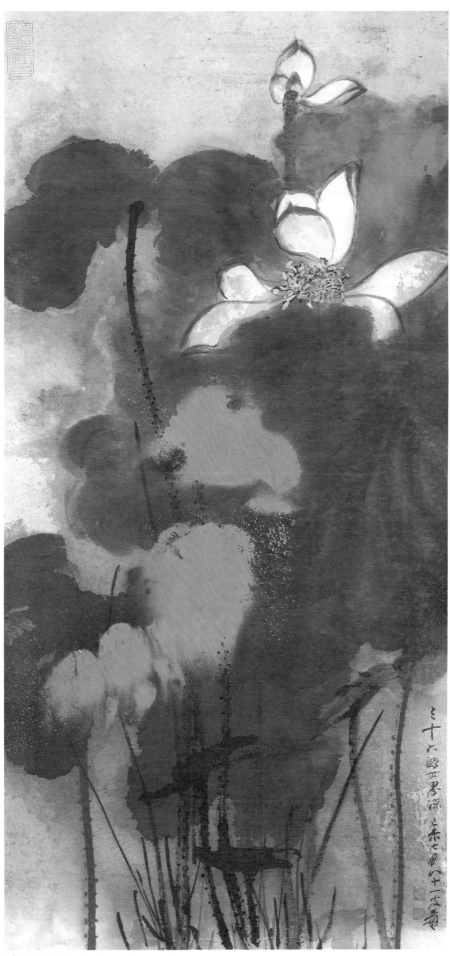

30　雨荷圖　Rainy Lotus

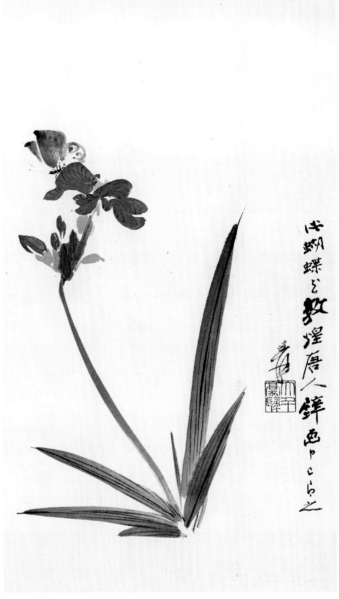

31　雙淸圖　Butterfly and Orchid

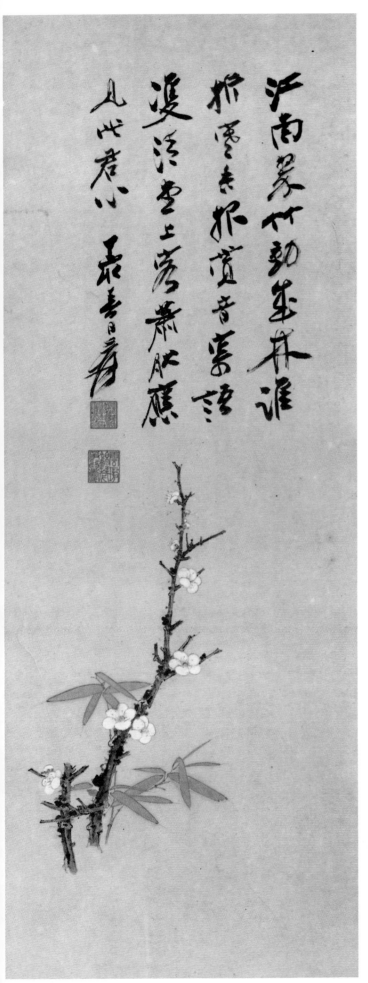

32　蝴蝶蘭　Moth Orchid

ON PAINTING FLOWERS AND PLANTS

In studying flowers and plants, one will do well to refer to an old standard botanical treatise, entitled *A Comprehensive Catalogue of Beauties.* Although this book is entirely devoid of illustrations, it gives an excellent description of the physical likeness of the various species as well as their characteristics. As it is easy to recognize the former but difficult to know the latter, the *Catalogue* remains an important reference book for those who take up flower painting. There are two kinds of flowers and plants, namely, those of the tree family and those of the herbaceous family, between which the beginner should learn to distinguish.

In this department of painting, the artists of the Sung Dynasty, of course, have a claim to precedence. The idealistic state revealed in their work is of the loftiest order and their mastery of the contour technique hardly to be equalled. In the Yuan Dynasty many flora painters attained perfection in the impressionistic style though in the Sung Dynasty such artists were yet few and far between. That school gradually degenerated in the Ming Dynasty into that of slipshodism until the artists had completely deviated from the principles of observation, understanding and communion. It fell to the lot of Pa Ta Shan Jen (who towered into eminence in the 17th century) to overshadow his predecessors and lift the decadent art from the ridiculous to the sublime.

As not all flowers lend themselves to the painter's art and no painter is equally proficient in portraying different kinds of flower, it is for the painter to make his own choice. To have a thorough knowledge of the special characteristics of even a few species is no easy matter. Unless one has a deep impression of a plant through observing it, from its very sprouting from the seed to its culmination in full bloom, one cannot expect to understand its nature really well and to do justice to it in painting. The artist should be able to predict the colour of the flower by examining the first leaf of a sprouting plant, before he may be considered as its true friend and master painter.

It is advisable for the artist to plant flowers in his garden and keep some in vases in order that he may have the advantage of living with them and observing them at close range. Such everyday intimacy will enable him to give full expression to the infinite variety of the flower's lovely presence and attitude, as well as its dynamic urge to live and grow. He must manipulate his brush with sprightliness which, calling for both vitality and spontaneity, is to be distinguished from slapdash carelessness. The ink used by the painter should have a clear lucid tone, instead of being muddy. Should the painter make a selective study of the celebrated masterpieces of the ancients and learn the best they have to offer, he would be able to master the technique as a matter of course. There is another point which one should bear in mind: it is that the stem (or the stalk, as the case may be,) is the mainstay of the flower. In case of perennials, the stem should be erect and vivacious but not too straight and stiff. In case of herbaceous plants, the stalk should have the feel of flexibility and gracefulness.

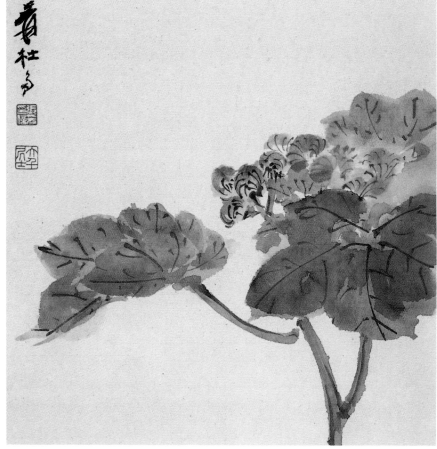

33 芙蓉 Hibiscus

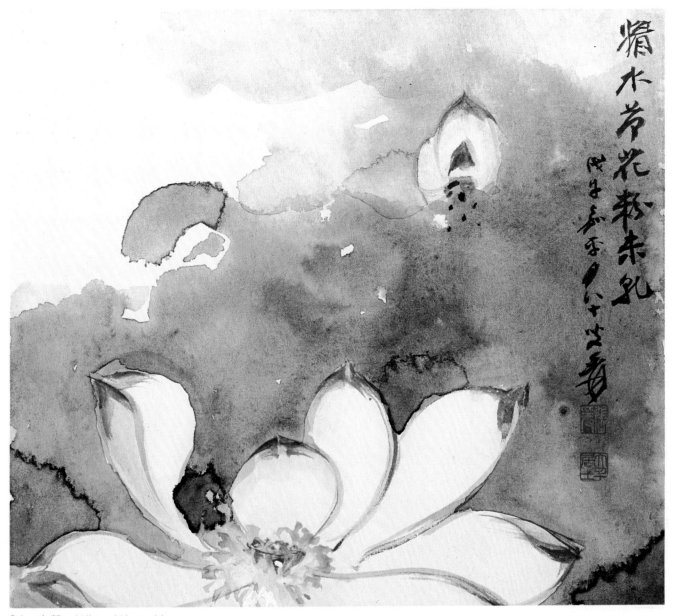

34　白蓮　White Water-lily

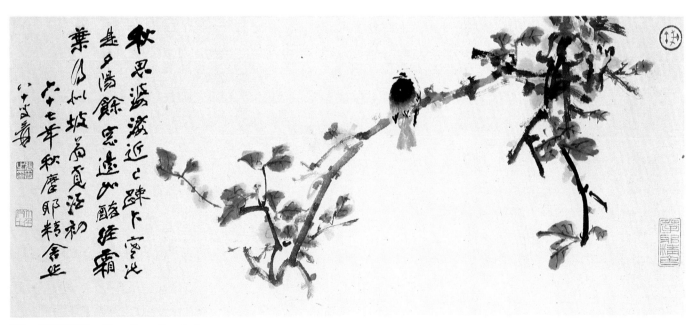

35　霜葉迎秋　Greeting the Autumn

沒骨花卉

　　爲什麼叫做沒骨法，就是不用墨筆
勾勒，祇用顏色來點戮，這就叫作沒
骨。這畫法創始於北宋徐崇嗣，花卉
是以清妍艷麗爲主，完全拿顏色來表
現，是較爲容易的。這法傳到清初，
要算惲南田第一，清妍艷麗四個字，
可以說是闡發無餘了。畫花瓣盡可全
用顏色，也不妨先用水墨點戮，然後
畧施淺色，覺得更有精神些。白陽石
濤是常用這方法的，荷花頗適合於沒
骨。先用淺紅色組成花形，再用嫩黃
畫瓣內的蓮蓬，跟着卽添荷葉荷幹，
葉是先用大筆蘸淡花靑掃出大體，等
色乾後，再用汁綠層層渲染，在筋絡
的空間，要留一道水線。荷幹在畫中
最爲重要，等於房子的梁柱，畫時從
上而下，好像寫大篆一般。要頓挫而
有勢，有亭亭玉立的風致。如果畫大
幅，幹太長了，不可能一筆畫下，那
麼下邊的一段，就由下衝上，墨之乾
濕正巧相接，了無痕跡。幹上打點，
要上下相錯，左右揖讓，筆點落時，
畧向上踢。花瓣用較深的臙脂，再渲
染一二次，再勾細線條，一曲一直，
相間成紋；花鬚用粉黃或赭石都可。
這時看畫的重心所在。加上幾筆水
草，正如書法所說的「寬處都走馬，
密處不通風」也。

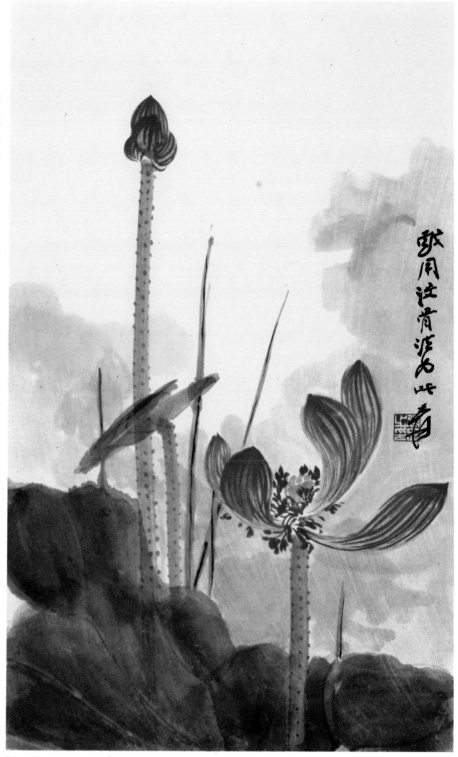

36　荷　Lotus

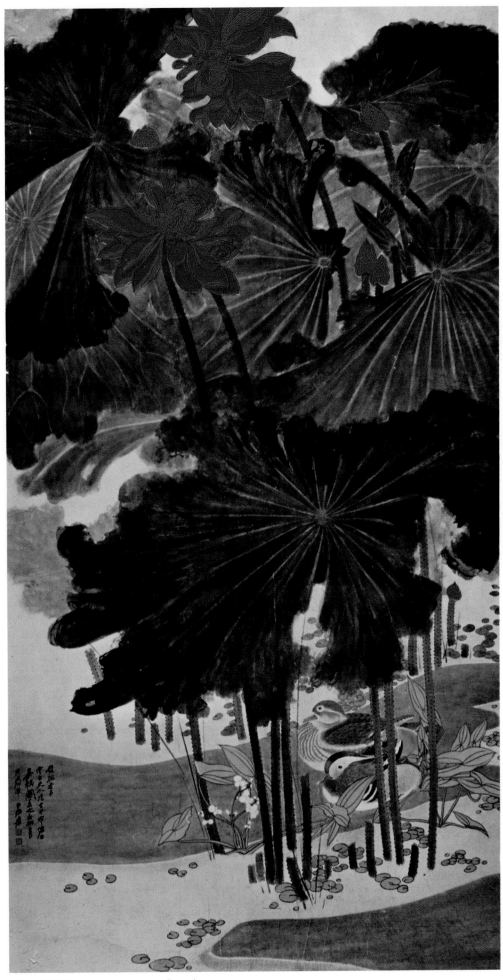

37　嘉耦圖　An Excellent Couple

FLOWERS AND PLANTS IN THE MO KU STYLE

By *mo ku fa* (literally, the boneless method) is meant the application of graduated washes of colour without ink outlines. This technique was originated by the celebrated master Hsu Ch'ung-ssu of the Northern Sung Dynasty. As flowers and plants are distinguished principally for their purity, delicacy, radiance and splendour, they easily lend themselves to representation in colour. Handed down to the Ch'ing Dynasty, Hsu's mantle fell upon the shoulders of Yun Nan-t'ien who, by leaving little to be desired in his exposition of these four cardinal virtues, may be considered as the foremost exponent of the *mo ku* art.

While it is admissible to paint the petals entirely in colour, one may also render them in ink monochrome first and then touch them up with light-coloured pigment. This technique, frequently employed by Pai Yang Shan-jen (alias Ch'en Shun) and Shih T'ao, seems to have a more pronounced vivaciousness.

The lotus flower is a very suitable subject for the *mo ku* method. The painter may build it up with modulated light-red washes, then paint the seed-case in tender yellow and finally the leaves and stalks in succession. The leaves should be done in broad sweeps with a big brush soaked in light indigo, to be covered with coats of sap green, when dry; leaving only thin lines where the leaf-veins are to be. Like the pillars of a building, the lotus stalk is of paramount importance in composition. It should be painted in one descending stroke, as though one were writing in the grand seal script style, with properly modulated pressure and dynamic force, so that it may have the

gracefulness of an angel standing in beauty. If the stalk happens to be too long to be done in one stroke, as it may be in a large scroll, the lower part may be painted in an upward stroke which, being similar to the upper stroke in ink content; will

not show any trace where the two ends meet.

Tiny dots, representing the prickles, should be stippled with a slight upward "kick" of the brush-tip, up and down both sides of the stalk alternatively. The petals are to be rendered

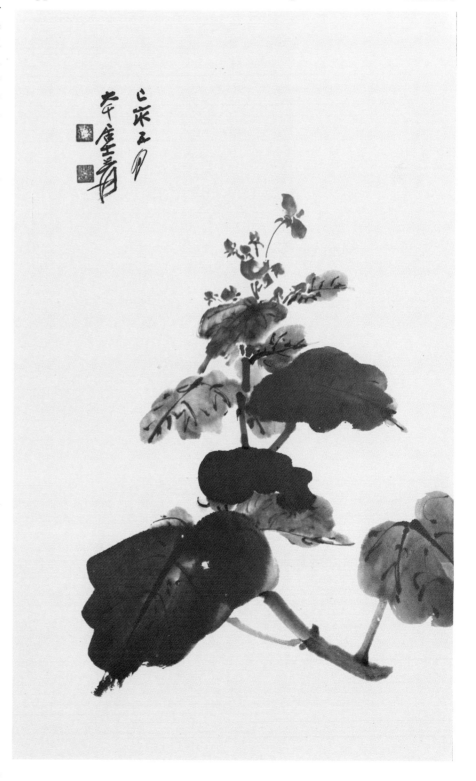

with graded washes of saf-flower red. After one additional coating or two, the painter may start to draw the petal-veins in thin lines, one straight and one curved, in alternate order. The filaments and anthers may be done either in red ochre or in whitish yellow. The addition of duckweeds is optional, depending on the desirability of their presence in the compsition. In the same way it is said of the art of calligraphy, "Where expansiveness is required, let there be room enough for a trotting horse; where compactness is required, let no wind pass through."

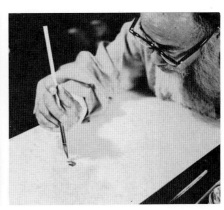

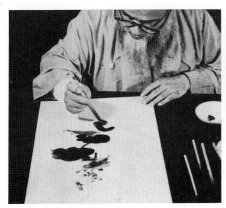
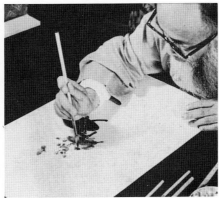
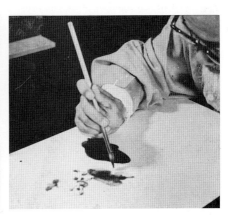

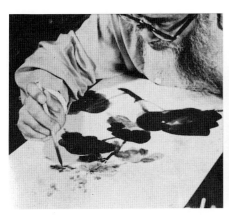
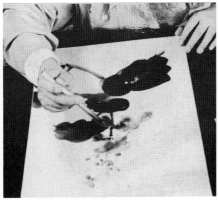
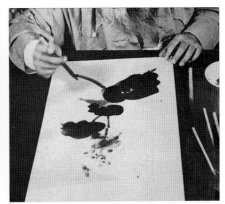

39　示範秋海棠的繪畫過程　Demonstration of Painting the Beqonias in Successive Stages

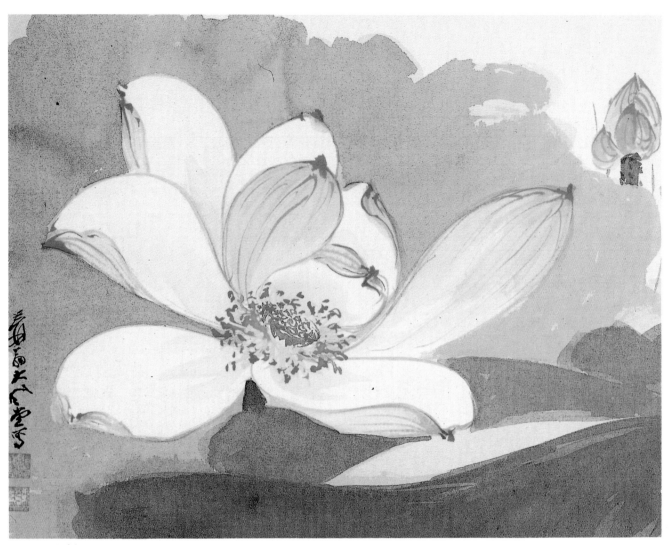

40　荷花　Lotus

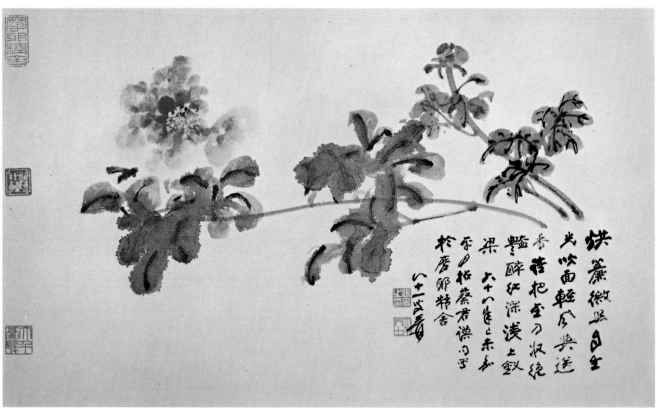

41　芍藥　Peony

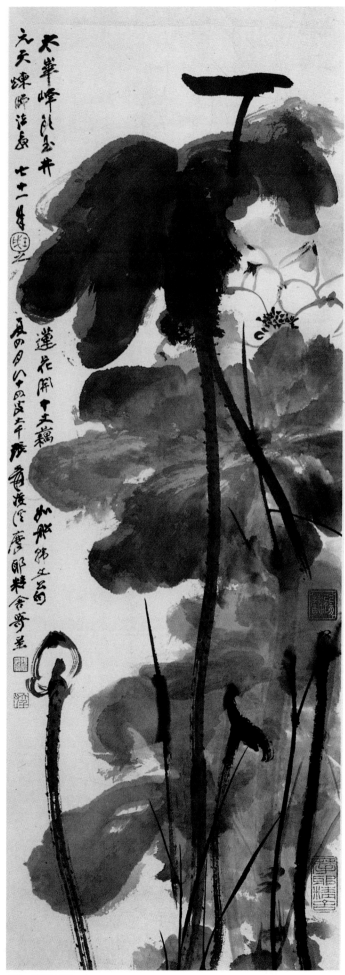

42　荷花圖　Lotus

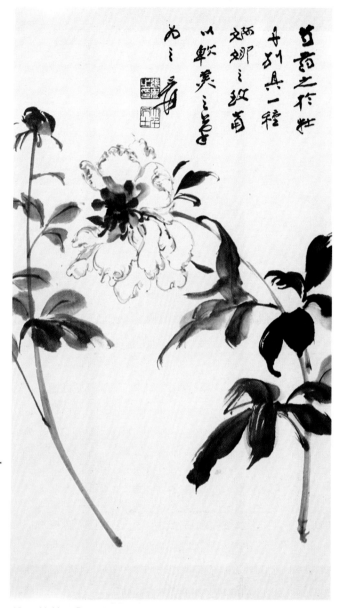

43　芍藥　Peonies

工筆牡丹

　　牡丹華貴穠艷，所以尊爲花中之王，稱爲國色天香。畫工筆花卉要拿牡丹來代表。牡丹種類特別多，但是我生平所愛好而最喜歡畫的是照殿紅、潑墨紫、佛頭靑三種。畫這種畫，須要下些功夫，不是草率而成的，因爲用礦物質的顏色研磨與下膠，都比較麻煩。膠不可太輕，輕就容易脫落，也不可太重，重就容易板滯。今天用，今天下膠，用後就要加水，把膠退去，若不退膠，經宿靑綠就失去本色。西洋紅有現成含膠的，否則也須自己加膠，用手指細研才合適。畫的時候先拿細筆淡墨勾好花瓣，第二才把枝葉分佈，穿挿須要配合花形。花瓣用較淡洋紅，一瓣一瓣染勻淨，等乾了仍用淡洋紅再加上，然後用深洋紅留水線一道，又一瓣一瓣加三、四次，那麼顏色就會高凸紙上好像剪絨一般。用重洋紅勾邊，最後更用泥金加勾一次，自然華貴穠艷。花蕊用粉黃點戳，如果全開的花，花心用石綠來畫成粟子的狀態，尖上用臙脂畧畧勾染，花蕊仍用粉黃或泥金亦可。枝葉末用石綠時，須先用赭石打底，上過石綠，等乾了以後，用汁綠勾准輪廓，正面葉用綠汁渲染也須兩三次，最後一次，筋旁也當留水線，中間加上石靑，向兩邊暈開，漸漸淡到沒有。葉背和嫩葉，那就全用二綠或三綠。葉的反背，各用花靑和汁綠勾勒，能夠再用金勾一次更覺得醒眼。佛頭靑枝和葉的畫法，和上相同，所分別的祇是花頭不用洋紅，而用石靑。石靑以三靑爲宜，平塡不分深淺，花瓣反面，就用四靑，邊緣必須勾花靑和泥金，不然就沒有神。潑墨紫用花靑打底一次，用淺洋紅平蓋一次，然後用深洋紅留水線，跟着塡三次，就可以了。瓣勾用深洋紅，最後加勾泥金，枝葉着色，和前面法子相同。

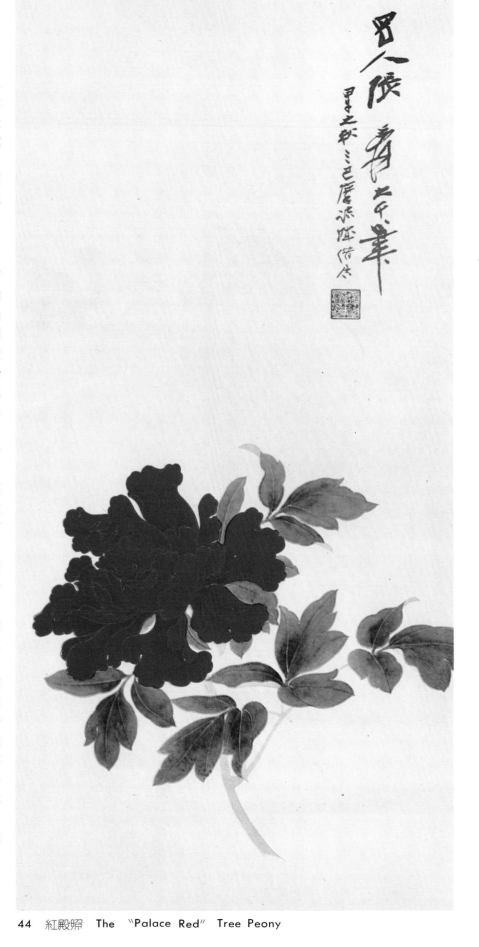

44　紅殿照　The　"Palace Red"　Tree Peony

雙雀識秋　Early Fall

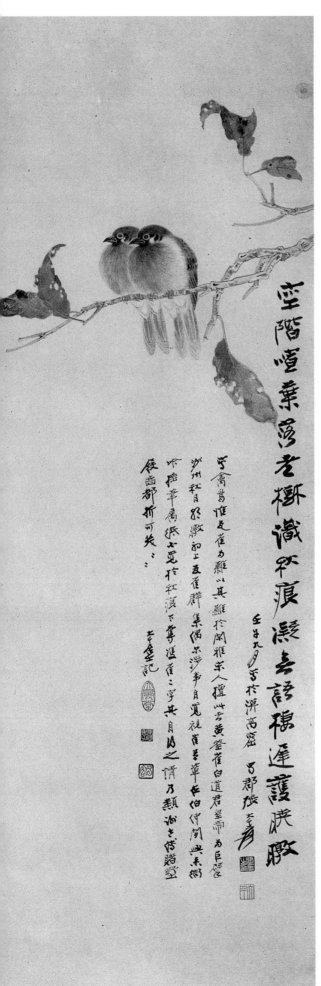

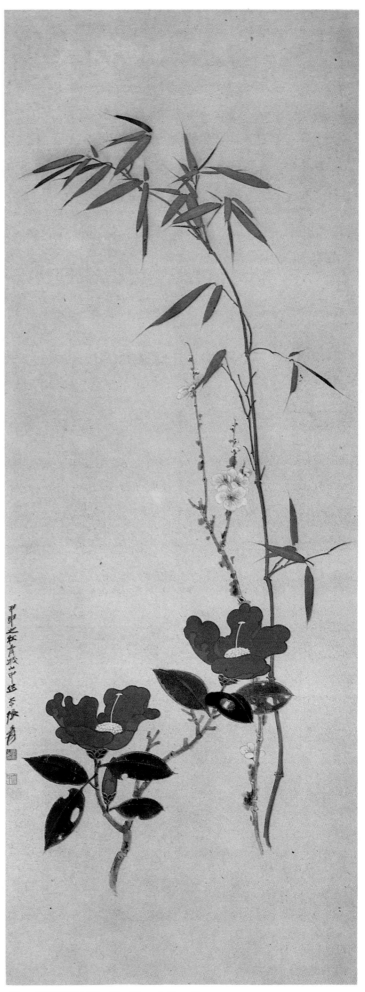

5　雙雀識秋　Early Fall

46　秀竹迎牡丹　To Greet the Peony

PEONIES IN THE ELABORATE STYLE

Blessed with majestic elegance and splendour, the peony is hailed as the queen of all flowers, the reigning beauty of celestial fragrance. Hence, in the elaborate style of painting, it may be regarded as the representative of the floral kingdom.

Of the numerous species of tree peony, the ones I like best are the Palace Crimson, the Inky Purple and the Buddhahead Blue. To paint these varieties, one must make painstaking efforts and not expect to get good results via the slipshod way. It is no child's play to grind the mineral pigments and mix in the right proportion of glue. If the glue content is too low, the pigment may easily fall off; if too high, it may become dull and sluggish. The glue must be mixed into the pigment on the day it is used and should be drained off after use by means of a bath, or else the original colour of the azurites and malachites will be lost. A certain kind of crimson has a glue content ready for use; the others must be pulverized with the fingers and glue-processed by the painter himself.

The Palace Crimson. The artist begins with tracing the outline of the petals with a thin brush and diluted ink. Next he draws the branches and leaves in such an order as may befit the form of the flower. The petals should be filled one after another with even washes of light carmine and, when dry, with another coat of the same colour. Then he washes every petal over with deep carmine three or four times so that the pigment will stand out in relief with a velvety effect. The contour of each petal is to be outlined with heavy carmine and again with milk gold, thus adding lustre to the

regal elegance of the flower. The anthers should be stippled with whitish-yellow. In case of a full-blown flower, the pistils should be painted with malachite into the shape of a cluster of miller grains and touched with saf-flower red at their tips. The anthers may be dotted with whitish-yellow or milk gold.

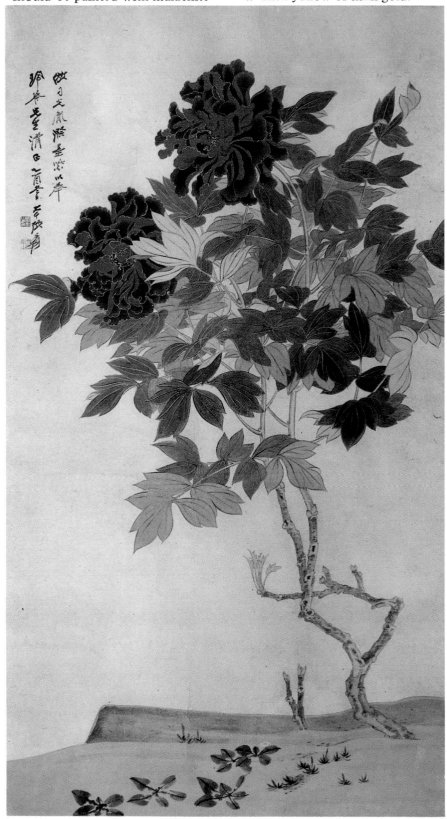

47　紫牡丹　Purple Peony

It is the practice to provide the leaves and branches with a red ochre base before washing them over with malachite green. When dry, the painter may define their contour with sap green and wash the leaf-face over with the same colour two or three times. In the final wash, space should be left along both sides of the leaf-veins to make allowance for the gradual fade-out of the azurite line to be drawn in the middle. For the other side of the leaves and the tender leaves, No. 2 or No. 3 green is commonly used. Light indigo and sap green are suitable for describing the contour of the back of leaves. If the lines are drawn once again with milk gold, the effect will be even more engaging.

The Buddhahead Blue. The technique of painting the leaves and branches is the same as that depicted above. But instead of carmine, the artist fills the face of the petals with flat washes of azurite, preferably No. 3, without gradation, and the back with No. 4. The boundaries must be outlined with light indigo and milk gold, otherwise the flower may appear insipid and dull.

The Inky Purple. Lay out the groundwork of the flower in light indigo and coat it once over with flat washes of light carmine. Then fill the contour with deep carmine washes, leaving only the boundary lines, then repeat the process three times in succession, and that is all. The petals should be outlined with deep carmine first and with milk gold later. The technique of colouring the branches and leaves is identical with that mentioned above.

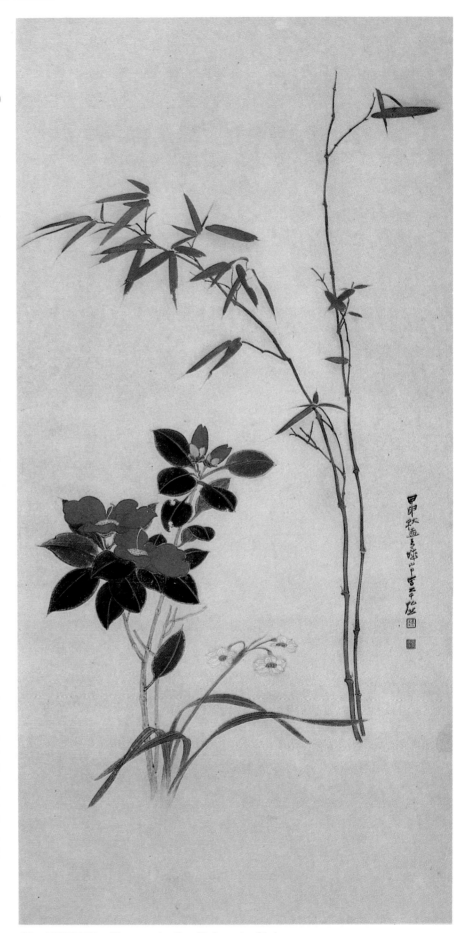

48 工筆花卉 Flowers in the Elaborate Style

山水

所謂山水，就是西畫及攝影的風景。國畫中山水的境界最爲重要，然而也要筆墨來輔助。有了境界，但是沒有筆墨，或者有了筆墨，但是沒有境界，也就不成爲名畫。它那結構和位置，必須特別加意，如畫寺觀，這些地方就不宜像人家的廬舍，好像和講風水一樣。這個說法，要多看古人名迹，以及名山大川，名勝古蹟，自然會了解的。假如畫了一張畫，其中主要安置人家處，却恰恰似一塊墳地。這樣的畫，掛在中堂上面，試問別人看了，舒服不舒服呢？還能引人入勝嗎？郭河陽論畫，要可以觀，可以遊，可以居。他所謂可以觀的，是令人一看這張畫，就發生興趣，要一看再看，流連不捨。第二步就想去遊玩遊玩，第三步就連想到，這樣的好地方，怎樣能夠搬家去住才好呢！這樣的山水才算夠條件了。有些人說中國山水畫，是平面的，畫樹都好像是從中間鋸開來的，這話絕不正確。中國畫自唐宋而後，有文人畫一派，不免偏重在筆墨方面，在畫理方面，比較失於疏忽。如果把唐宋大家名迹來細細的觀審，那畫理的嚴明，春夏秋冬，陰晴雨雪，簡直是體會無遺。董源畫樹，八面出枝，山石簡直有夕陽照着的樣子。關仝畫叢樹，有枝無榦，豈是平面的嗎？畫山水一定要實際，多看名山大川，奇峯峭壁，危巒平坡，煙嵐雲靄，飛瀑奔流，宇宙大觀，千變萬化，不是親眼看過，憑着意想，是上不了筆尖的。眼中看過，胸中自然會有，　搖筆間，自然會一齊跑在你手腕下。畫山最重皴法，古人有種種名稱，祇不過是就其所見的山水而體會出來的。應該用那一種皴法傳出，那所見的形狀如何，遂名叫作某某皴，並非勉強，非用此皴法不可。如北苑用披麻皴，因爲江南的山，土多過石，又因爲諭畫的林木蓊鬱，自

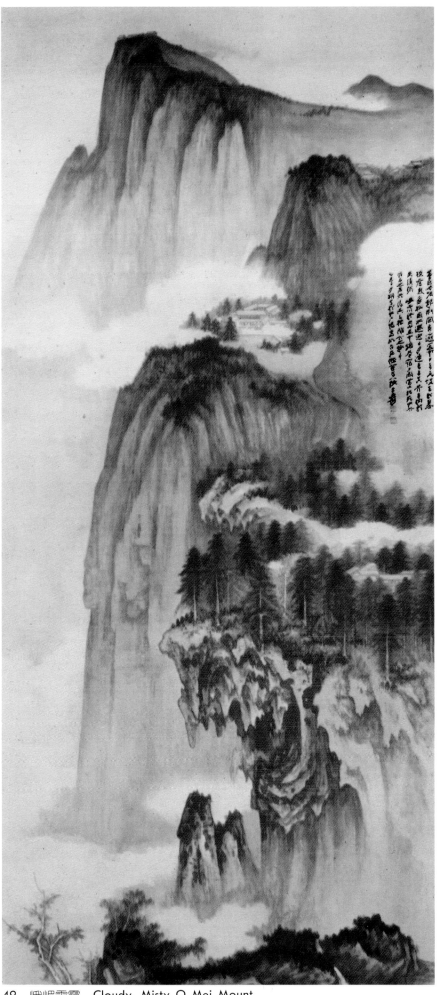

49　峨嵋雲靄　Cloudy, Misty O Mei Mount

宜於用這皴法。若范華原畫北方的山川，太行王屋，石多過土，地也高亢，草苔也稀少，自然宜於用泥裡拔釘、雨打墻頭、鬼面這些皴法。設使二公

的皴法，互相變換，又成何面目？所以我的意思山水皴法不必拘泥，祇要看適於某一種，就用某一種皴法。古人皴法，累舉數種，荷葉皴、大小斧

劈皴、披麻皴、雨打墻頭皴、泥裡拔釘皴、雲頭皴、折帶皴、鬼面皴、牛毛皴、馬牙皴、卷雲皴、礬塊皴，此皆常用者。

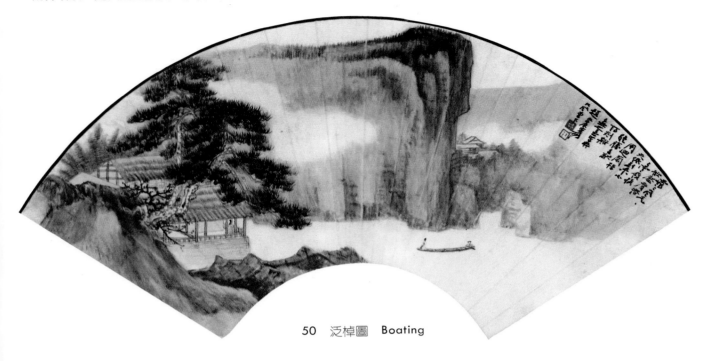

50　泛棹圖　Boating

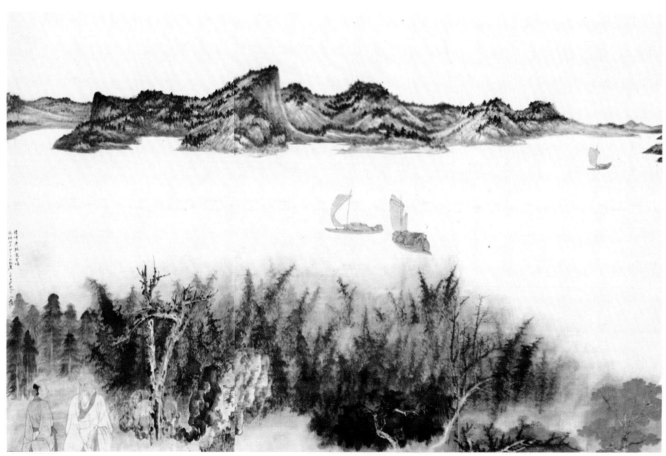

51　瓊峰蕭散圖　Chilly Hills

OF LANDSCAPES

The so-called mountain-and-stream is similar to the landscape in Western art or scenic shots in photography. In Chinese art the conceptual state revealed in landscape painting is of paramount importance, although it needs must have the support of the brushwork. No landscape could ever become a masterpiece, should its conceptual state be divorced from good brushwork, or *vice versa.*

In landscape painting, special attention must be paid to the composition of the picture as a whole and to the relative position of its detail alike. For instance, if one means to paint the locale of a Buddhist or Taoist monastery, then it should not bear any resemblance to that of a layman's cottage — as if in keeping with the maxims of Chinese geomancy. The painter may gain a full understanding of this principle through extensive study of the works of old masters as well as the great mountains and rivers, famous scenic spots and ancient remains. Suppose one paints a picture in which the site for a house looks like a burial ground, and hangs it on the centre wall of a hall. Would not those who see it feel rather ill at ease? How, then, could the picture lead them into ecstasies of joy?

In his comments on art, Kuo Hsi of the 11th century maintains that the landscape should not only be worthy of contemplation but be able to inspire a yearning for excursion and inhabitation. To be worthy of contemplation, it must create an interest in the beholder so that he will pore over it again and again in lingering raptures. Next, he will wish to take a trip to the scene and, finally, by association of ideas, how he will wish to live in such a pleasant place!

Only a landscape like that may be considered as up to the mark.

Some people have maintained that the Chinese landscape painting is flat, and so the trees in it seem to be in vertical section. Such a contention is, of course, unfounded. It is true that the literati school that came into existence after the T'ang and Sung Dynasties, laid so much importance on the brushwork *per se* that it committed the error of not paying enough attention to the aesthetic principles of painting. If one examines the extant works of T'ang and Sung masters carefully, one cannot fail to see their strict adherence to the principles of painting and the thoroughness with which they regarded the different aspects of the natural world in the four seasons and under various weather conditions, whether it be spring, summer, autumn or winter, or overcast, fine, rain or shine. In Tung Yuan's scrolls, the tree branches stretch out in all directions and the mountain rocks appear to glow in the sunset. In the woodland pictures of Kwan T'ung the branches are visible but not the trunks. Is it fair to say that such paintings are flat?

To paint landscape, it is imperative to be practical and to see as much as possible the famous mountains, great rivers, prodigious peaks, hanging precipices, dangerous crags, even slopes, misty haze, rolling clouds, swooping cataracts and rushing torrents. The scenic wonders of the world are legion and their changes and transformations infinite. The painter cannot conjure them out of the brush-tip merely on the strength of imagination, without having seen them with his own eyes. Only through actual observation, can he have an impression in his mind, and they will then come to his finger tips spontaneously at a mere flip of the brush.

The Wrinkle Technique. The wrinkle technique is of primary importance in landscape painting. There are many different styles of wrinkling, each having a special name given to it by the ancients. They were developed by the old masters from the individual impression of the scenes they had respectively seen. Whichever method of wrinkling might best represent the perceptual image of the landscape was used and called as such, accordingly. There are no hard and fast rules governing the wrinkle technique and the painter is not obliged to adopt any particular style unless he sees fit. For example, Tung Yuan used the hemp-fibre wrinkles because of their fitness for the Kiangnan mountains which generally have more top soil than bare rocks and a luxuriant growth of woods and bushes. On the contrary, such wrinkles as "pulling nails out of the mud", "rain lashing at the wall" and "the demon's face" are suitable for Fan K'wan's landscape of North China because the T'ai Hang and Wang Wu or Tsung Nan and Tai Hwa mountains are rocky, the ground is elevated and dry and there is a scarcity of weeds and mosses. Should the two masters have exchanged their respective wrinkle methods, one can fairly imagine what their landscapes would have looked like. Hence, in my opinion, one may use any particular style of wrinkle at his own discretion, instead of placing himself under pedantic constraint. Of the wrinkle methods developed by the old masters, those in common use are the following: the lotus-leaf wrinkles, the big and small

axe-chop wrinkles, the hemp-fibre wrinkles, the rain-lashing-at-the-wall wrinkles, the pulling-nails-out-of-the-mud wrinkles, cloud wrinkles, folded-sash wrinkles, the demon's face wrinkles, and the ox-hair wrinkles.

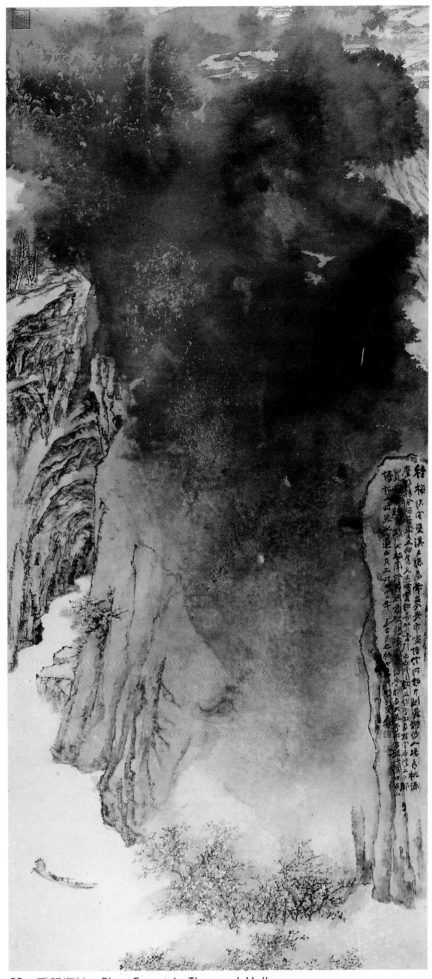

52 千壑梅林 Plum Forest in Thousand Valleys

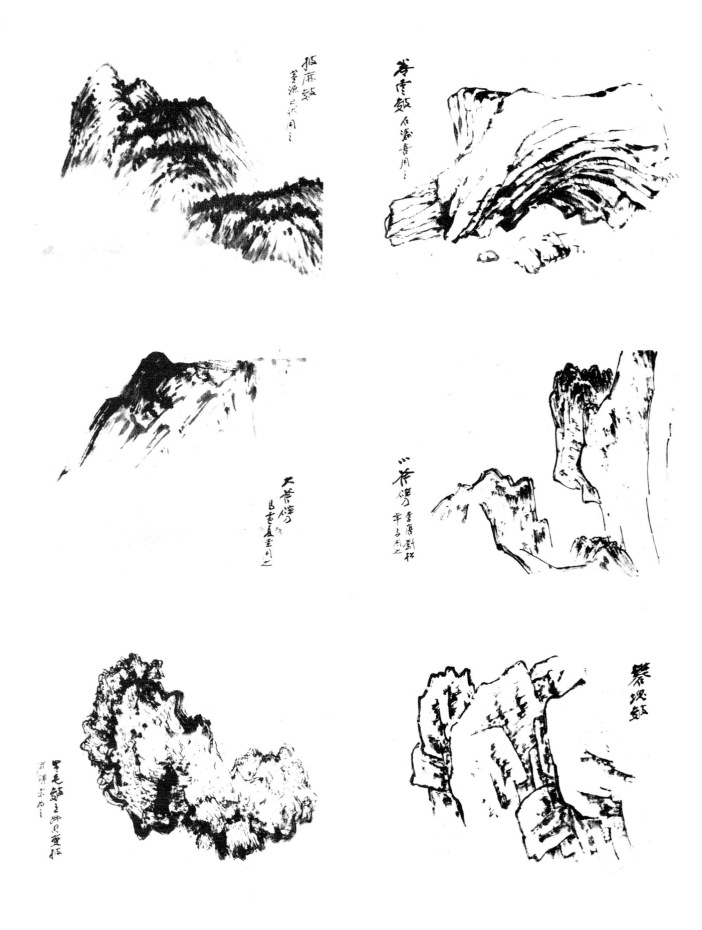

53　皴法示範　Demonstration of Wrinkle Style Ⅰ

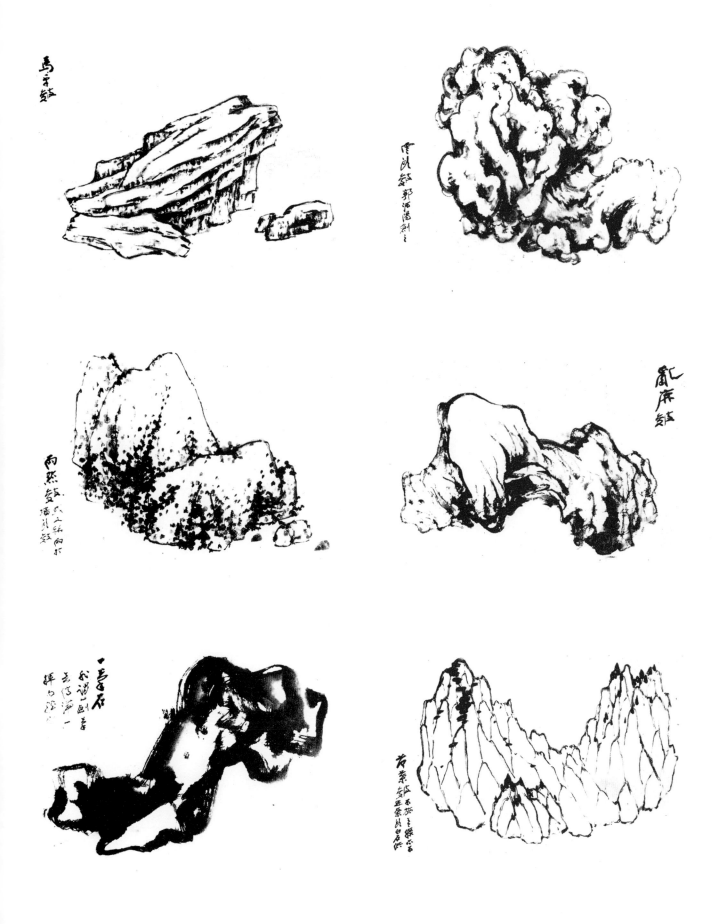

馬牙皴

雲頭皴郭海溜劑之

亂麻皴

雨點皴

一馬石

方荼皴

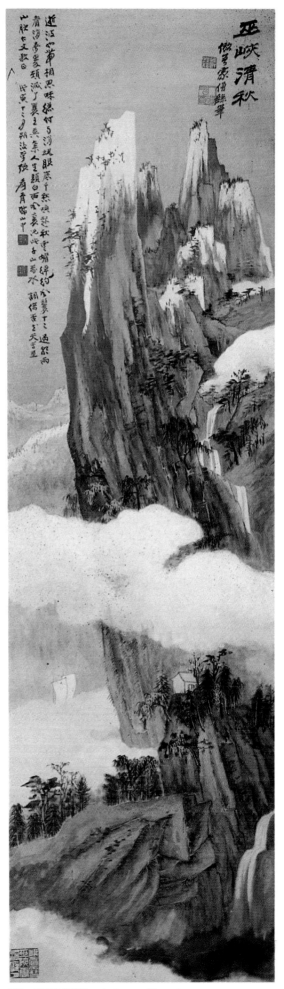

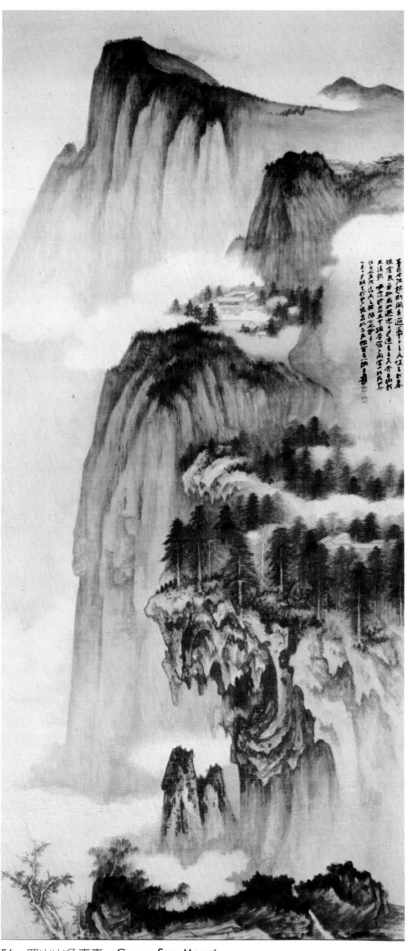

56　蜀山山色青青　Green Szu Mount

55　巫峽清秋　Autumn Mount

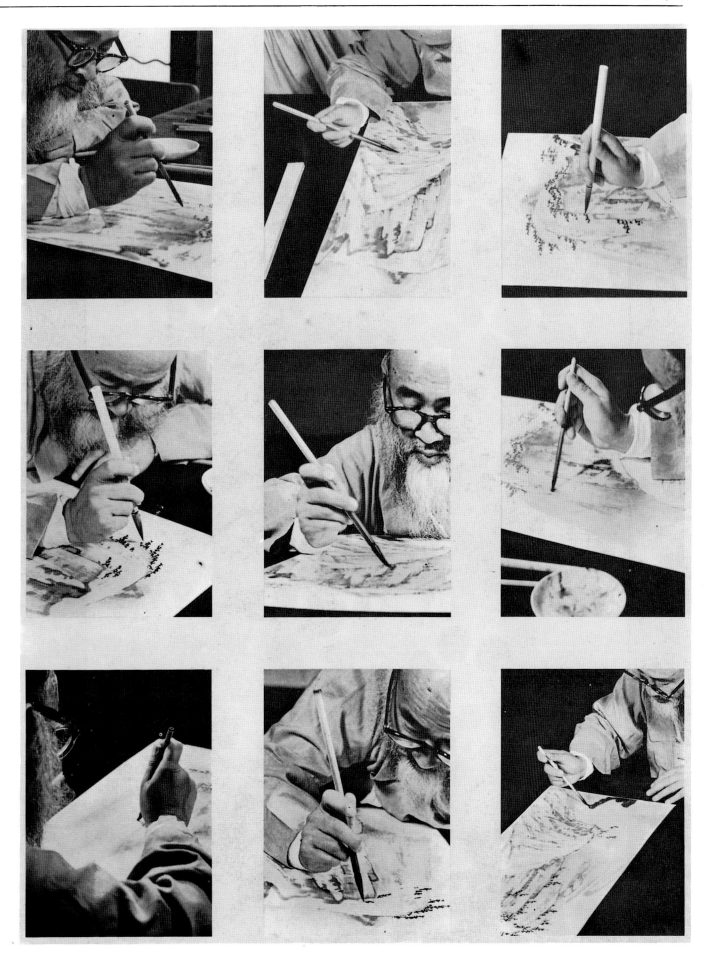

57　毛筆使用示範　Demonstration of Manipulating a Brush

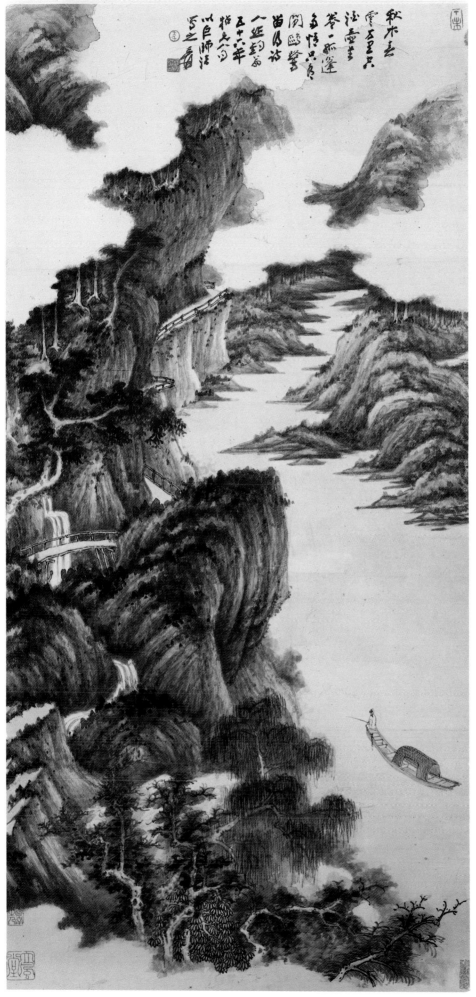

58 秋木孤舟　Loneliness

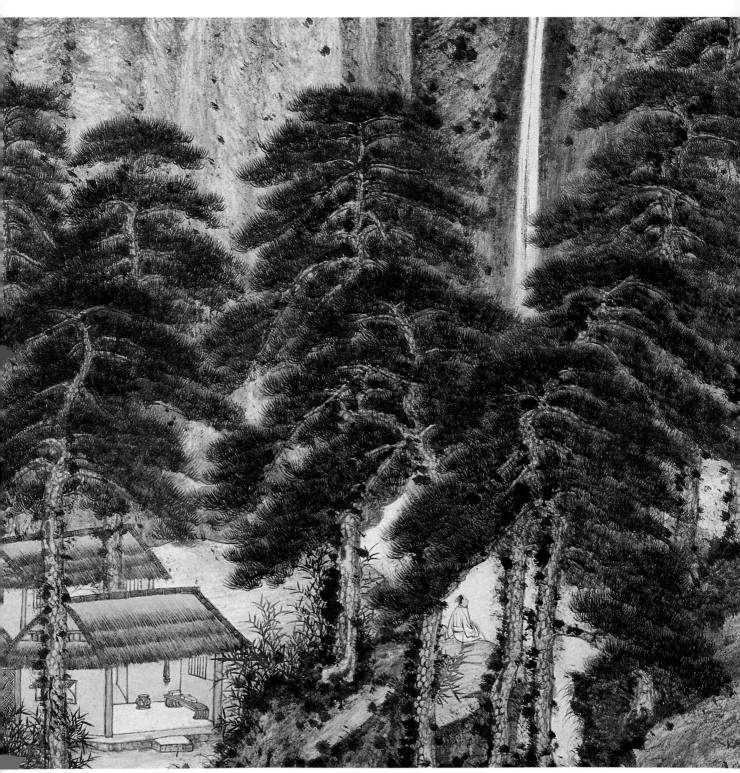

松林瀑布（局部） Piny Falls

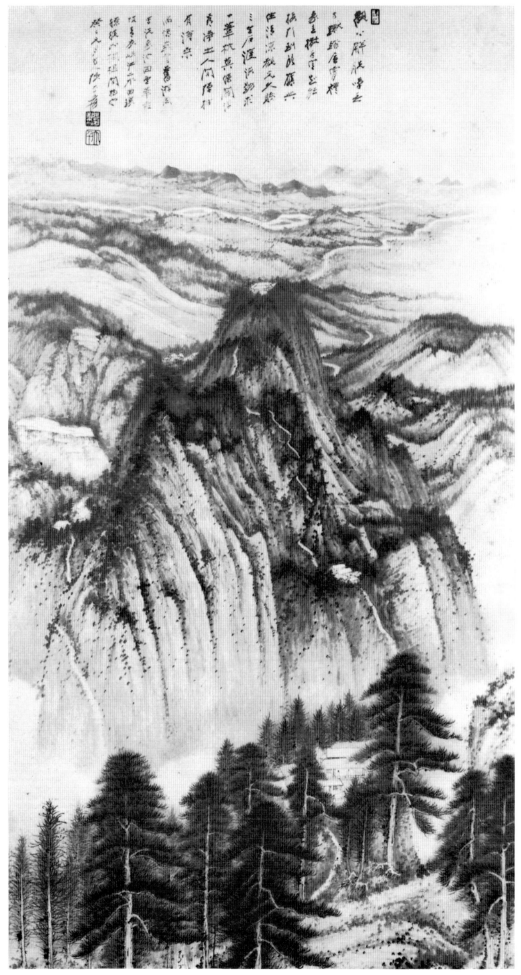

60　洗象池　Hsi-Hsiang Chih, a Famous Scenic Spot of O-mei Mount

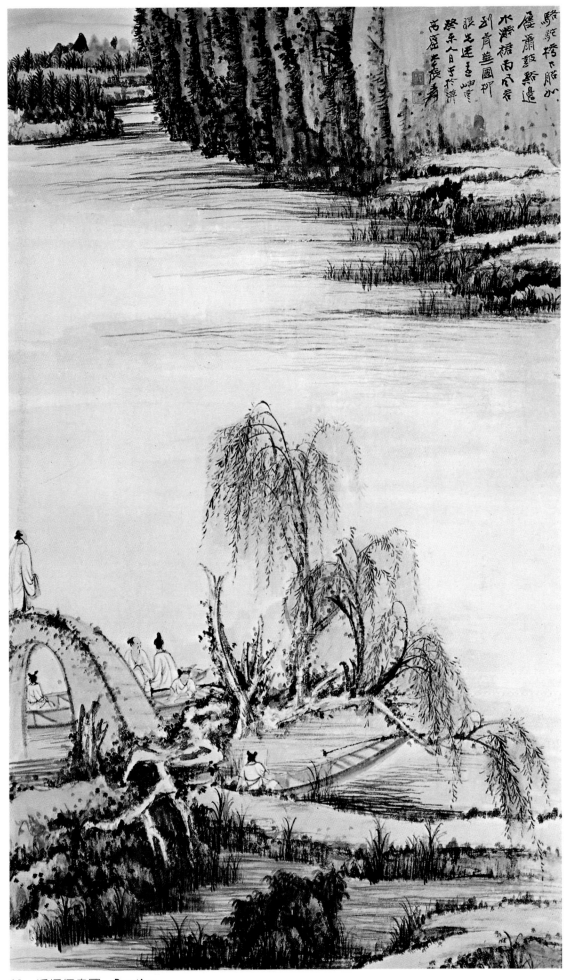

61 溪橋行舟圖 Boating

工筆山水

工筆畫，就是細筆畫，水墨、淺絳、青綠、金碧、界畫、都包含在內。工筆不比寫意，必須先打成底稿，貼在壁上，觀察刪改，遠近高低，佈置得宜，然後把這個稿本，用柳炭在反面一條線一條線的勾過，拍上紙絹。那裡面的樓閣人物，尤其要特別注意，樓閣要折算停勻，人物要眉目生動，衣袂好似要會飄動。畫時先用淡墨勾出輪廓，然後皴擦渲染。畫樹要點夾相參，淺絳中着一二青綠夾葉，或紅樹一株，更覺得有趣。夾葉樹的樹身，不可着色，愈覺顯然。青綠就要打好勾勒底子，不用皴擦。山石用石綠的，拿赭石打底，加石綠二三次，要薄一點才好，太濃就鈍滯了。若用石青，就在赭石上面填石綠一次，再加二三遍石青就可以了。不可用花青汁綠打底，因為這兩種都不明透。金碧那就在青綠完成後，用花青就山石輪廓勾勒，然後再用泥金逐勾一次，石脚亦可用泥金襯它。青綠或金碧山水，水天都宜於着色，水更宜有波紋。古人畫水有好多種，那裡面是以網巾魚鱗兩種為適合。古人說「遠水無波」是遠了看不清楚的意思，所以勾踢水紋，越遠越淡，淡到了無為妙。畫水在岸邊留一道白線，看起來特別精神。畫要有氣韻，一落板滯，就不入鑑賞。此中要點，不僅要把畫面的賓主虛實，前後遠近弄清楚，而是在用筆用色用水的靈活生動。石青、石綠、泥金的下膠，尤須切切注意。

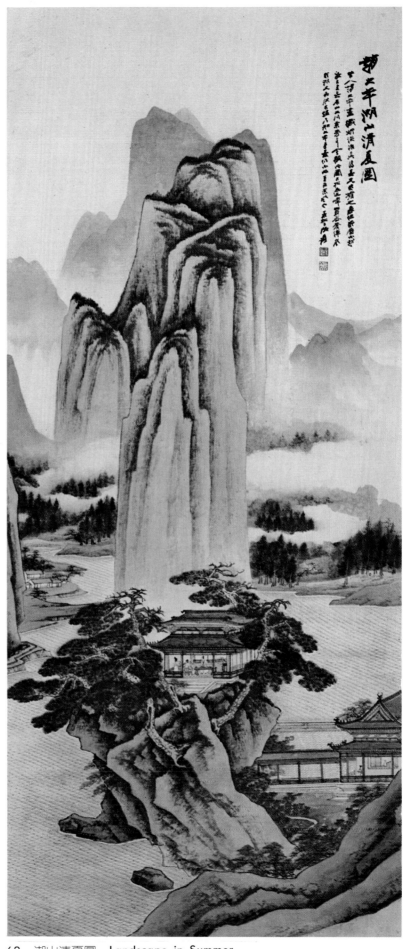

62　湖山清夏圖　Landscape in Summer

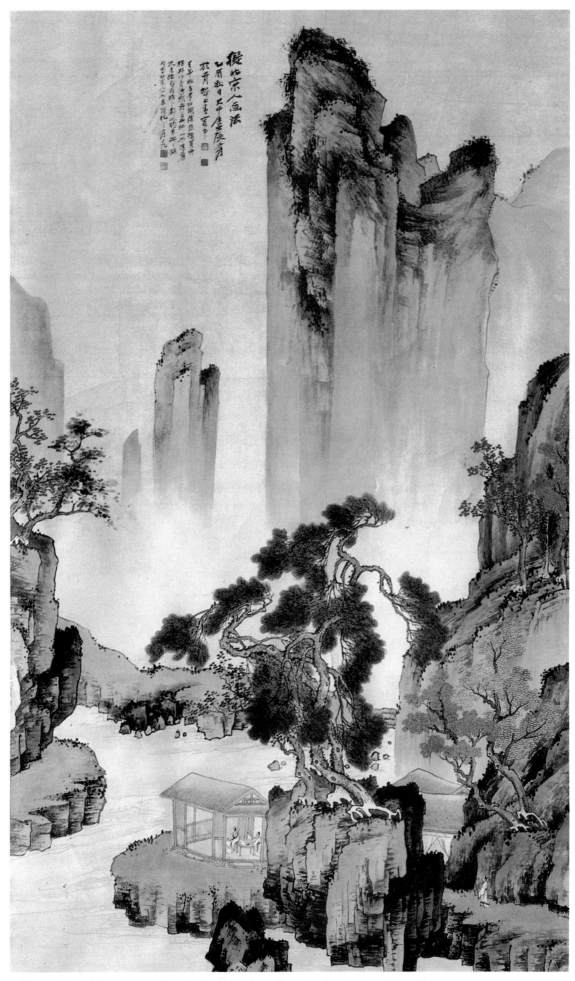

63　擬北宋畫法　Imitate the Method of Drawing of North Sung Dynasty

LANDSCAPE IN THE ELABORATE STYLE

Landscape in the elaborate style is one in which the detail is minutely worked out. It may be painted either in ink monochrome, light red-ochre, blue-and-green, gold-and-azure, or in linear drawing. Unlike the impressionistic style, it must needs have a preliminary draft to be put on the wall for contemplation and retouching. When the perspective has been properly adjusted, as well as the height of the horizon, the painter traces the outline of the picture with willow charcoal on the back of the draft and transfers it onto the paper or silk by means of contact imprinting. Special attention should be paid to the figures and buildings in the picture: the latter should be in correct proportion; the former should have lively features and flowing robes that seem to flutter in the breeze.

The painter starts with drawing the outline of the picture with diluted ink, then fills in with wrinkles, wipes and washes. While working on the trees, he should try to break their monotony with a sprinkling of different colour. One or two verdant leaves in a light red-ochre landscape or a tree with ruddy foliage will make the picture much more interesting. On the contrary, the trunk of the trees, if un-coloured, will stand out in contrast with the leaves.

In blue-and-green landscapes, it is necessary to define the boundary lines, without any wrinkles and wipes. If the mountain is to be painted in green, the painter should prepare the ground with red ochre, then apply over it two or three successive coats of malachite, preferably thin, or else the colour may look dull and sluggish. If the mountain is to be painted in blue, he should wash over the red ochre base once with malachite green – instead of light indigo or sap green which are not clear and opaque – to be followed up with two or three coats of azurite.

After that, if the painter desires to turn the picture into a gold-and-azure landscape, he may define the contour of the mountain with light indigo, then enliven it with a thinner outline in milk gold and tinge the foot of the mountain with the same colour.

In blue-and-green or gold-and-azure landscapes, it befits the sky and the streams to be coloured. The streams, in particular, should have ripples. Of the various styles of ripples originated by the old masters, the "meshes" and the "fish-scales" are the most appropriate. As the ancients say, "There are no ripples on remote waters." It means that distance tends to obliterate what is visible at close range. Hence, the best way to paint ripples is to let them dwindle into the distance gradually till they fade out. A white line alongside the shore of distant waters will enhance the vividness of the scene.

Rhythmic vitality is essential to landscape painting and its absence will exclude the picture from the true connoisseur's appreciation. It is not enough

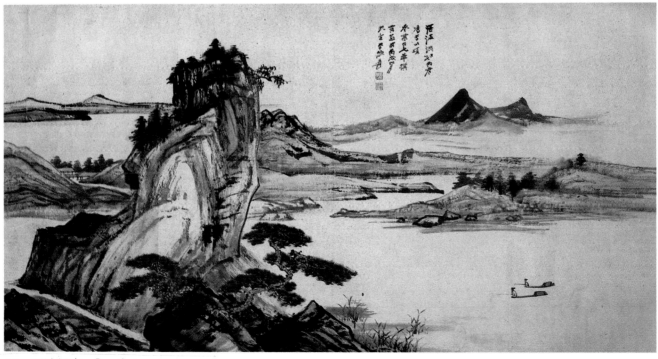

64　混波行舟　Boating

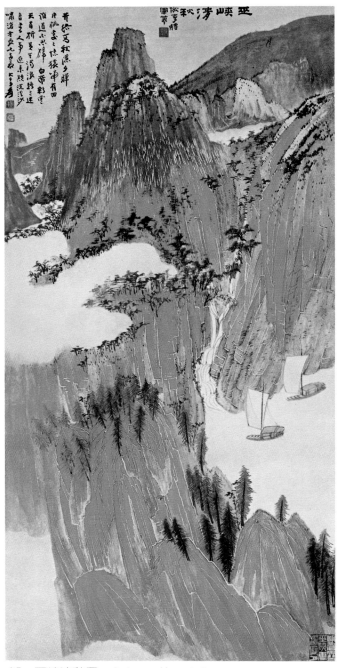

65　巫峽清秋圖　Autumn Mountain

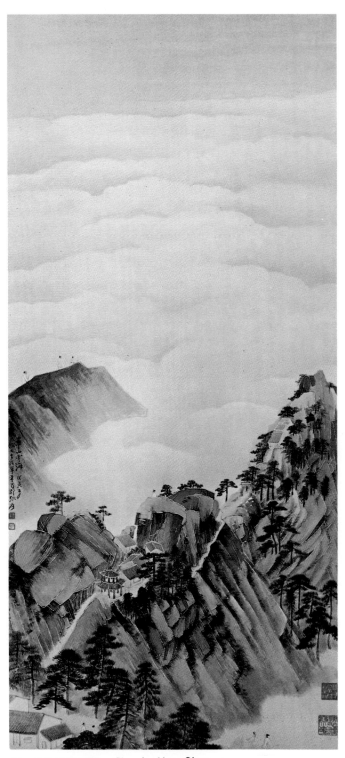

66　華山雲海圖　Cloudy Hua Shan

merely to distinguish between the principal and the subordinate parts, the express and the implied, the foreground and the background, and the near and the distant. The secret lies in the inspired dynamic application of the brush, pigment and water. Special care must also be taken while processing the azurites, malachites, or milk gold with glue before use.

寫意山水

　　寫意兩個字，依我看來，寫是用筆，意是造境，不是狂塗亂抹的。也不是所謂文人遣興，在書房用筆頭寫寫的意思。作畫自然是書卷氣爲重，但是根基還是最要緊的。若不從臨摹和寫生入手，那麼用筆結構都不了解，豈不大大錯誤。所以非下一番死工夫不可。臨摹古人，要學他用筆用墨，懂得他苦心構思。寫生要認識萬物的情態。畫時先用粗筆淡墨，勾出心裡面要吐出來的境界。山石、樹木、屋宇、橋樑、佈置大約定了，然後用焦墨渴筆，先分樹木和山石，最後安置屋宇人物，勾勒皴擦既完畢，再拿水墨一次一次的渲染，必定要能顯出陰陽、向背、高低、遠近。近處石頭稍濃，遠處要輕淸。創境有曲折不盡的意味，其中的人物用減筆爲宜，越簡單越妙。古人說「遠人無目」，若在須要有照應的時候，也不妨點目，不必拘泥。近樹根枝要分明，遠則點戮，不必見枝。寫意畫創自元代四家，到了明末淸初四高僧，石谿、漸江、石濤、八大，神明變化，一直掩蓋過了前人。漸江戌削，八大樸茂，拿用筆表現他的特點，石溪、石濤的特別拿意境來顯出他的特點。至於石濤尤其是了不起，他自己題他所畫黃山說：「予得黃山之性情，不必指定其處也。」又說：「出門眼中所見即寫之，此是寫生。」又說：「拈禿筆用淡墨半乾者。向紙上直筆空鈎，如蟲食葉，再用焦墨重上，看陰陽點染，寫樹亦然，用筆以錐得透爲妙。」這簡簡單單幾句話，簡直透漏了畫家不傳的秘密。

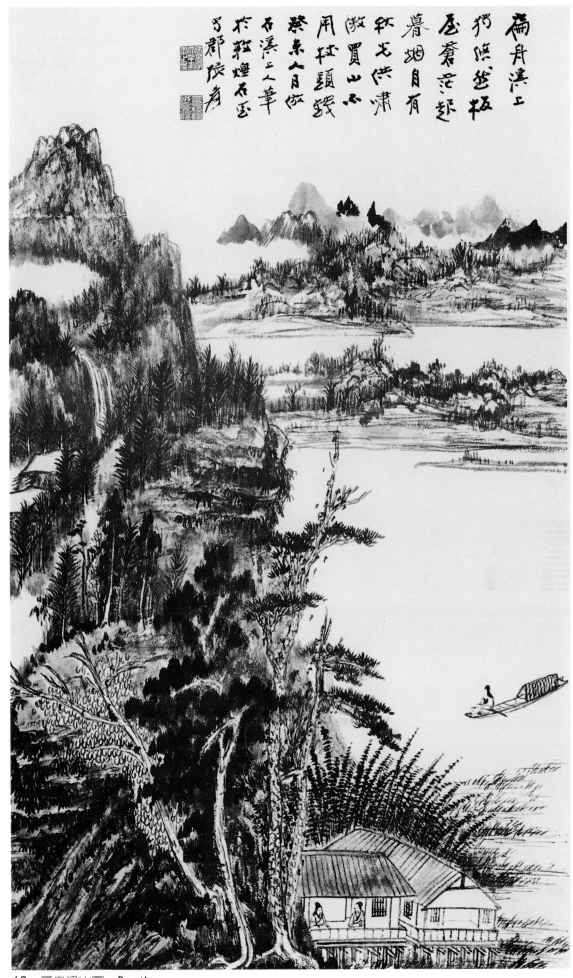

扁舟溪上
狎興竿板
屋簍宛然
暮烟月有
秋戈供蕭
澂買山小
用杖頭錢
癸卯八月做
石溪上人筆
於敦煌石室
弓郡張爰

68　扁舟溪山圖　Boating

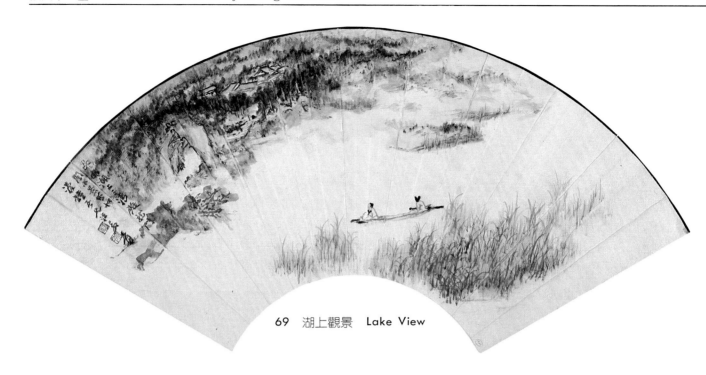

69 湖上觀景 Lake View

70 山巒 Mountains

71 登峯 Reach for the Sky

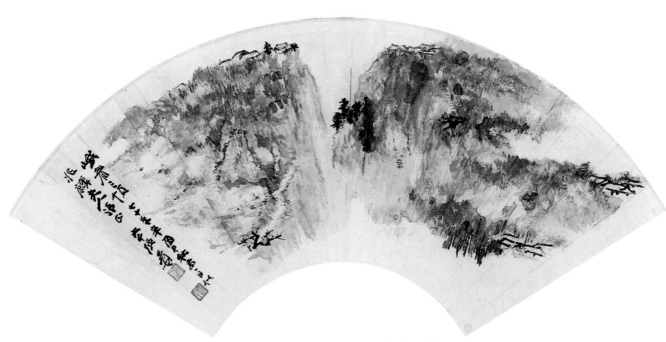

72 峨眉山之行 A Trip to O-Mei Mount

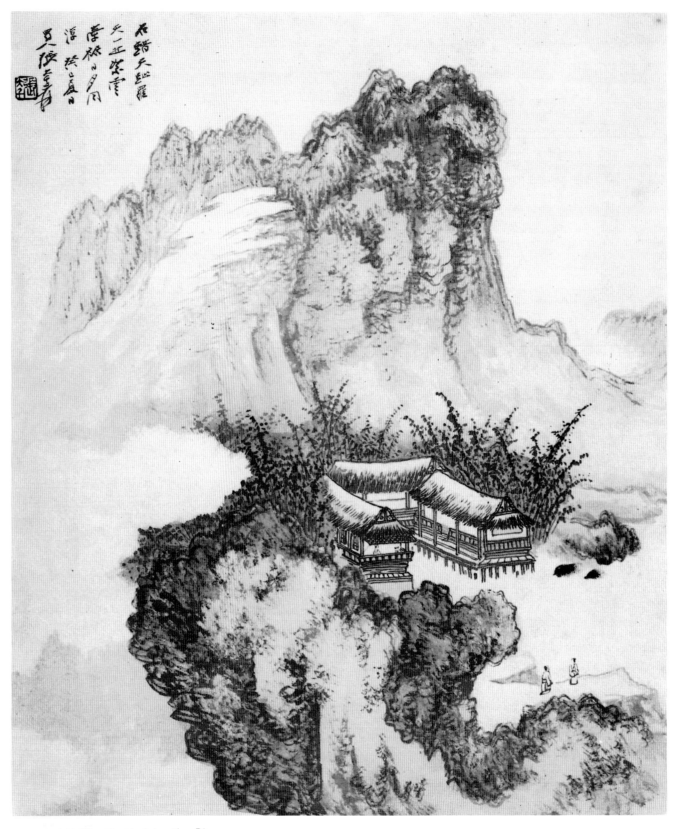

73 臨流清話　Chatted by the River

左上
中
下 } 加漿彩

74　古代人物造型　Formative of Ancient Figures

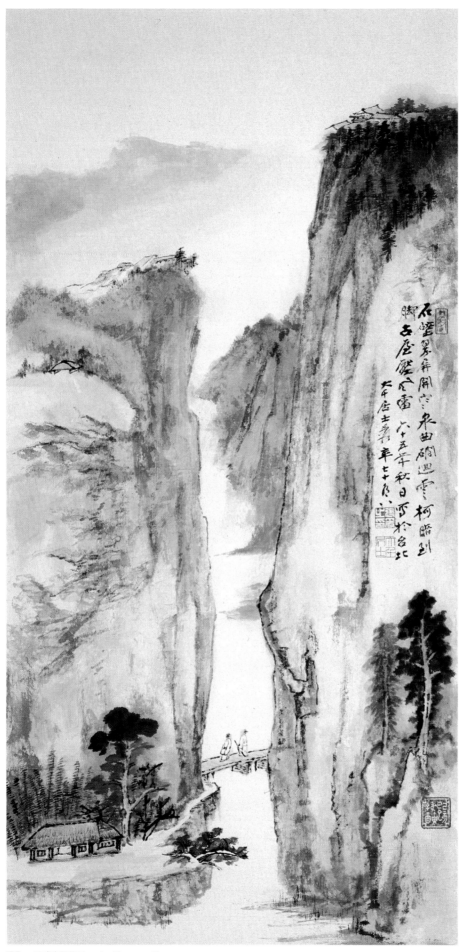

石壁翠屏開空泉曲硐迴雲柯瀋到
腳五庭歷灰雷六十五年秋日寫於台北
大千居士爰　辛七旬八

中段改大瀑布

75　石壁翠屏　A Green Screen

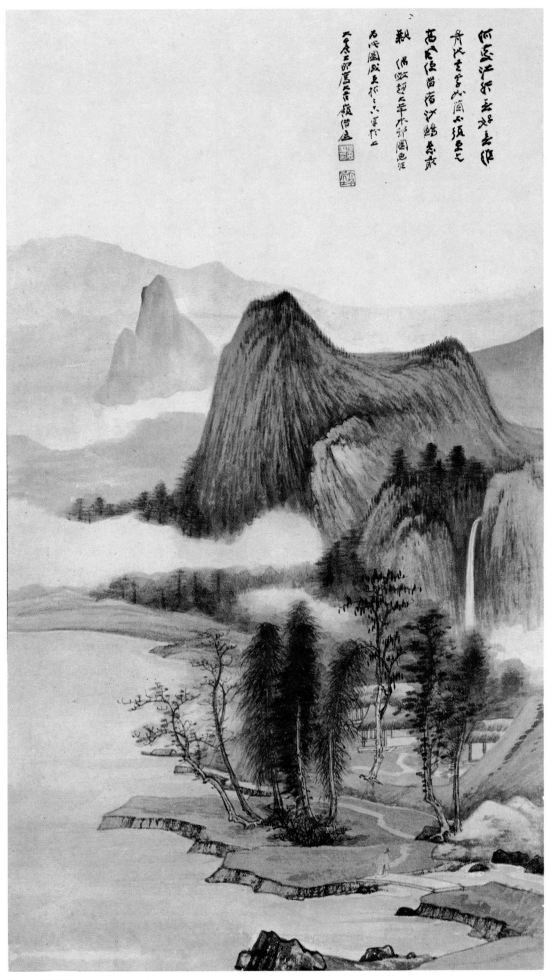

76　夏初邨水　Autumn Lake

論臨摹

臨摹工夫，對於增長學力，非常重要。摹寫既熟，然後對着畫臨摹，對臨摹有了心得，然後背着畫去臨。能在看過名畫以後，憑着記憶，背着它畫出來，筆墨位置，都能得到十之八九。能有這樣的功力，然後融合古人所長，參入自己所得，寫出胸中意境，那才算達到成功境界。如果祇是閉門造車，那就未必出門合轍啊！我們生在現代，眞是幸運。從前的畫家，要想看到一張名畫，那是何等的艱難！藏在內府及王公名宦家裡的自然不允許隨便看到；就是流傳在民間的，也因交通不便，往往聞聲相思，託諸夢想，有一生一世不能夠得償素願的。現在交通既便，世界名區，都有博物館陳列，任人參觀，並可向他們借來攝影。我國故宮博物院，最近且影印名畫三百種拿來供給世人臨摹鑑賞，眞便於學人不少。擺在面前，有這許多參考品，等於給我們開了一條大路。我們應該有條件的，融合古人所長，創造自己作品，超過古人，不是不可能的啊！

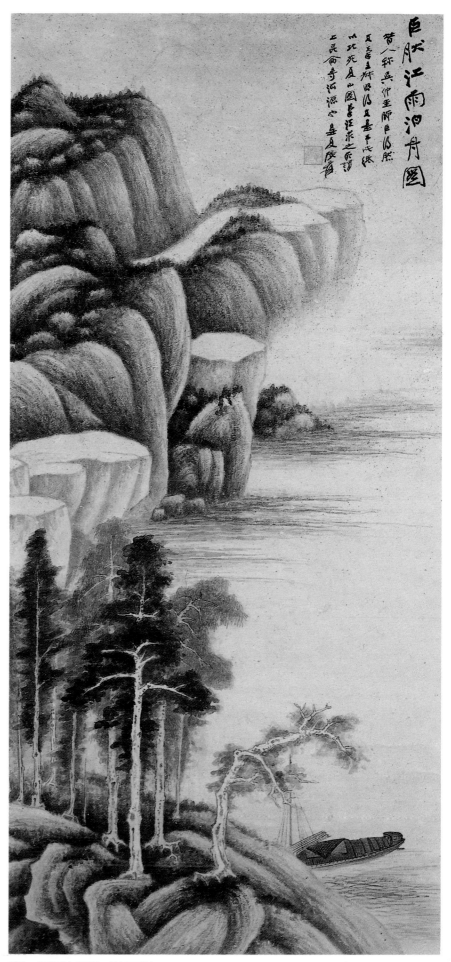

77 江雨泊舟圖（仿巨然）　Parking in the Rainy River

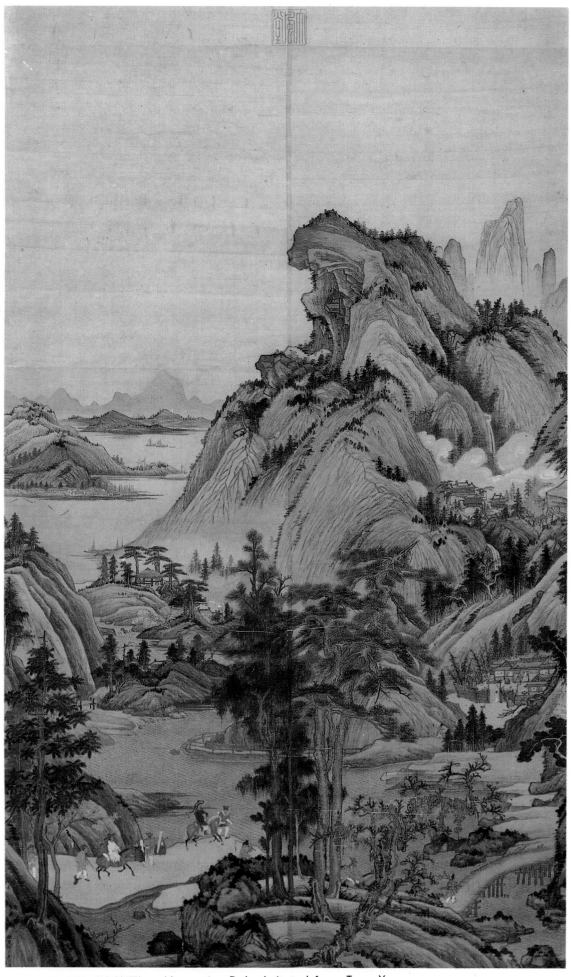

78　江堤晚景（仿董源）　Vespertine Dyke Imitated from Tung Yuan

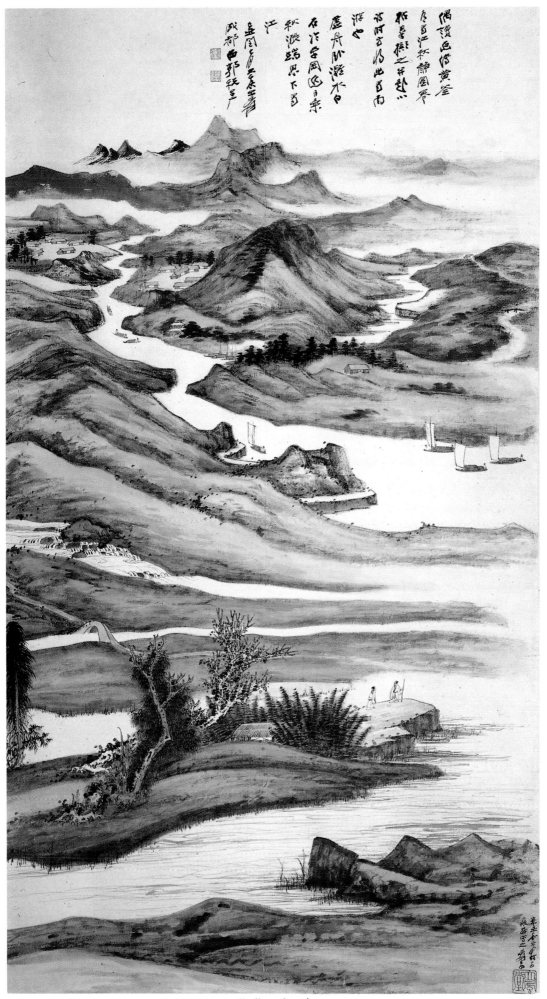

79　江山無盡（仿宋趙大年靑綠山水）　Endless Landscape

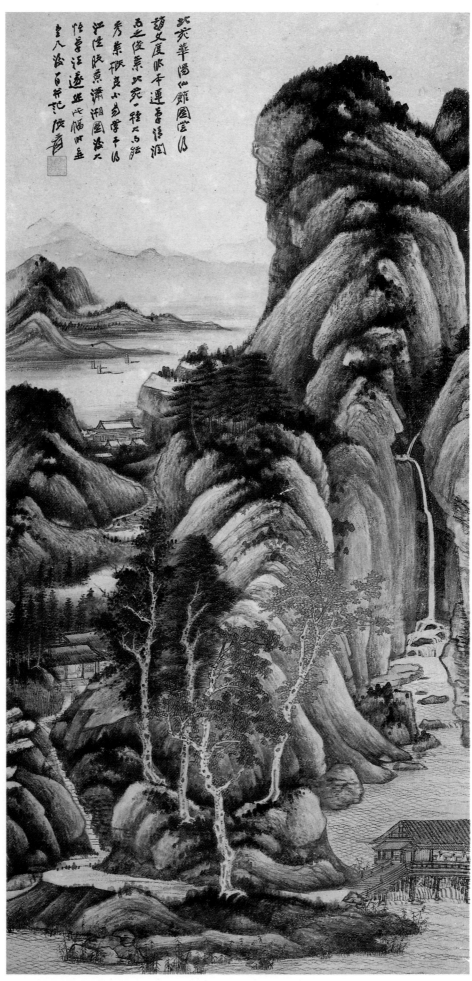

80 華陽仙館圖（仿董源江堤晚景四） A Desolate Resort in Mountain
(Imitated from Tung Yuan's Vespertine Dyke)

ON COPYING THE OLD MASTERS

The importance of copying the old masters, as a step towards the mastery of the technique of painting, can hardly be exaggerated. Prior to copying, it is advisable for the beginner to get acquainted with the composition of a masterpiece by tracing it on a piece of semi-transparent paper, as many times as necessary. When he has gained an insight into the picture through repeated copying, he should practise painting it from memory. By dint of assiduity, he should be able to copy any old master's work in the absence of the original, with amazing faithfulness to its brushwork and structural detail, after studying it once over.

The painter must acquire such skill before he can fuse the technique of the old masters together with his own genius and thereby attain the artistic perfection of being able to give full expression to the idealistic state of his mind. If he should develop his own technique independently like a cloistered wagon-maker, he might eventually find the vehicle of his art not in agreement with the tracks of the world outside.

We are lucky to have lived in an age of mass enlightenment. In other days, the famous works of the old masters in the private collections of the Chinese emperor, aristocrats, and the influential ministers and courtiers, were far beyond the access of a common painter. The few that were open to the public were usually kept at secluded monasteries and historical remains in remote corners of the country. The chance of beholding an authentic piece of old painting was so slim that many painters had never seen a single masterpiece in their life-time, except in dreams.

To-day, one may see the masterpieces of Chinese painting in the large museums all over the world and obtain their reproductions without any difficulty. Recently the Palace Museum Section of the United Museums and Libraries, Taiwan, published an album of 300 best scrolls of its world-famous collection, thus rendering the national art treasure available to painters and art students alike.

With such facilities and reference materials at our disposal, we have the advantage of starting our journey on paved ground. We should enrich ourselves with the best the old masters had to offer and create something of our own that may usher Chinese painting into a new and more glorious epoch.

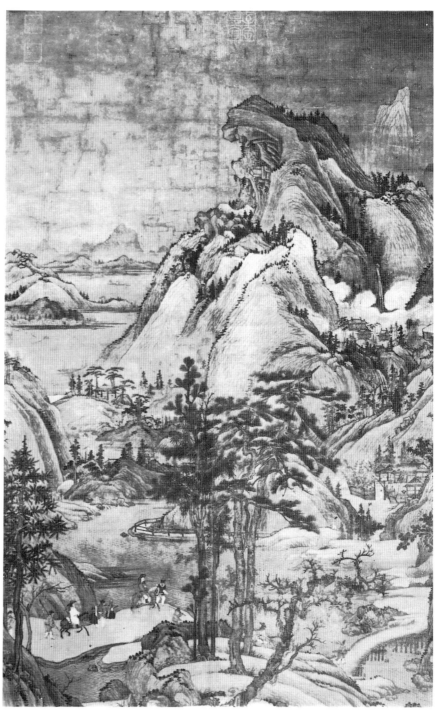

81　江堤晚景（董源作）　Vespertine Dyke

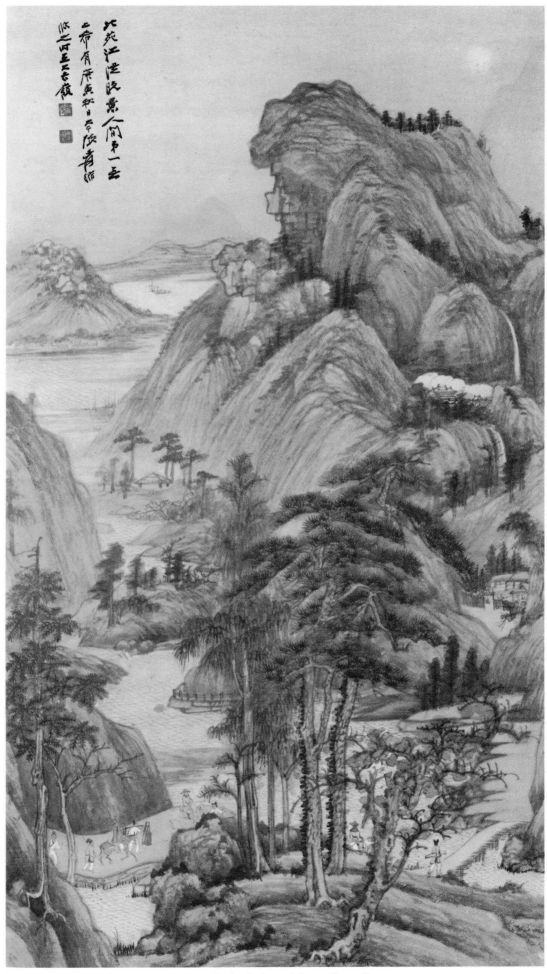

82 仿董源的江堤晚景　Vespertine Dyke Imitated from Tung Yuan

淺絳山水

　　淺絳山水，大多數用在秋景。這是
創始於黃大癡，後來南宗一派把它作
爲標準，用色拿赭石做主體，在林木
上面畧畧施點花靑就是了。淺絳不是
單用來表示秋景，大凡石質的山，都
宜採用這方法，如像畫黃山，是最宜
於此法的。中國畫，光和色是分開來
用的，要拿顏色做主體的地方，便用
色來表現，不必顧及光的一方面。所
以只說淺絳兩個字，便可表現山的季
節了。淺絳畫的畫法，畫時仍和墨筆
山水一樣，先用淡墨畫就大體，再用
較深的墨加以皴擦，分開層次，等它
乾了之後設色。在景物上，由淡到深
渲染數次，等到全乾，再用焦墨渴筆，
加以皴擦勾勒。樹木苔點，拿淡花靑
或汁綠一處一處的暈出來，當向陽的
地方，用赭石染醒它，這是最要緊的。
屋宇上色拿淡墨或淡花靑代表瓦屋，
拿赭石來代表土屋和草屋。

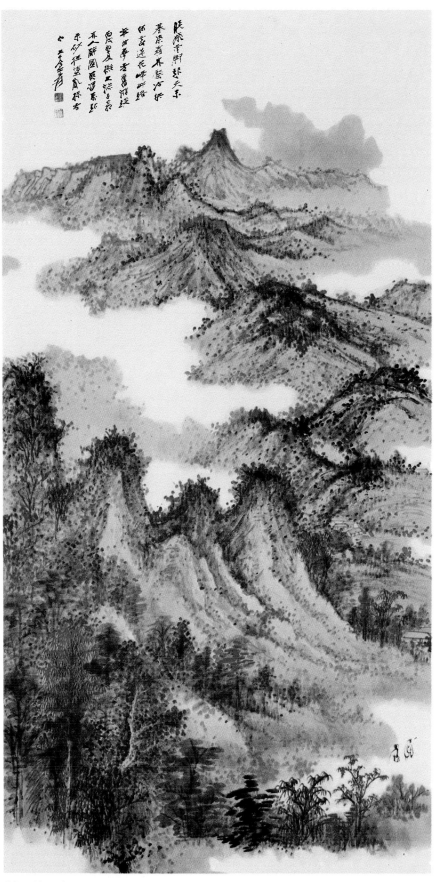

83　仿石濤秋山圖　Autumn Mount, Imitated from Shih T'ao

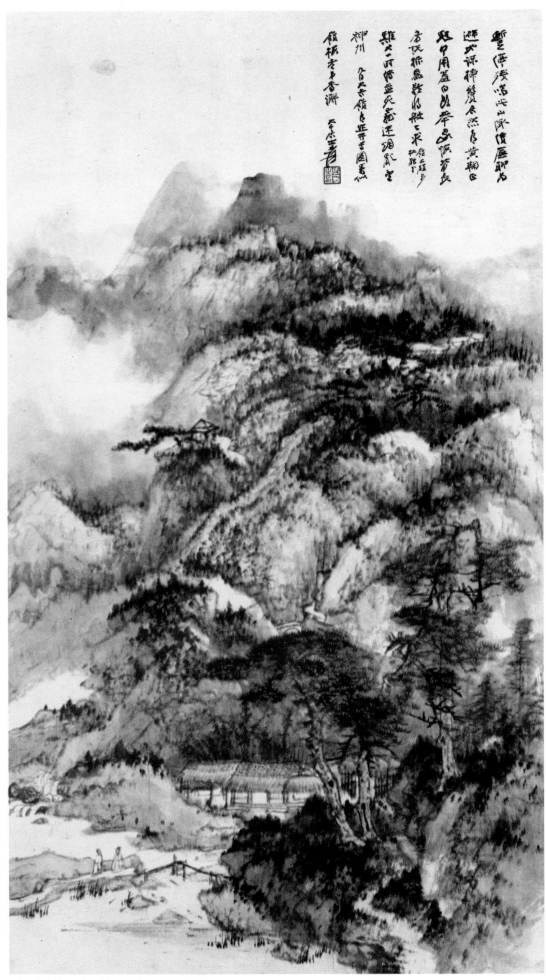

84　秋山憶舊　Memories

LANDSCAPE IN LIGHT OCHRE

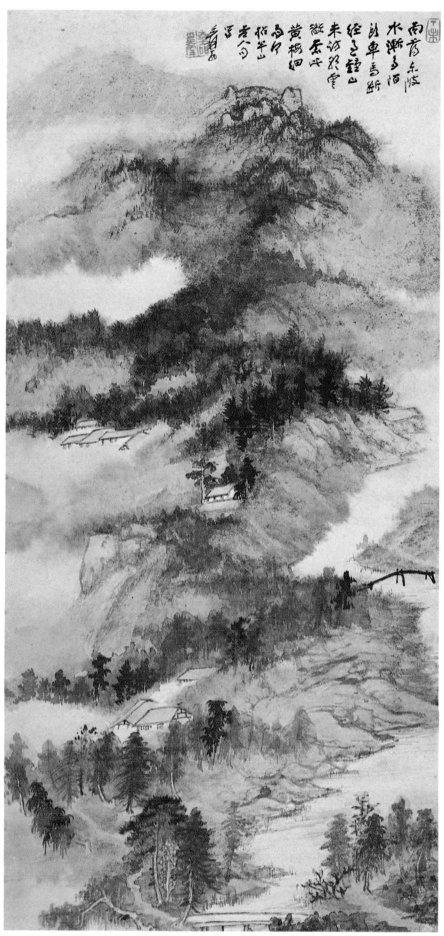

（一）
加
題
：
谿
山
林
藪

（二）
左
上
中
段
改
大
渾
彩

The landscape in light ochre, generally devoted to autumn scenes, was originated by the 13th century master Huang Kung-wang. The Southern School of landscapists subsequently made it their standard practice, using red ochre as the reigning tone and dabbing the woods and trees sparingly with light indigo.

Light ochre, however, is not used only as a means to indicate the autumn season but also as an appropriate technique for delineating craggy hills and mountains, such as the Huang Shan. In Chinese painting, light and colour are dealt with separately. Wherever colour should prevail, the painter may seek expression by pigment alone, without minding the light aspect. The mere mention of light ochre, terefore, is sufficient indication of the season of the landscape.

The technique of light ochre landscape is similar to that of ink monochrome. The painter first makes a general sketch with diluted ink, then fills in with wrinkles to indicate perspective elevation and distance. As soon as the ink dries, he may apply graded brownish-pink washes several times from light to deep ochre. He must wait till the picture becomes dry again, before executing additional wrinkles and outlines with 'thirsty brush and charred ink'. The moss patches on the trees should be individually touched up with light indigo or sap green; and above all, those parts of the picture that face light, should be enlivened with ochre. The tiles on the house-top are to be denoted with light ink or indigo, the mud huts and thatched cottages with ochre.

85　山水　Landscape

（一）
87圖↑
改放於：
86圖之上

（二）
改為大潑彩

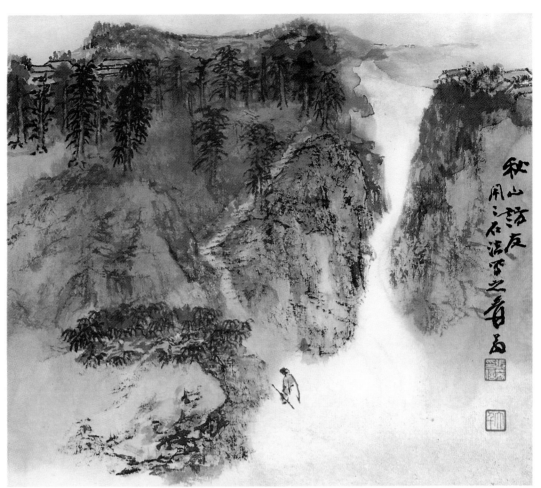

86　秋山訪友　An Autumn Visiting

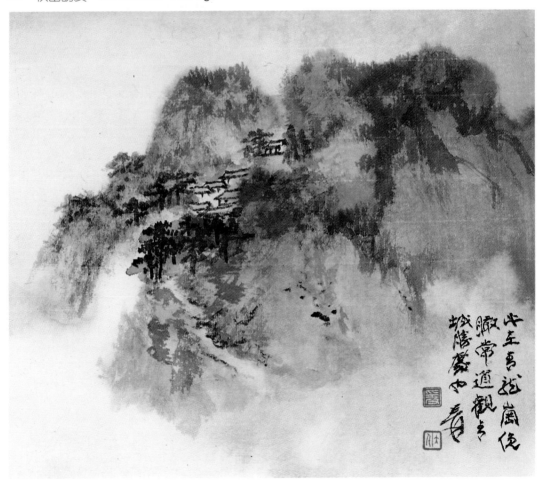

87　青龍崗之秋　Green-dragon Ridge

雪景

　　雪景是不容易畫的，我也不善於畫
這種畫。雪景色調旣單純，山石樹木
又須處處見筆，烘天和留白更是困
難。一般山水，天空和水面都是空白，
雪景必要將水天用淡墨烘染，不如此
不能顯出雪的情景，染淡墨的時候，
天和水在絹上，可用排筆，但曲折凹
凸處仍須用筆細去塡，在生紙上，那
就更難了，旣不可能使用排筆，用筆
烘染也有浸潰的痕迹。有人先將生紙
噴濕，然後渲染，叫作潮染，墨色雖
勻，看來總是死板板的，這是畫家的
大忌，反不如乾染比較妙，雖不免有
點浸潰的痕迹，到底比死板板的好得
多了。我的意見，若要畫雪景，簡直
用絹和熟紙，才足以表現得出。雪景
應該拿唐宋人的畫就範本。唐人畫不
可以見得到，宋人畫還有存在的，可
以資我們的參考。宋徽宗的雪江歸棹
卷，那眞是好老師。雪景畫除了拿水
墨留空白以外，山頭樹上亦可以用
粉。寺觀欄楯再用點硃砂，那在寒色
淒迷裡面，忽有和暖的氣氛，方才到
了妙境。雪景畫不限定在多景，唐朝
的楊昇，有峒蒲雪，宋代的趙幹有江
行初雪，都是寫的秋景，用靑綠打底，
山頭施粉，中間略微點一點硃碎小
樹。至於寫初春的霽雪，古人就更多
了。

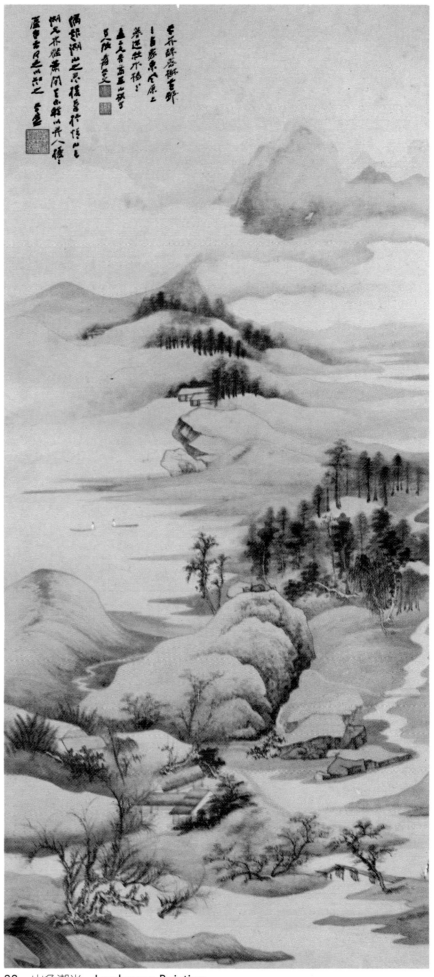

88　山色湖光　Landscape Painting

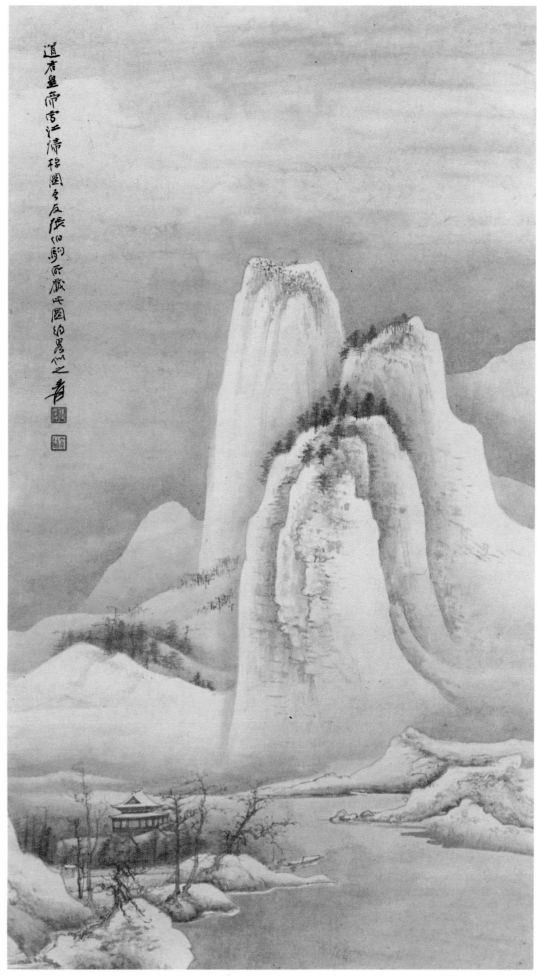

89　雪江歸棹　Returning

SNOW SCENES

Snow scenes, of which I am not a master, are difficult to paint. Their colour scheme is simple, yet the painter's brush-stroke must manifest itself here and there in the hills, rocks and trees, and the problem of shading the sky and leaving blank space for the snow is particularly baffling.

In ordinary landscapes, the sky above and the waters below are represented by blank space; in snow scenes they must be shaded with pale ink in order to bring into relief the predominant white. In the process of ink-shading, it is possible to use the raft-brush * if the painting is to be done on silk. But on unsized paper, the necessity of ink-washing every minute nook and corner with an ordinary brush, poses an almost insuperable problem to the painter, because

it is impossible for him to use the raft-brush on the exceedingly absorbent paper and the ordinary brush will inevitably leave undesirable water-marks. Some painters prefer to use the so-called "wet shading" technique by spraying water on the paper before starting the ink-washes. By so doing, an eventoned shading is achieved; but it looks lifeless and is, therefore, against the cardinal principles of painting. For this reason, "dry shading" is preferred by most painters in spite of its unavoidable water-marks. In my opinion, it is better still to paint snow scenes on silk or on sized paper, which will enable the painter to obtain the desired shading effect.

In painting snow scenes, we should model after the great masters of the T'ang and Sung

Dynasties. Though few T'ang paintings are in existence, we may still refer to the extant masterpieces of Sung. The scroll entitled *Home-coming Boats in Snowbound River* by Emperor Hui Tsung is a truly good example.

Apart from leaving blank space for the snow, flake white is also applied to the top of hills and trees. A little crimson on the balustrades and door-frames of temples will break up the general bleakness with a touch of warmth and make the picture interesting.

Snow is not confined to winter scenes. *The Snow Scene of the T'ung Pass* by Yang Sheng of the T'ang Dynasty and *The First Snow on the River* by Chao Kan of the Sung Dynasty are scenes in autumn, both having blue-and-green as the

90　瑞士雪山　Snowy Mountains in Switzerland

foundation colour with flake white on the hill-tops and a few dots of crimson on one of the trees. Scenes of spring after snowfall are even more common among the works of the old masters.

* A number of brushes bound together like a raft.

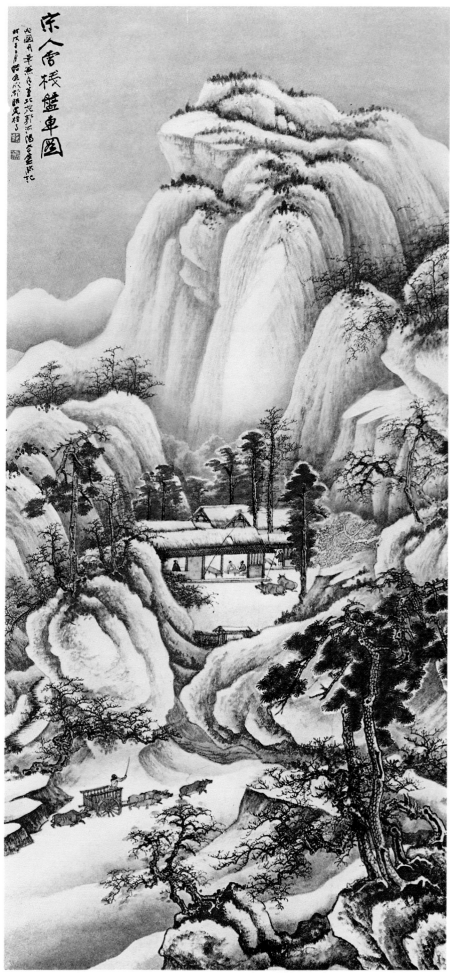

91 仿宋人雪棧盤車圖 Driving in Snow, Imitated from Painter of Sung Dynasty

物理、物情、物態

作畫要明白物理，體會物情，觀察物態，這才算到了微妙的境界。譬如畫山，要了解南北氣侯的不同，土質的各異，於是所生的樹木，也就迥然不同。因此種種關係，山石的形成，樹木的出枝發葉，一切一切，各自成就它的姿態。如畫花卉，有向陽者，有喜陰者，向陽的必定要有挺拔的姿勢。喜陰的必定要有荏弱的意態。挺拔與荏弱，它的姿態自然不同。由理生情。由情生態，由態傳情，這是自然的道理。現在舉個畫梅花的例子來講，林和靖的名句：「疏影橫斜水清淡，暗香浮動月黃昏。」這橫斜二字，浮動二字，便是梅花的理。楊鐵崖的：「萬花敢向雪中出，一樹獨先天下春。」這便是梅花的情。高季迪：「雪滿山中高士臥，月明林下美人來。」便是梅花的態了。所以無論畫什麼，總不出理、情、態三個原則。畫人物要識得窮通壽夭。畫仕女要識得幽嫻貞靜，妖嬈艷冶。畫山水要識得南北

節物。畫翎毛更要注意到種類的不同，情態一定也不同。飛鳴食宿，各極其狀，東坡詩云：「何處得此無人態」，史是體貼入微了。

92　湖山小景　Landscape

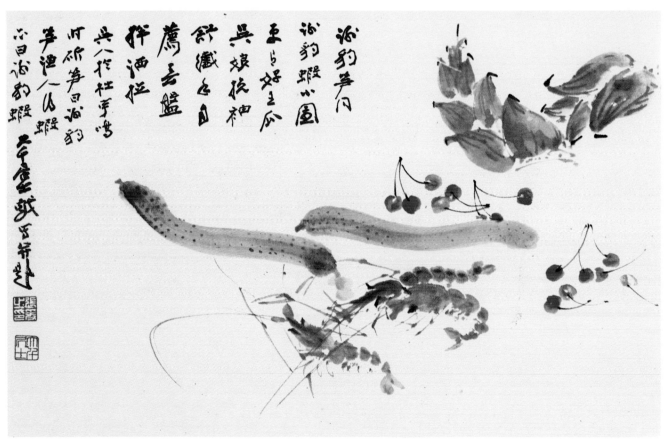

93　蔬果　Vegetables and Fruits

唐人畫牡丹金碧
輝映爛若雲錦者
居海上�論主雪岑文
齋p乜刀丸胤五色
此丹猩邪品齋p
此道君皇帝佛頭
青花效唐汪之明以来宇惠
雖沒輕胝而愛多穠溪貴
彩岩山因乜吳　甲卯秊李宇記

94　佛頭青（藍牡丹）　Blue Peony

OF NATURE, FEELING AND ATTITUDE

The painter should know the nature of his subject, fathom its feeling, and observe its manner and attitude, before he can attain the state of subtle ingenuity. If he paints a landscape, he must understand that the disparity in the climate and soil of the south and the north is responsible for the striking difference between their respective trees and plants. For the same reason, everything has a particular manner of its own, be it the formation of rocks, the branching out of boughs, the germination of leaves or what else. In case of painting flowers, those which take to sunshine must needs have an erect poise, those preferring the shade a delicate appearance. Their manners, of course, are poles apart. As intrinsic nature determines disposition, so disposition dictates manner and attitude which, in turn, gives expression to their disposition. That is the way of Nature.

Let us take the painting of plum blossoms for instance, with reference to the immortal lines by the famous poet-recluse Lin Ho-ching of the T'ang Dynasty: —

As mirror'd in shoal water
 clear,
Its image lies aslant and sparse;
As moon through shady twi-
 light peeps,
Its fragrance faintly floats and
 stirs.

In these lines the poet holds up the mirror to the nature of the plum blossoms. Another poet, Yang T'ieh-yai, sings of the same flower in a different light: —

While myriad flowers dare not
 brave the snow,
One tree in blossoms leaves
 the world behind.

Here the poet identifies his own feeling with that of his subject which, in poetry as in art, is the truth and the only truth. But it takes yet another poet, Kao Chi ti, to depict the form and attitude of the plum blossoms: —

Like hermit proud at rest in
 snowbound hills,
Or lovely belle's advent in
 moonlit woods.

This couplet reflects not only the form and attitude of the plum blossoms as they are personified in the poet's concept, but their character as well.

Whatever an artist may paint, he should never depart from the three cardinal principles of observation, understanding and communion. He must study his subject till he fully recognizes

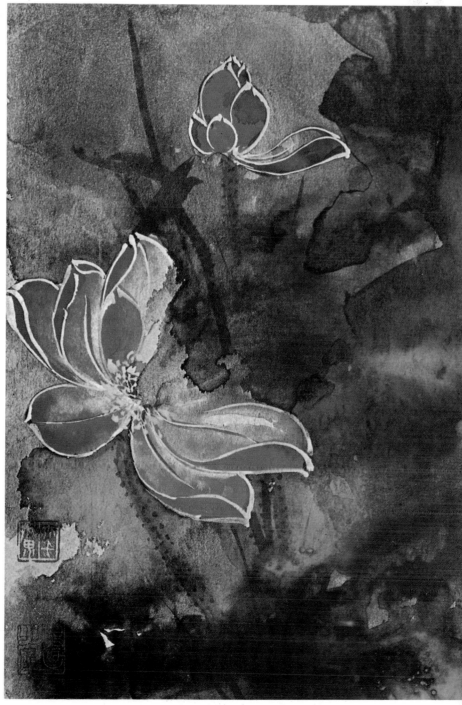

95 赤蓮 Crimson Lotus

its varying forms and attitude: such matters as, whether a landscape is in the bleakness of winter or the glory of spring; whether a bird is flying, chirping, pecking or perching. From that he may gain an insight into the nature of his subject: such as, whether a woman is modest, gentle, chaste, quiet, lascivious, coy, voluptuous, or gay. Finally, he must commune with his subject so that he can even feel what a blade of grass does under different weather conditions.

The great Sung Dynasty poet Su Shih once exclaims,
 Where could one find an attitude
 That's so forgetful of mankind?
And that is the height of subtlety an artist may attain.

紙墨

墨對畫的表現，紙對墨的承受。紙與墨對於畫，關係太重要了，如果所用的墨不好，所用的紙不知其性格，天大的本事，也不能得心應手的。石濤說過：「紙生墨漏，亦畫家之一厄也。」拿石濤天馬行空的天才，還有這種嘆聲，可見紙墨關係太大了。寫意畫要用生紙，因為生紙能發墨。工筆畫要用熟紙，熟紙不滲，生紙易滲。古時候的熟紙，是本質堅潔，畫上去不板滯。現在的熟紙，是用膠礬水來施的，既不受墨，又且澀筆。如果是畫工筆，絹是比較合用。

紙的種類很多，唐宋以來，紙質大都堅挺，潔白，最能受墨。後來有麻紙，看來稍粗，但仍是很堅實，畫寫意畫是最相宜的。到明朝才有宣紙，是宣州涇縣所造，或謂是明宣宗發明的，所以又叫做宣德紙。它的質料是用檀樹皮做的，宜書宜畫，傳到近世，檀樹皮也用盡了，大半用稻草代替，看來雪白潔淨，用起來真不如意。所以我們喜歡用舊紙，並不是紙放舊了就好畫，實在是因為古人做事，不肯偷工減料，他的本質自然就好。四川的竹紙很好用，受筆發墨，但不能經久。貴州都勻的皮紙，能耐久，墨色却不甚好。日本紙頗有可用的，墨色有浮光，又是美中不足。綾絹質料和紙不同，性質也就不一樣，綾子不上膠礬，可畫寫意畫，絹必須膠礬後才可用，生絹極不受墨，寫意工筆，兩種都不適宜。

墨是油煙最合宜，松煙紙是黝黑，並且沒有光彩，不宜於作畫，偶然用它來渲染髮、鬢、髭、鬚也可。山水花卉，沒有用它的地方。墨是要陳纔好，和紙一樣，因古人不專為牟利，搗煙很細，下膠輕重合適，近日粗製濫造，下膠又重又濁，並且用洋煙，甚至有用煙卤煤煙的，所以越發不能用了。欲找好煙，要光緒十五年前所製的，乾隆御製更好，因為宮中多有明墨，因風碎裂，加膠重新製造，所以又黑又光亮，用起來真可以墨分五

96　夏山高隱　Summer Resort

彩。古人曾說：「輕膠十萬杵」這句話，做墨的要點，盡於這五個字裡面了。

改為大滌子 右下加扁舟

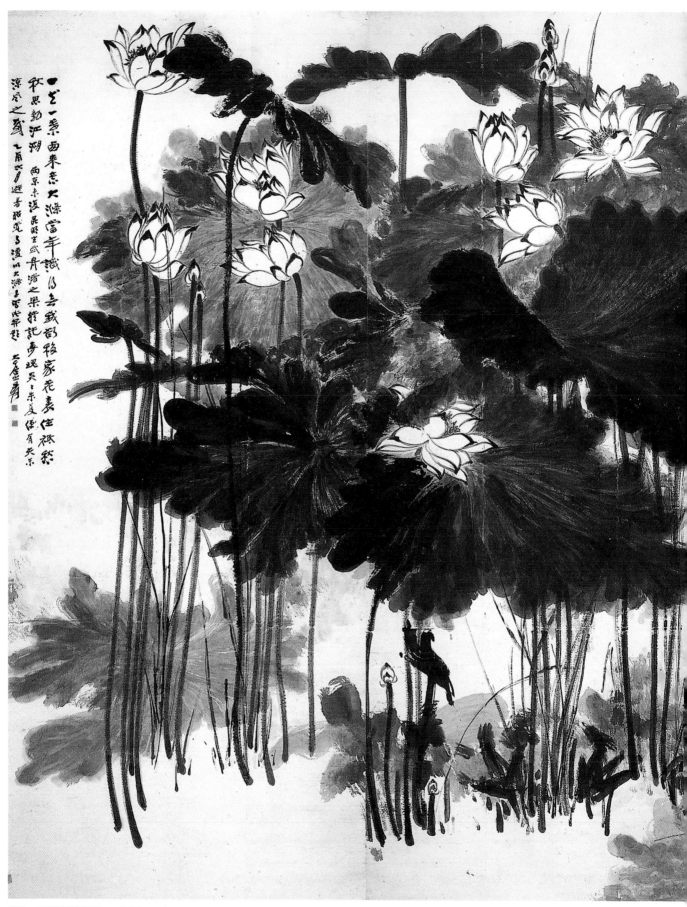

97　巨荷四連屏　"Giant Lotus" a Four-Paneled Painting

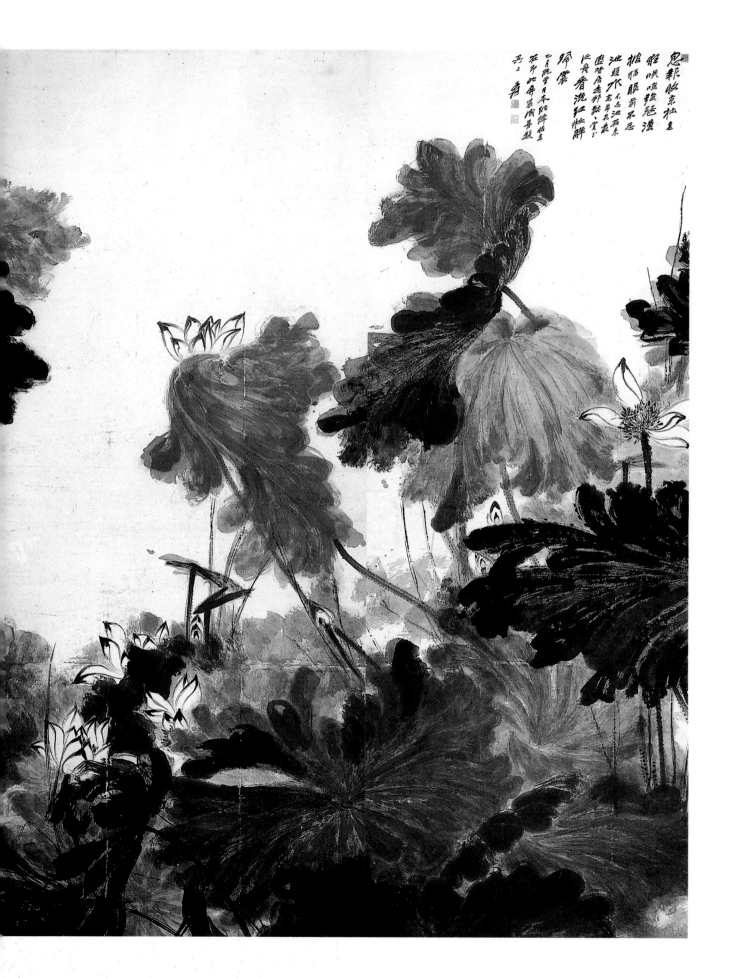

OF PAPER AND INK

Painting depends on the ink's capacity for expression and ink on the hospitality of the paper. Paper and ink are, therefore, essential to painting. Should the painter use ink of poor quality or paper of an unknown character, he will never be able to execute a picture to the content of his heart and hand, however adept he may be. Shih T'ao once remarked, "Unwonted paper and seeping ink are a disaster to painters." Since even he, whose genius is often likened to a Pegasus galloping in the clouds, cannot help uttering such an outcry, the vital importance of ink and paper is all the more evident.

For the impressionistic style of painting, it is imperative to use unsized paper because it can give a lift, so to speak, to the ink. For paintings in the elaborate style, however, it is advisable to use alum-sized paper, on which the ink does not diffuse as it would on the unsized. In ancient times, the sized paper was of a fine solid texture so that the painting on it did not look dull and stagnant. The same paper of to-day is processed with a mixed alum and glue solution; it is not only reluctant to receive ink but tends to drag the brush. Hence, so far as elaborate painting is concerned, the Chinese pongee, *chuan,* is comparatively more suitable.

There are many kinds of paper for painting. In the T'ang and Sung Dynasties, the texture of paper was, as a rule, solid, firm, unblemished, white and most hospitable to ink. Later, there was the so-called hemp paper which looked rather coarse but was full-bodied, none the less, and most suitable for paintings in the impressionistic style. It was not until the Ming Dynasty that the Hsuan paper came into existence. This paper was made at Ching Hsien in the Hsuan Prefecture and was believed by some people to be invented by Emperor Hsuan Tsung (1426-1435). Hence, it is also known as the Hsuan Teh paper. Made of sandalwood bark, it was originally a happy medium for both painting and calligraphy. But in recent ages the dearth of sandalwood bark has obliged its manufacturers to substitute straw, so that the paper, though still white and spotless in appearance, leaves much to be desired in use. That is why most painters prefer to use old paper — not that its substance improves with age but that its superior quality is guaranteed by the ancients' aversion to slipshod production and the use of inferior materials.

The bamboo paper of Szechuan is good for the brush and ink alike, but rather short-lived. The mulberry-bark paper of Kweichow, though long lasting, is not expressive of the delicate tonal nuances of the ink. Quite a few kinds of Japanese paper are serviceable, in spite of their shortcoming of producing a glossy effect on the ink-tone.

The texture of the thin *ling* silk and Chinese pongee is different from that of paper, so is their substance. *Ling,* being untreated with alum and glue, lends itself to paintings in the impressionistic style. Raw pongee must be treated before use to make it ink-receptive. For all paintings in the elaborate style, both *ling* and pongee are unsuitable.

Of ink tablets, those made of tung-oil soot are the most appropriate. The resin soot ones are jet black but not ideal for painting, because of their want of lustre, except for delineating hair and beards. They are not used for painting landscapes, flowers and plants. Like paper, ink tablets made by the scrupulous ancients are superior, for the soot was finely pulverized and the glue content just right. The slipshod products of to-day are made of imported lamp black, or even chimney soot, with heavy and often impure glue, thus rendering themselves utterly unserviceable.

In quest of good ink tablets, the painter should try to obtain those made prior to 1884. The ones produced by Emperor Ch'ien Lung (1736-1795) are decidedly the best, because they were made from disintegrated Ming Dynasty ink-tablets in the Imperial store-house. Black and rich in lustre, they can really be graded into five shades in use. As the ancients say, "One hundred thousand pestle strokes and light glue;" therein lies the secret of making ink-tablets.

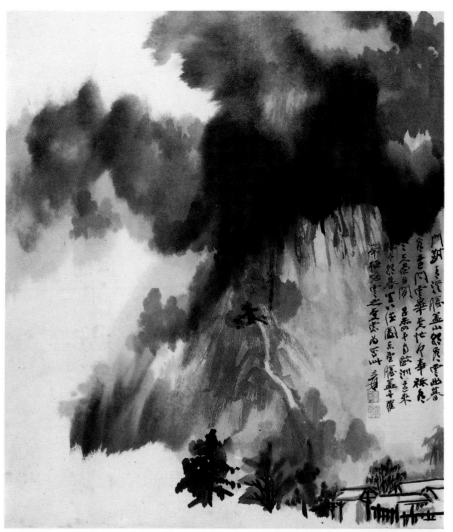

98　雲山　Cloudy Mount

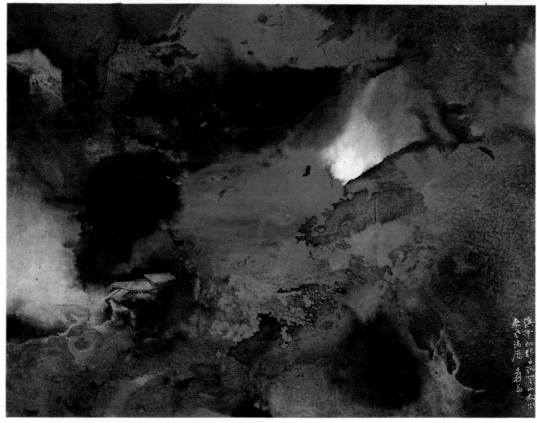

99　山雨欲來　The Approach of Mount Storm

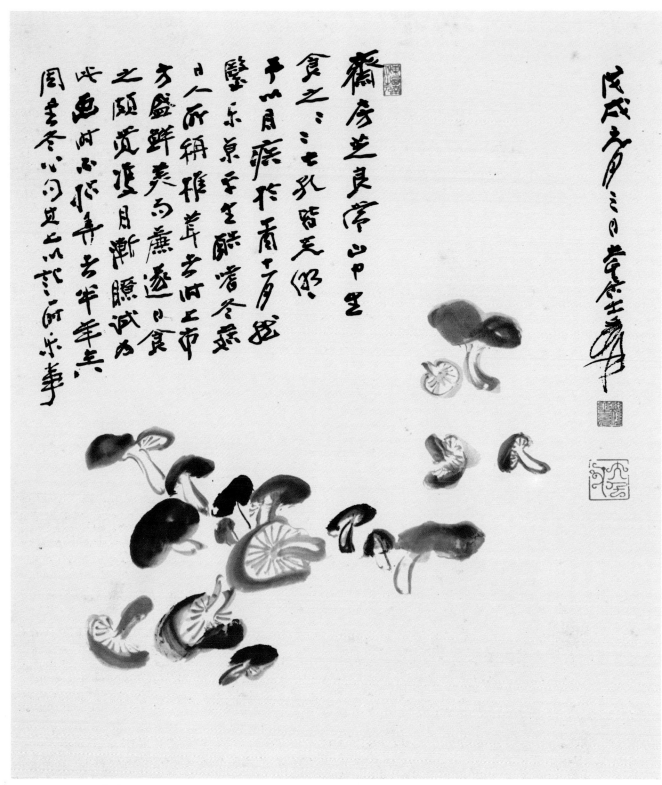

100　冬菇　Mushroom

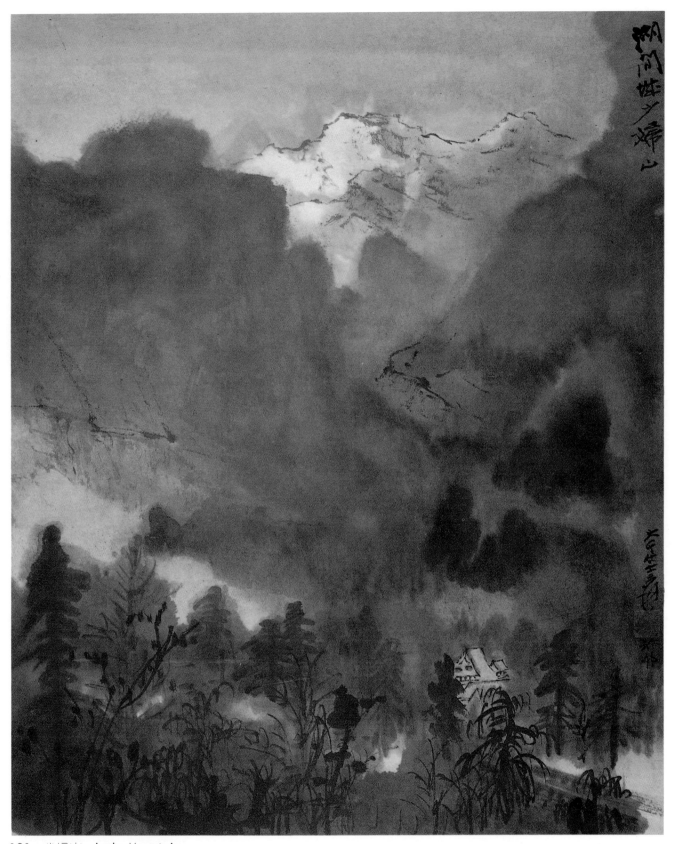

101　少婦山　Lady Mountain

用筆與水法

古人曾說過：「得筆法易，得墨法難，得墨法易，得水法難。」筆法還可以拿方式做準則，墨法就要在蘸墨在紙上的時候去體會的，所以說比較筆法更難。至於用水，更難拿方式規定出來，所以算最難的。筆法的要點，是要平、要直、要重、要圓、要轉、要拙、要秀、要潤，違反這些要點，那就是不妙。用筆拿中鋒做主幹，側鋒幫助它。中鋒把體勢建立起來。側鋒來增加它的意趣。中鋒要質直、側鋒要姿媚。勾勒必定用中鋒，皴擦那就用側鋒，點戳用中鋒，渲染是中鋒側鋒都要用。濕筆要重而秀，渴筆要蒼而潤，用筆要明潤而重厚，不可灰黯而模糊，硯池要時時洗滌，不可留宿墨。宿墨膠散，色澤暗敗，又多渣滓，無論人物、山水、花卉都不相宜。至於水法，無法解說得清楚，在自己心領神會而已。因筆端含水的多少，施在紙絹上各自不同，絹的膠礬輕重，紙質的鬆緊，性質不同，水量自然不同，水要明透，又不可輕薄，所以是最難的了。

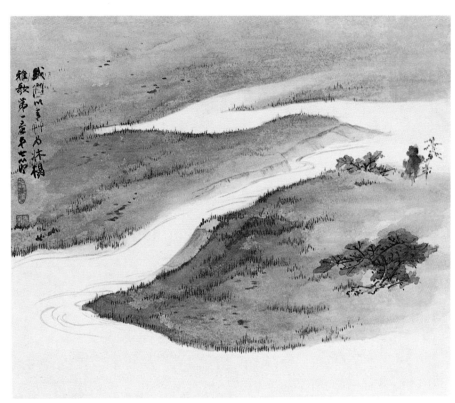

102　春水　Spring Water

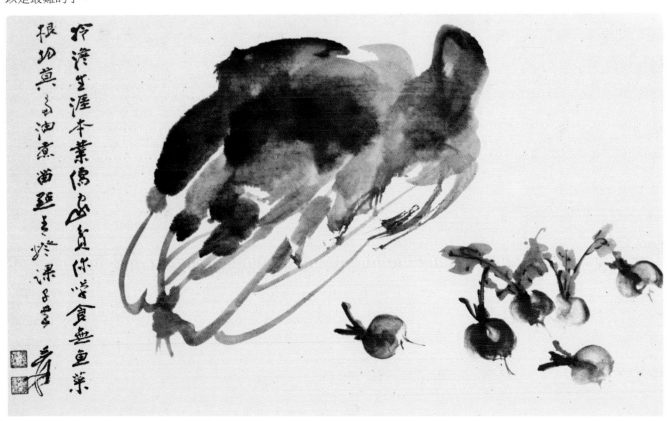

103　蔬菜　Vegetables

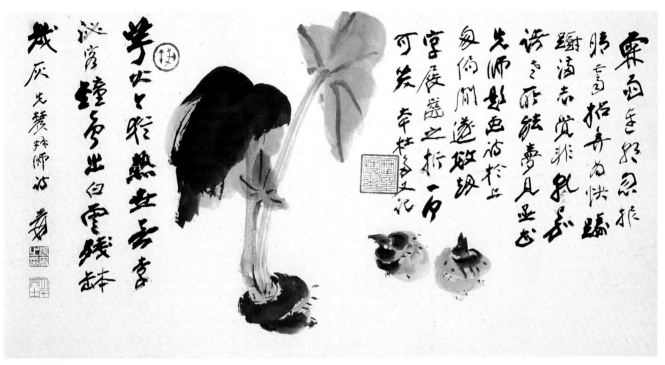

104 芋頭 Taro

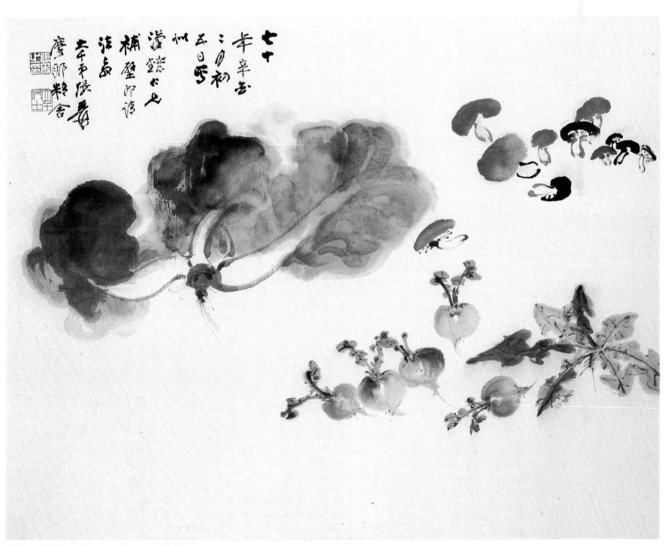

105 蔬果 Vegetables and Fruits

OF BRUSH AND WATER

"It is comparatively easier to master the brush technique than to acquire proficiency in the application of ink," an old master once remarked, "and to know the secret of using water is even harder." Whereas brushmanship may be perfected by adhering to the standard methods, the expert application of ink can only be learned by experimenting with the brush on the paper. That is why it is more difficult. As to the desirable quantity of water to be used in each brush-stroke, it is quite impossible to lay down any precise formula for the beginner to follow. Therein lies the capital difficulty.

The brush technique calls for balance, straightness, weightiness, fullness, versatility ruggedness, gracefulness, and smoothness. Failure to observe these essential points will lead to unhappy results.

The artist should employ the central brush-point, i. e., the core of the brush made of long hair, as the mainstay to be supported by the shorter hair on its periphery. The core lays out the structural form, to which the sides add perceptual meaning. The former should be sturdy and erect, the latter graceful and charming. The brush should be manipulated as follows: by using the central brush-point for defining outline or executing dots and flips, the brush-side for the wrinkles and daubings, and the core and the side jointly for the washes and shadings. Heavy brush-strokes should be weighty yet graceful, the 'thirsty' ones bony yet smooth. Good brushwork is invariably brilliant and sturdy, instead of being ashen and blurred.

The ink-stone must be constantly washed, without leaving any stale ink on it. The diffusion of glue-content causes the stale ink to lose its original lustre and to shrivel into dregs, thus rendering it unfit for painting human figures, landscapes, plants and, indeed, anything else.

It is impossible to teach a beginner how to administer water to the brush properly, which is a secret one has to learn through experience. How much water the brush-tip should absorb is a problem that differs according to the material on which a picture is to be made. As the silk is usually treated with glue and alum and the different kinds of paper have varying degrees of absorption, it is obvious that the quantity of water in the brush-tip should not be the same. Apart from that, the water must so dilute the ink that the effect produced is as clear as crystal, without being too light and thin — a feat most difficult to accomplish.

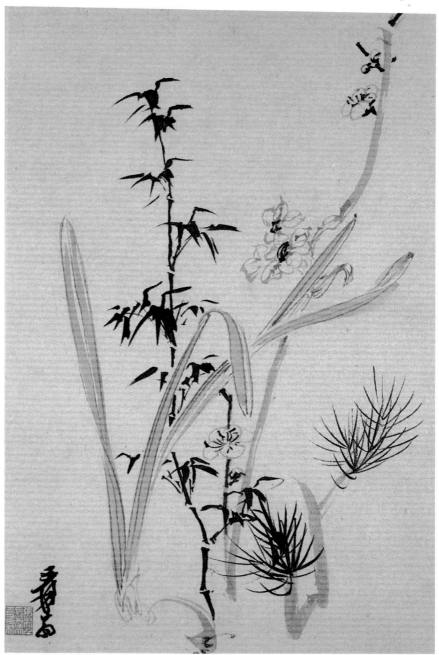

106　嚴冬四友　Prunus, Bamboo, Pine and Narcissus, Friends in Winter

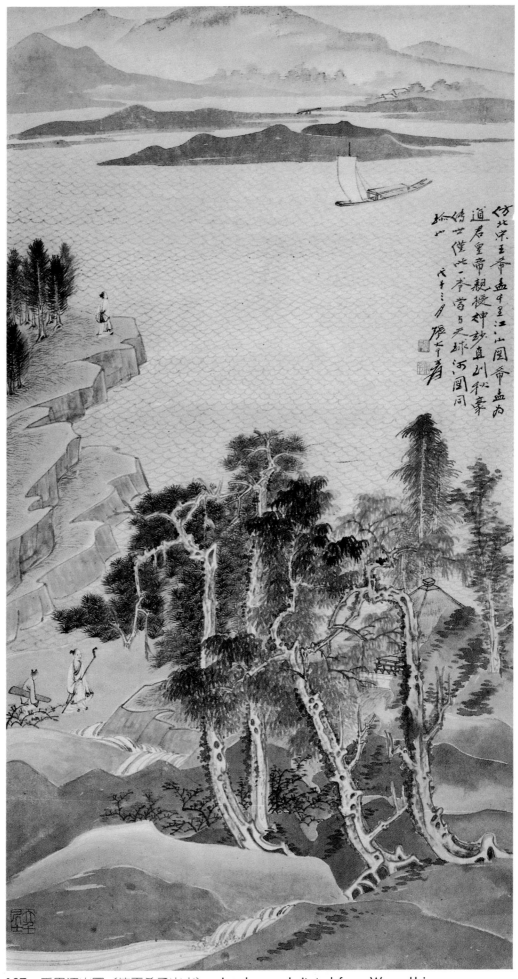

107　千里江山圖（仿王希孟山水）　Landscape, Imitated from Wang Hsi-meng

翎毛

　　畫翎毛，第一要明白鳥的雌雄。禽與獸都是雄性最美，少數的纔是雌雄的羽毛一樣，但是雌的總比雄的小一些。若是畫一隻，也要看得出是雌是雄，因為鳥的翅膀，超左超右，雌雄是相反的。這便是東坡先生所說的形理。畫一種東西，必須要了解其理、其形（形卽是態）、其情。鳥要畫得靈活。如何纔能畫得靈活呢？一種鳥有一種姿態，燕子與鴿子是不站在樹枝上的。鶴與鷺是拳一足而睡的，倘若祇了解鶴與鷺，拿它的姿態，來畫其他的鳥，豈不是笑話。烏鴉與喜鵲，動態是決不相同的，若將黑皮袍脫下來穿在喜鵲身上，就說它是烏鴉，那是絕對不可以的。所以必須微妙的觀察種種動態：啼晴、調音、踏枝、欲升、將飛欲墜、欲下、反爭、飛翔、飲啄。以上各種姿態，胸中都明白了，畫時自然會得心應手。畫鳥先畫嘴，次畫眼，次畫頭額，然後將全身輪廓掃出。翅尾須倒畫，這是最重要的。若是順畫，下筆時墨必重，與背上之毛絕不能夠銜接，倒畫則收筆輕而墨渴，自然而然的天衣無縫了。其次，爪在平地須要踏得穩，在枝上須要抓得住。此種筆墨宋人畫得最好，宋徽宗尤能體會入微，其點鳥睛，使用生漆，隱然比紙絹高出一些，奕奕有神。宋人鄧椿寫書繼一書，載有如下幾句：「宣和殿前植荔枝，旣結實，喜動天顏，偶孔雀在其下，亟召畫院衆史，令圖之，各極其思，華彩爛然，但孔雀欲升籐墩先舉右脚，上曰：未也。衆史愕然莫測，後數日再呼問之，不知所對，則降旨曰：孔雀升高，必先舉左脚，衆史駭服。」在這裡可以看見古人了解物理、物情、物態的深刻。翎毛無論工筆寫意，必須潤澤，若不潤澤，便是標本。再者，鳥類當它們棲宿或飛翔時，頭必迎風，如背着風，那麼羽毛必定掀起來。每到黃昏，衆鳥集於樹林，那一夜如果有東風，頭必向東，若是西風，頭必向西。風還未起，鳥能有前知的本領，就能有這樣的感覺，：所謂：「物能知機」，這又不可以不注意的。

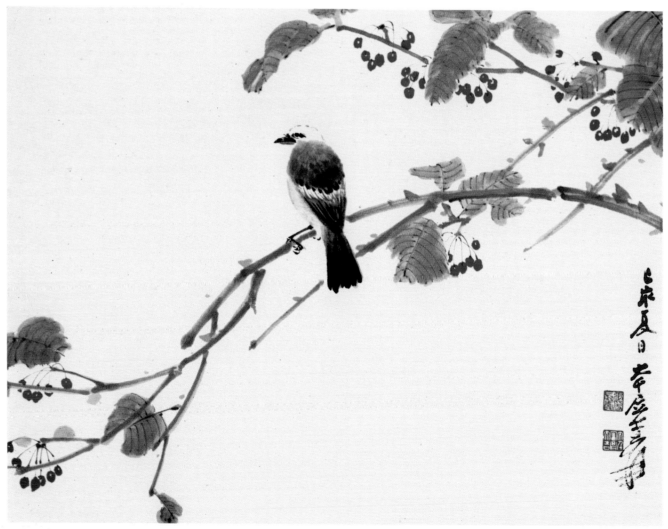

108　白頭翁　Sturnus Chineraceus

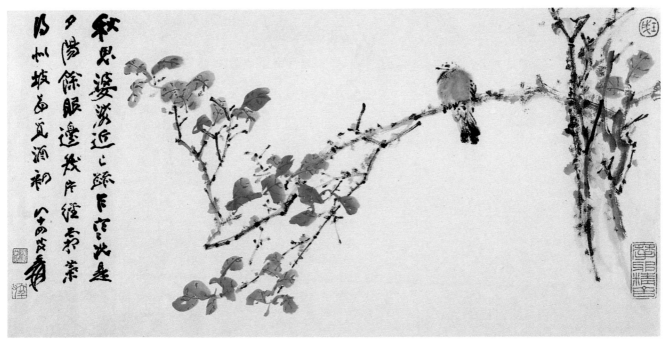

109　紅葉小鳥　Red Leaves and Bird

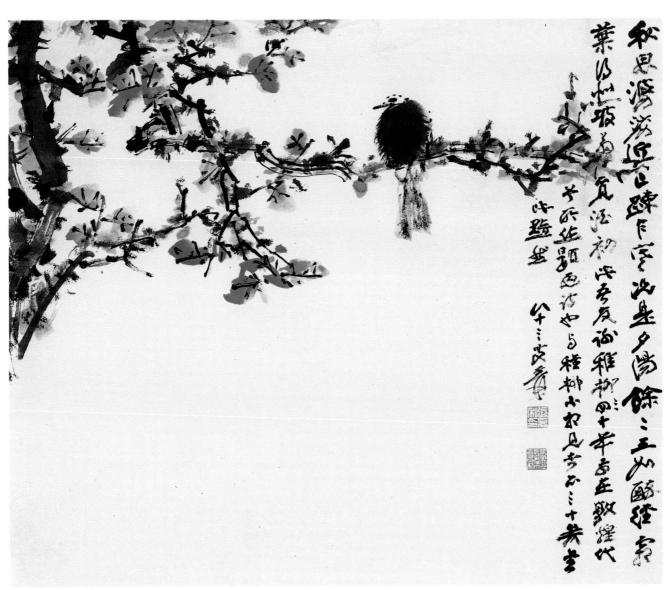

110　深秋　Deep in Autumn

OF BIRDS

To paint birds, one must first know the distinctinction between the male and the female species of the feathered tribes. In the animal kingdom, the male members are generally endowed with greater physical beauty. There are only a few species, of which the outward appearance of the two sexes is the same; but, even so, the weaker vessel is usually smaller in size. When only one bird is painted, its sex can be told from the slight difference in the relative length of its wings, i. e., whether the left, or the right, wing is longer. That, in the words of Su Shih, is *hsing li,* the expression of inherent nature in form.

Whatever one may paint, one should comprehend its nature, its from (i. e., attitude) and its feeling. Birds should be painted so that they look alive. But how? one may well ask. To begin with, the painter should know that each bird has its own particular manner and attitude. The swallows and the pigeons, for instance, do not perch on the boughts of a tree, and the crane or the egret invariably tucks one leg in its down, when at rest. If one knew only the habit of the wading birds and painted other species in the same manner, would not that be absurd? Another example: — the form and behavior of crows and magpies are decidedly different. If one should clothe the latter in the feathers of the former and insist that it was a crow, that would be indeed inconceivable. The painter, therefore, should minutely observe the various behaviors of the bird, such as, greeting the sun with songs after the rain, calling mates, perching on the boughts, heading upwards, making ready to take off, stooping to dive, intending to descend,

turning back to fight, fiving, drinking and pecking food. An intimate knowledge of such manners and attitudes will naturally enable the painter to command his technical skill, while painting, in perfect accord with his perceptual image.

The usual order of painting a bird is to do the beak first, next the eyes, the head, then the general outline of the whole body in sweeping strokes. The most important point is that the tail and wings must be drawn by starting the brush-stroke from the tips; otherwise, the heavy ink-tone at the outset would not blend with that of the feathers on the back. By reversing the stroke, the ink-tone will gradually become lighter, as the brush-stroke sweeps to its end, and the merging will be practically undetectable. Finally, as to the bird's feet, they should look steady on the level ground and their grip firm while on a branch.

In such detail, the superb technique of the Sung masters is unmatchable. Emperor Hui Tsung, in particular, excels in finesse. He dots the irises of birds with raw lacquer which, after drying up, becomes slightly embossed, thus enhancing the liveliness of the eyes. In *Hwa Chi* by Teng Ch'un of the Sung Dynasty, there is an anecdote, as follows: —

"When the lichee tree in the courtyard of Hsuan Ho Hall began to grow fruits, His Majesty Emperor Hui Tsung was greatly pleased. By chance, a peacock sauntered about under the tree, whereupon the Emperor immediately sent for the artists of the Imperial Academy to paint a picture of it. They carefully studied the bird, each with all his wits about him, and their scrolls

soon emblazoned with iridescent splendour. When the peacock lifted its right leg with the intention of mounting a rattan pedestal, His Majesty remarked, 'Not yet.' And verily it stopped short and the surprised academicians were mystified by the monarch's uncanny prediction. Two days later, when questioned by the Emperor, none of them could explain the mystery. Whereupon His Majesty said, 'When a peacock ascends the steps, it invariably lifts its left leg first.' With gaping mouths, the academicians humbly acknowledged the Emperor's acumen."

This anecdote may serve to show how thoroughly the old masters understand the nature, feeling and attitude of their subject.

The picture of a bird, whether in the elaborate style or the impressionistic, must needs be brilliant and vivid; otherwise, it would be a mere illustration in an ornithological book. Another point: whether birds are roosting or in flight, their heads are usually against the wind which, if in the opposite direction, would rumple up their feathers. At dusk, when the bires perch in the trees, they will face east if the wind is to be easterly during the night, and *vice versa.* For they can foretell by instinct the direction of the wind before it starts to blow. As it is said, "the lower order of life has a sixth sense for Nature's secrets." This is another point which the painter will do well to bear in mind.

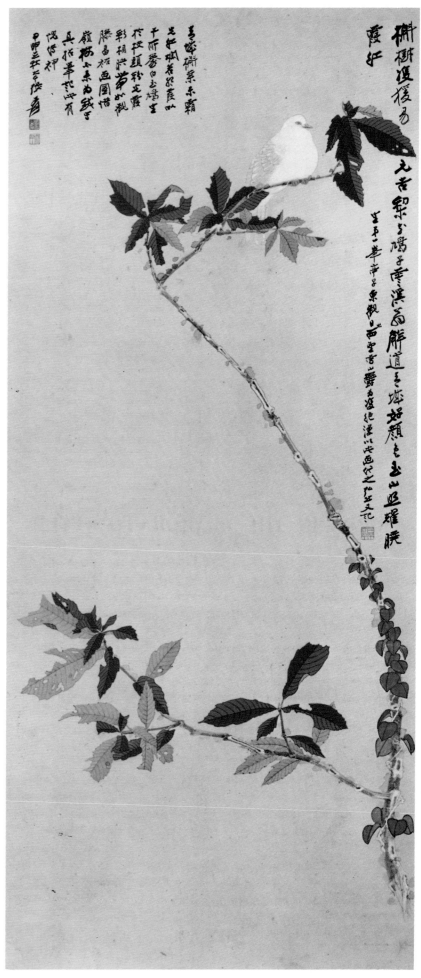

111　紅葉白鳩　White Turthe Dove on Loranchaceae Branch

工筆翎毛

寫意的畫，是拿神與意做主體。工筆那就要形意同時並重，當然更要注意到神。畫翎毛眞是要將羽毛一根一根的畫清楚，但是這樣畫是最容易流於匠氣的，或是竟成爲標本畫。

我國國畫最重者爲用筆用墨，若要不入工匠氣，須在筆墨上留心，至於色澤當然也是重要的。

宋徽宗畫鳥，用生漆點睛，看來像活的一樣，這就是傳神妙筆。鳥的脚爪也要特別留意，不但站樹枝要有勢有力，脚上的紋和爪，都足以表現畫的精神，必要一絲不苟的畫出。

花鳥以宋朝爲最好，因爲徽宗自身就畫到絕頂，兼之大爲提倡，人才輩出。宋人對於物理、物情、物態，觀察得極細微，現在我再舉幾件可以作爲師資的名畫，是故宮博物院的。

黃釜山鷓棘雀圖、崔白山雀野兎圖、李安忠浴沙鷯鶉圖、宋人無款杏竹聚禽圖，（當是崔白所製）宋人無款蘆汀雙鴨圖（疑爲徽宗之筆），又長春散出。徽宗金英秋禽圖，以上都是神品。

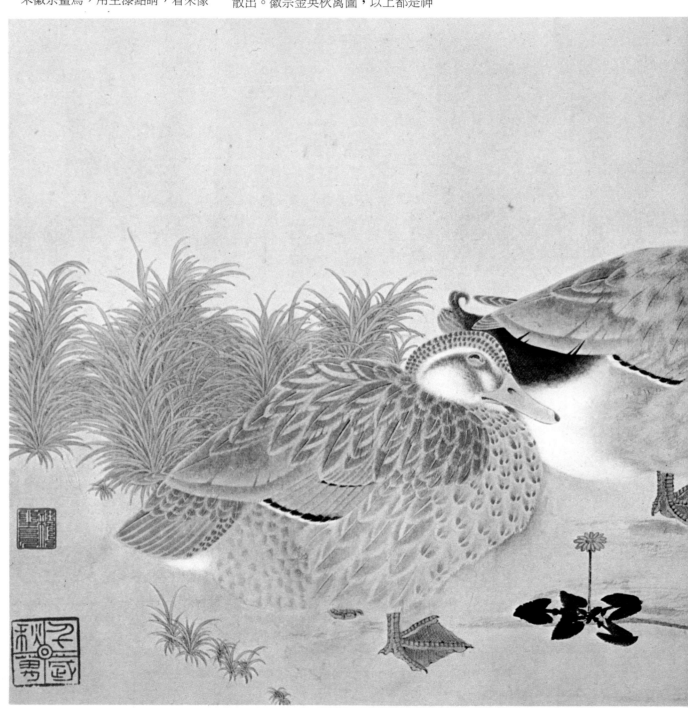

112　雙鴨　The Couple

中國嘉德2010春季拍賣會
China Guardian 2010 Spring Auctions

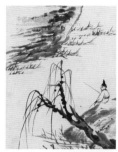
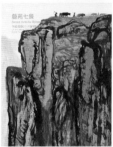
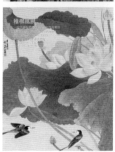
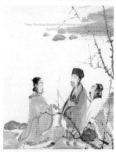

拍賣安排　AUCTION

北京國際飯店會議中心三層紫金大廳A廳
Hall A, Purple Palace, Convention Centre, Beijing International Hotel
(北京市東城區建國門內大街9號)
(9, Jianguomennei St., Dongcheng Dist., Beijing)

中國古代書畫（一）	5月15日　上午9:30
Ancient Chinese Painting and Calligraphy（Ⅰ）	Saturday, May 15 9:30am
中國古代書畫（二）	5月15日　下午2:30
Ancient Chinese Painting and Calligraphy（Ⅱ）	Saturday, May 15 2:30pm
宋元明清法書墨迹	5月16日　上午9:30
Traces of Ink by Song, Yuan, Ming and Qing Calligraphers	
	Sunday, May 16 9:30am
中國近現代書畫（一）	5月16日　下午2:30
Modern Chinese Painting and Calligraphy（Ⅰ）	Sunday, May 16 2:30pm
藝苑七景	5月16日　晚上7:30
Seven Artistic Spheres	Sunday, May 16 7:30pm
一代書聖于右任	5月17日　上午9:30
Yu Youren—Calligraphy Master for a Generation	
	Monday, May 17 9:30am
亞洲重要私人珍藏系列	5月17日　下午2:30
Important Works from Private Asian Collectors	Monday, May 17 2:30pm
稚柳風腕－紀念謝稚柳誕辰100周年作品集珍	5月17日　晚上7:00
Xie Zhiliu's Elegant Brushwork—Fine Paintings Commemorating Xie Zhiliu's 100th Birthday	Monday, May 17 7:00pm
三石集珍	5月17日　晚上7:30
Three Precious Stones—Fine Painting and Calligraphy by Qi Baishi, Fu Baoshi and Wu Changshuo	Monday, May 17 7:30pm
借古開今－張大千、黃賓虹、吳湖帆及同時代畫家	5月17日　晚上8:00
Ancient Methods and Modern Innovations-Zhang Daqian, Huang Binhong, Wu Hufan and Contemporary Artists	
	Monday, May 17 8:00pm
中國當代書畫	5月18日　上午9:30
Contemporary Ink Painting	Tuesday, May 18 9:30am
中國近現代書畫（二）	5月18日　下午2:30
Modern Chinese Painting and Calligraphy（Ⅱ）	Tuesday, May 18 2:30pm

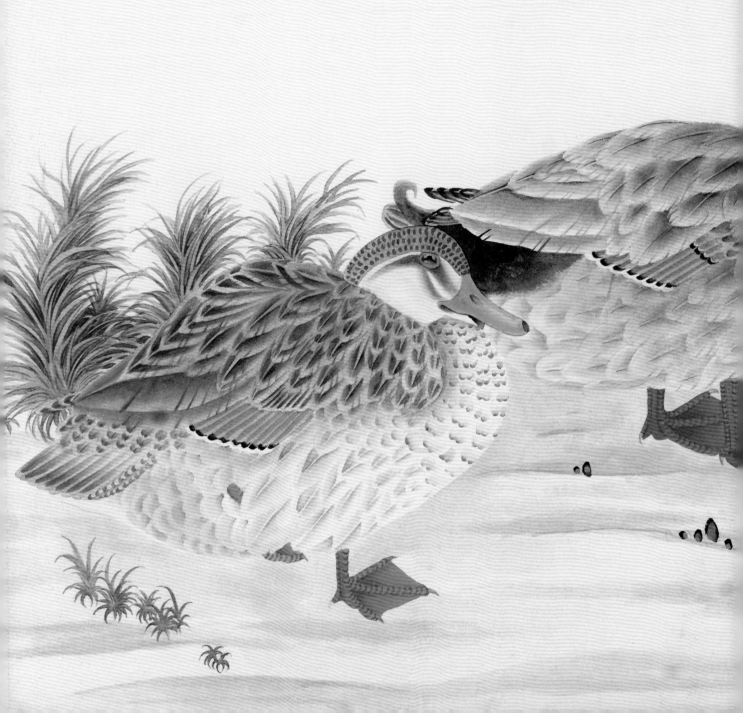

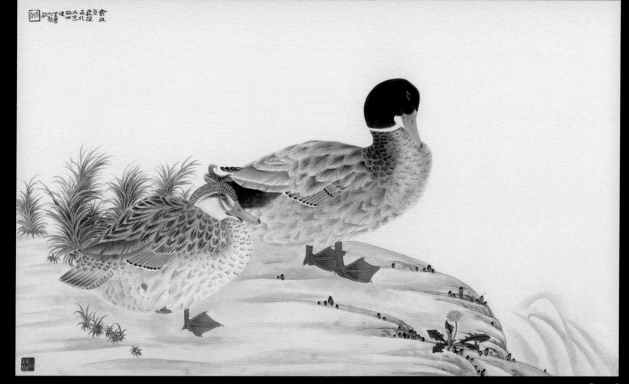

【1288】

* 1287

張大千（1899-1983）、俞致貞（1915-1995）作

文殊蘭

立軸 設色紙本

鈐印：俞致貞、一雲

本幅陳佩秋(b.1922)題：此圖用紙為大風堂一九三九年親往夾江監製。見李永翹《張大千全傳》。紙上尚存暗花帶一條，迎光可照見。圖中畫文殊蘭一株，應為俞致貞教授所寫。蘭後荊棘以及花上蛺蝶，並蘭下之坡石流水，皆為大千先生所補。師徒之間雖有默契，然用筆懸殊。細參筆法奧妙，當知余言屬實。己丑(2009年)初冬，截玉軒中識。健碧時年八十七又晉壹。　鈐印：陳氏、又之、陳佩秋印、秋崟香室、江上詩堂

致貞、一雲二印為力上家屬所鈐。健碧又及。　鈐印：陳氏

陳佩秋題簽條：張大千先生俞致貞教授師徒合寫文殊蘭。己丑，健碧簽。

說明：Lot1286-1293號拍品徵集自俞致貞、劉力上家屬。

Zhang Daqian and Yu Zhizhen
ORCHID AND BUTTERFLY

Hanging scroll; ink and colour on paper
With two artist seals; inscription by *Chen Peiqiu*, signed *Jianbi*, with one

1288

俞致貞（1915-1995）

雙鴨圖

鏡心 設色紙本

鈐印：俞致貞

本幅陳佩秋(b.1922)題：俞致貞教授畫於北京。故世後健碧代題款。
　　鈐印：健碧

說明：Lot1286-1293號拍品徵集自俞致貞、劉力上家屬。

Yu Zhizhen
PAIR OF DUCKS

Mounted; ink and colour on paper
With one artist seal; inscription by Chen Peiqiu, signed *Jianbi*, with one
artist seal

54.5×89.3 cm. 21 1/2×35 1/8 in. 約4.4平尺

RMB: 80,000-120,000
USD: 12,100-18,200

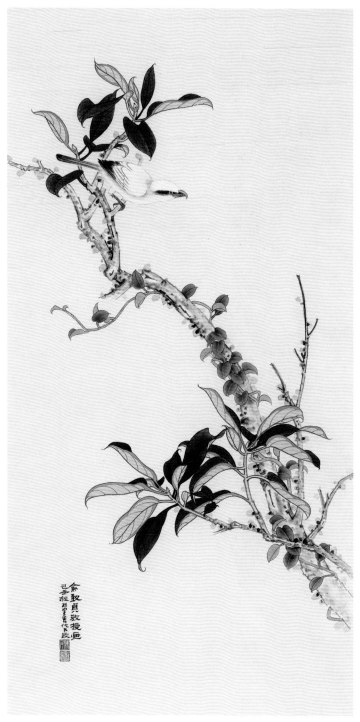

【1289】

1289

俞致貞（1915-1995）

紅葉小鳥

鏡心 設色紙本

本幅陳佩秋(b.1922)題：俞致貞教授畫。己丑
　　(2009年)秋日，健碧代書款。　鈐印：
　　陳氏、健碧

說明：Lot1286-1293號拍品徵集自俞致貞、劉
　　力上家屬。

Yu Zhizhen

SMALL BIRD AMONG RED LEAVES

Mounted; ink and colour on paper
With inscription by Chen Peiqiu, signed
Jianbi, with two artist seals

90.8×45.5 cm. 35³/₄×17⁷/₈ in. 約3.7平尺

RMB: 38,000-48,000
USD: 5,800-7,300

中国近現代書畫(二)

2010年5月18日星期二下午二点三十分
拍賣品1261—1583號
北京國際飯店會議中心紫金大廳A廳

Modern Chinese Painting and Calligraphy (Ⅱ)

Tuesday, May 18, 2010 2:30pm.
Lot 1261 to 1583
Hall A, Purple Palace, Convention Centre,
Beijing International Hotel

索 引
INDEX OF ARTISTS

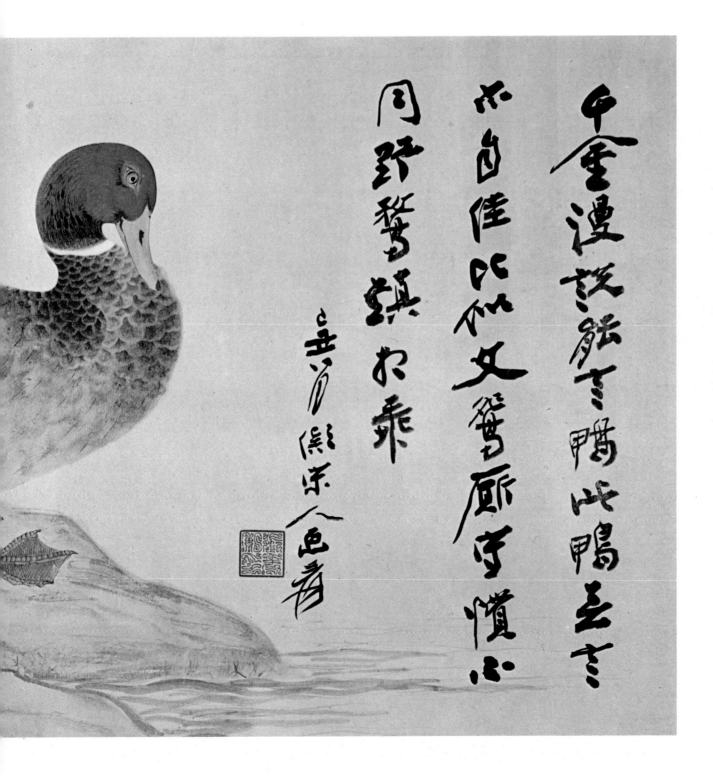

BIRDS IN THE ELABORATE STYLE

While in the impressionistic style of painting, spiritual quality and conceptual sublimation play the essential role, in the elaborate style form and concept are of equal importance and, of course, the spiritual quality also demands special attention. The artist should paint each feather and plume of a bird precisely as they are in life, but more often than not his efforts are liable to commercial sweetness or identifiable with ornithological illustrations.

In Chinese painting, the most important thing is the mastery of the brush and the ink. To be at a safe distance from the sweetness of commercial paintings, the painter should devote himself to the brush and ink technique. It goes without saying that he should also set store by colour.

Emperor Hui Tsung of the Sung Dynasty was accustomed to apply raw lacquer to the irises of the birds he painted, so that they not only had an authentic lustre but looked as large as life. The painter must also pay special attention to the feet of birds. When perching, the feet should manifest strength and firmness. The lines and claws on the feet may also convey the spirit of the painting and, consequently, should be painted with meticulous care.

The painting of flowers and birds reached the zenith in the Sung Dynasty. Under the patronage of Emperor Hui Tsung, who had himself attained the summit of the art, a host of gifted painters rose to fame. The Sung masters are noted for their punctilious observation and understanding of the nature, feeling and attitude of their subjects. In conclusion, let me mention a few scrolls in the celebrated Palace Museum collec-

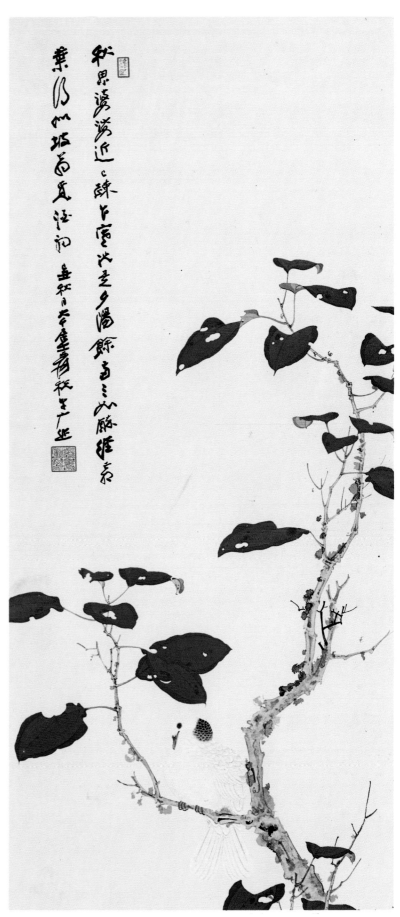

113　紅葉白鳩　White Pigeon and Red Leaves

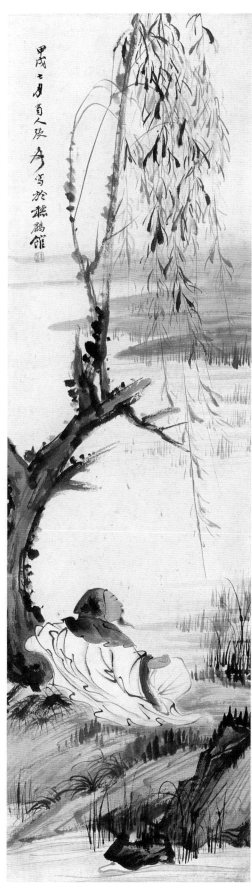

1007

1007
張大千(1899—1983)　柳蔭消夏
立軸　設色紙本
1934年作
款識：甲戌七月，蜀人張爰寫於聽鸝館。
印文：大千所作

ZHANG DAQIAN　SUMMER DAY UNDER
THE WILLOW TREE
hanging scroll; ink and color on paper
129.5 × 37 cm.　51 × 14 ¹/₂ in.　約 4.3 平尺
RMB: 120,000 — 150,000

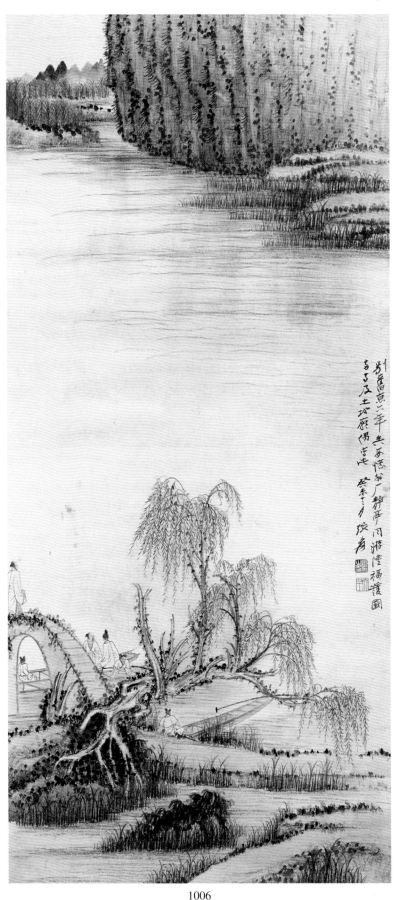

別舊京六年矣，每憶非厂、静亭同游隆福、護國兩寺及土地廟，偶寫此。癸未十二月張爰。

原画見藝術圖書公司「張大千畫」
↳ P65頁61圖。

1006
張大千(1899 — 1983)　春江泛舟
鏡心　設色紙本
1943 年作
款識：別舊京六年矣，每憶非厂、静亭同游隆福、護
　　　國兩寺及土地廟，偶寫此。癸未十二月張爰。
印文：張爰之印、大千

ZHANG DAQIAN　LANDSCAPE
mounted; ink and color on paper
96 × 42 cm.　37 ³/₄ × 16 ¹/₂ in.　約 3.6 平尺
RMB: 550,000 — 650,000

1006

画生 →自然有力
字尚可(略硬)，「國」字差遠矣。
↳取藝術圖書公司「張大千畫」一 P114圖之題識。

tion which are of instructional value: —

The Partridges and the Sparrows, by Huang Fu. *Titmouses and Hares,* by Ts'ui Po. *Quails Wallowing in the Sand,* by Li An-chung. *Birds in Apricot Trees and Bamboos,* by an anonymous Sung artist, probably by Ts'ui Po. *Ducks and Reeds,* by an anonymous Sung artist, suspected to be Emperor Hui Tsung. Also from a private collection originally at Ch'ang Ch'un: — *Chrysanthemums and Birds,* by Emperor Hui Tsung.

The above are the masterpieces of inspired masters.

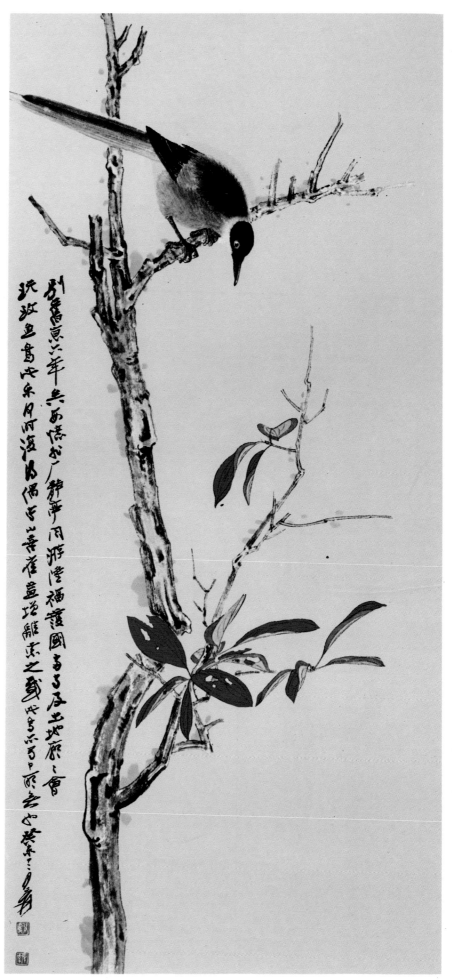

114　山喜鵲鳥　Magpie

畫魚

　　畫魚要能表現出在水中優遊的樣子，若畫出水魚那就失去物性的天然。畫時不必染水而自有水中的意態，纔算是體會入微。古人如五代的袁嶬，宋的劉寀、范安人都以畫魚著名，却都是工筆。當然是藝術高深，無可訾議的。但是我最佩服的還是八大山人。他畫魚的方法，能用極簡單的構圖與用筆，就能充分的表現出來，眞有與魚同化的妙處。山人藝術的成就，必然是經過多少時間的觀察和揣摹，纔能由繁而簡，却又表現無餘。試看他畫的嘴、眼、腮、鬐、脊、翅、尾、腹，那一點不體貼入微，而魚的種類不同，動態也不同，山人所畫盡不曲盡其妙。我們應該永遠拿他做老師，但不是說要照樣臨摹，是要學他的用心，若是依樣葫蘆，便爲畫奴了。

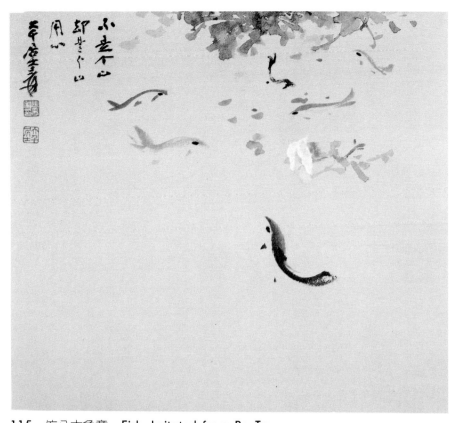

115　仿八大魚意　Fish, Imitated from Pa Ta

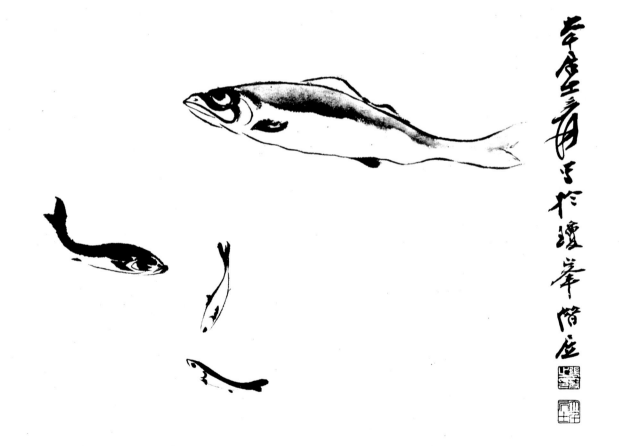

116　游魚　Fish

畫魚有時要配搭岩石、花草，來增加畫面的美點和曲折，總是以簡潔為主，也不宜設色，水墨的反覺得淡雅有致。

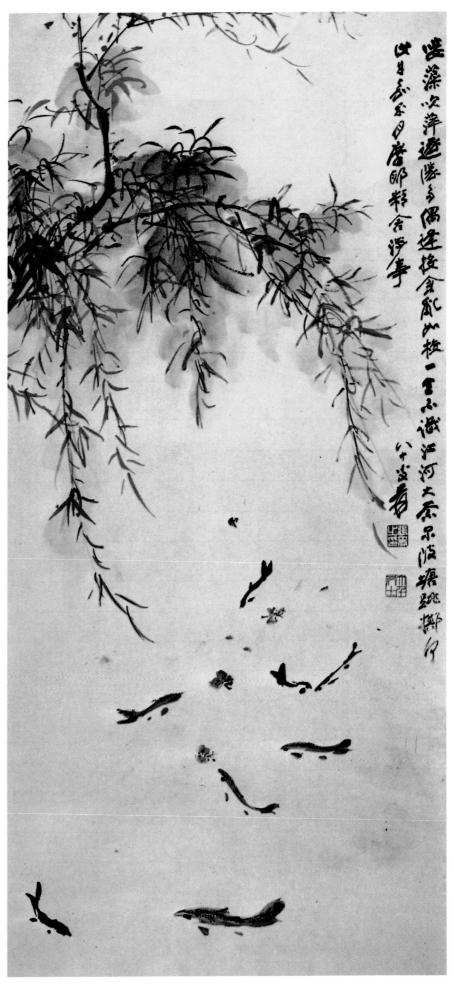

117　春水游魚　Fish in Spring Water

OF FISH

The secret of painting fish lies in the painter's ability to express the fishy gladness and freedom of motion in water. If the fish should appear to be out of water, so to speak, that would be tantamount to divorcing it from its natural instinct. The test of the painter's finesse is in the art of showing aquatic presence in the feeling and attitude of the fish, without having to delineate water.

Among the ancients, Yuan Yi of the Five Dynasties and Liu Ts'ai and Fan An-jen of the Sung Dynasty art famed for their skill in fish-painting. Their works, all in the elaborate style, are of a high artistic attainment and are technically impeccable. But the one I adore most is Pa Ta Shan Jen whose superb technique enables him to give full expression to fish by means of very simple composition and brush-work, and to reach the ideal

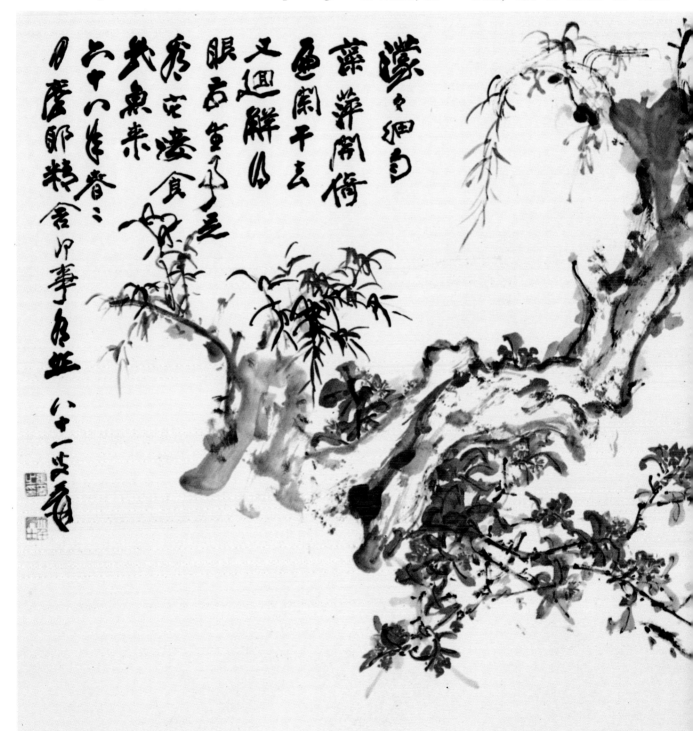

118　清池游魚　Fish in Clear Pond

state of being at one with his subject. Such artistic perfection as his must have passed through innumerable hours of observation and meditation before he could transform his technique from the complex to the simple without impairing its full capacity for expression. Let us examine the mouth, eyes, gills, dorsal fins, back, paddle fins, tail and abdomen of the fish he has painted. Is there any of these that does not reflect the subtle ingenuity of the painter? The various species of fish are different, each having its own particular manner and attitude in motion. Yet, whatever Pa Ta Shan Jen may paint, he has never failed to present it at its best. Let us always sit at the feet of Gamaliel, not by copying his work but by emulating his devotion to art. Should we merely imitate his style and technique, we would become, at best, slaves of the master.

In a fish picture, sometimes it is necessary to enliven the beauty of its composition and break its monotony with rocks and plants which, however, should be painted in ink monotone, instead of colour, in order to achieve the effect of plain refinement.

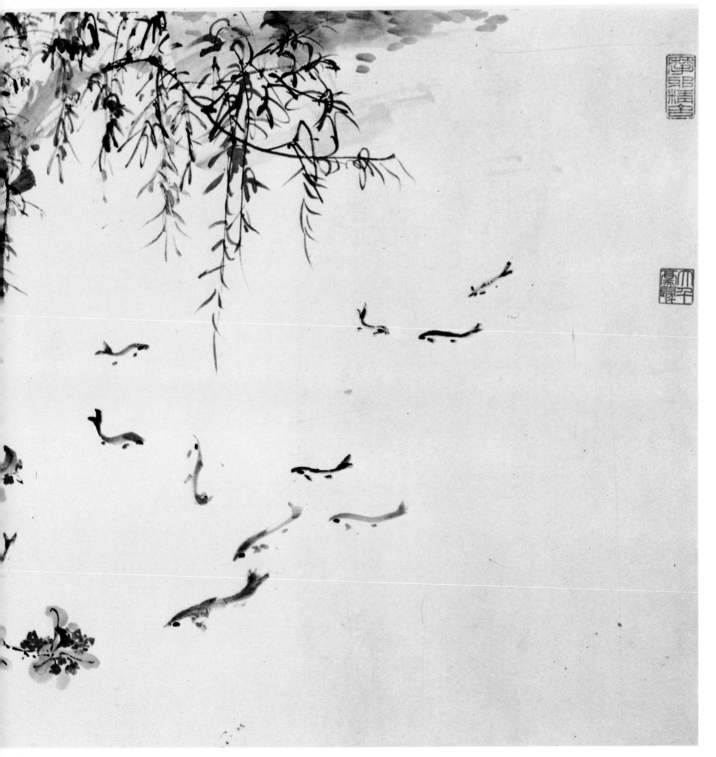

動物

畫動物，必須要懂得生理的解剖，然後纔觀察牠的皮毛筋肉。不懂得解剖，畫起來就會錯誤百出了。了解解剖，就再去寫生，這是第一要義。若不寫生，但憑師授或祇是臨摹那是很難成功的。開元時韓幹畫馬，明皇叫他以陳閎做老師，幹不接受詔旨，奏道：天閑萬馬纔是臣的老師。這便是說明他要實地觀察寫生的意思，北宋的易元吉以畫花竹禽獸著稱，尤其擅長畫獐猿，不特自己養有珍禽異獸，而且不畏艱險隱身林莽觀察鳥獸動態，得牠的自然。

先仲兄善子，他愛虎因而豢虎畫虎。他平生養過兩個老虎，一個是在四川，時間養得比較長久，後來因為牛肉不易買，老虎又不吃素，不得已飼以豬肉，養到三年多那個老虎就生痰死了；寓居蘇州網師園的時候所養的一個，是抗戰時在山西殉職的郝夢麟司令所贈，那虎兒才生出來六個月，先兄愛到極點，勝過於愛他的兒子，不加鎖鍊，不關於籠子裡，馴服過于貓犬，先兄天天和牠盤旋，觀其一切動態，心領神會，所以寫來沒有不出神入妙的。先兄在美國時羅斯福總統在白宮專筵招待他，先兄卽席揮毫寫了二十八隻老虎題「中國怒吼了。」把所有在旁看畫的人，都看得呆了。所以我舉出韓幹、易元吉、先兄三位來就是證明寫生，是最重要的。

我愛畫馬、畫猿、畫犬，因之也愛養馬養猿養犬，現在我投荒南美，犬馬的喜好不能敷再有，但還養了猿子十幾頭啊！

鳥獸有些是不宜入畫的，如豺狼鴟梟這些東西，容易啟發人的不良觀感，猿猴同稱，但猴的舉動輕率，面型醜惡。

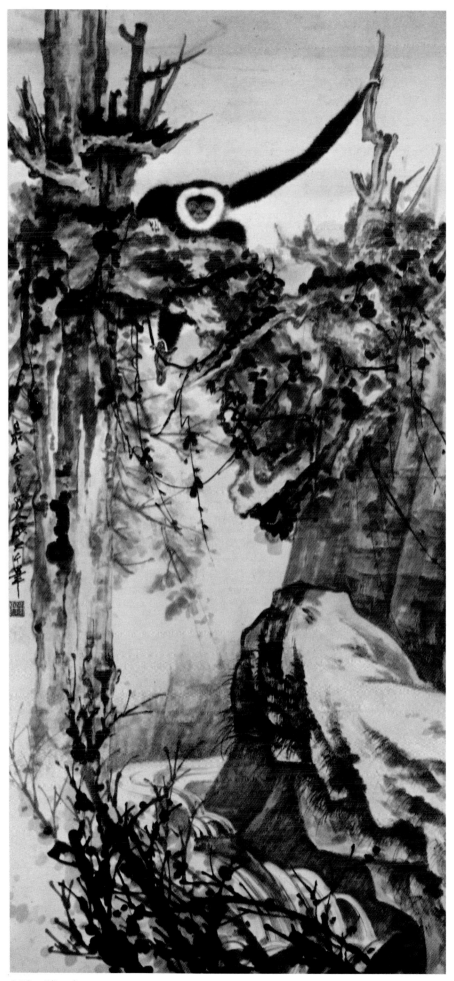

119　猿　Ape

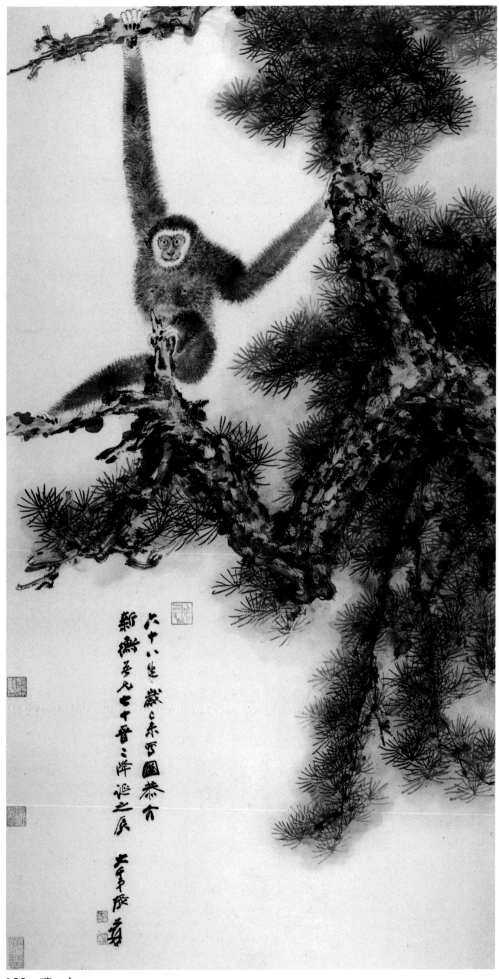

120 猿 Ape

OF ANIMALS

To portray animals, the painter should be conversant with their anatomy and bone structure before studying their skin, hair, sinews and flesh. As ignorance of the physical framework of animals may lead him into hundreds of errors and absurdities, his first prerequisite is to acquire a working knowledge of anatomy before starting to paint from life. Should he dispense with life study and rely entirely upon tutorial instructions or copying old masters, it would be impossible for him to succeed. During the reign of K'ai Yuan, Emperor Hsuan Tsung of the T'ang Dynasty once commanded the renowned horse painter Han Kan to study under the tutorship of Ch'en Hung. Making bold to differ, Han pleaded, "The myriad horses in the Imperial Stud, and they only, are your servant's masters." In other words, he preferred to paint from actual observation. Yi Yuan-chi of the Northern Sung Dynasty was noted for his painting of flowers, bamboos, birds and animals, particularly the roes and gibbons. He not only kept many rare species of birds and animals in his garden but often ran the risks of hiding in the woods and bushes to study at firsthand, the behavior of birds and animals in their natural state.

My late elder brother Chang Shan-tzu was so fond of tigers that he used to keep one as a model for his painting. In his lifetime, he had two pet tigers. The one in Szechuan lived longer but in its fourth year there was a shortage of beef and it had to be fed on pork. As a result, it soon developed a bronchial disease that caused its death. The other tiger, which he kept when residing at the Wang Ssu Garden of Soochow,

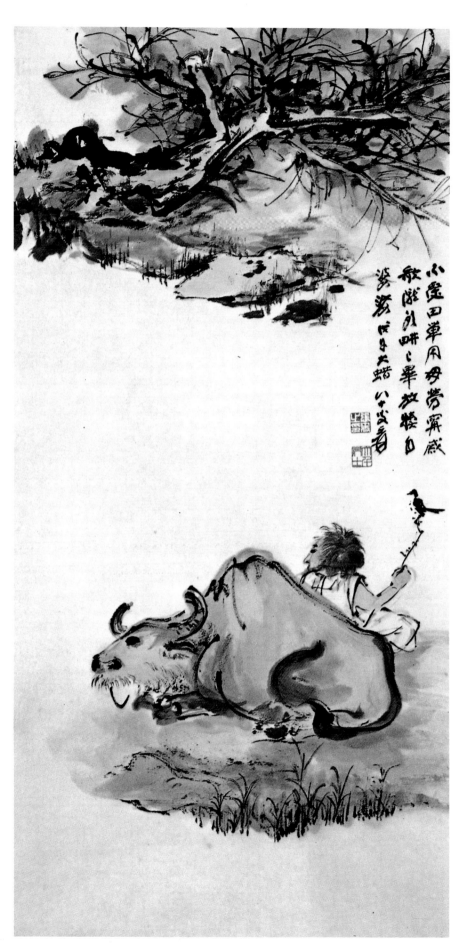

121　放犢　Herding

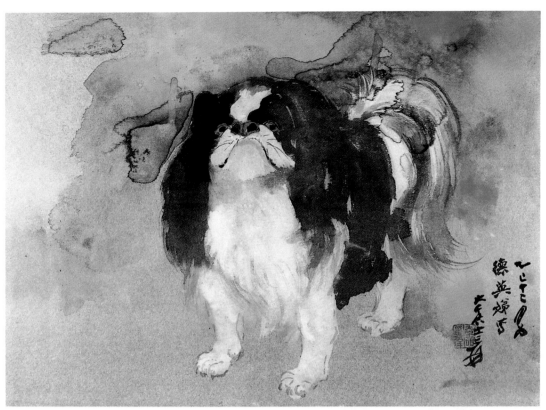

122 哈巴狗 Pekingese Dog

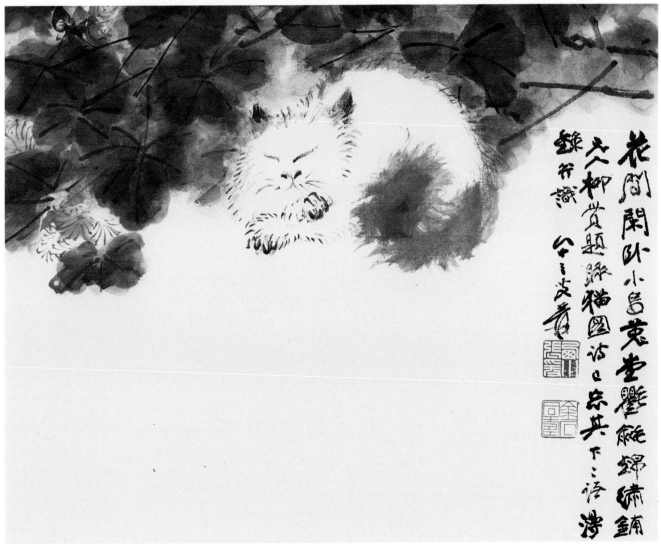

123 貓 cat

was a gift from General Ho Meng-ling who was subsequently killed in action in Shansi during the Sino-Japanese War. It was only six months old when it first came. Loving it better than his own children, my brother never kept it in chains or in a cage because it was just as tame and affectionate as cats and dogs. He played with it every-day to study its every movement and attitude till he had acquired such a deep insight into its whole nature that in whichever way he might paint it, he never failed to attain subtle perfection. While in America, at a banquet given by President Franklin D. Roosevelt, he painted twenty-eight tigers extempore and entitled the scroll "Roar, China!" to the amazement of all those present. I cite Han Kan, Yi Yuan-chi and my late brother as examples because they bear testimony to the supreme importance of life study.

I have a passion for painting horses, gibbons and dogs and so I also like to keep them. Now that I am in exile in South America, I am no longer in a position to satisfy my passion for breeding horses and dogs; however, I still have more than a dozen gibbons with me.

Some birds and animals, such as wolves, owls and the like, are not appropriate subjects for painting because they tend to inspire aversion in the viewer. Gibbons and monkeys are kin but the latter have never been a favourite of the painters by reason of their frivolity and ungainly appearance.

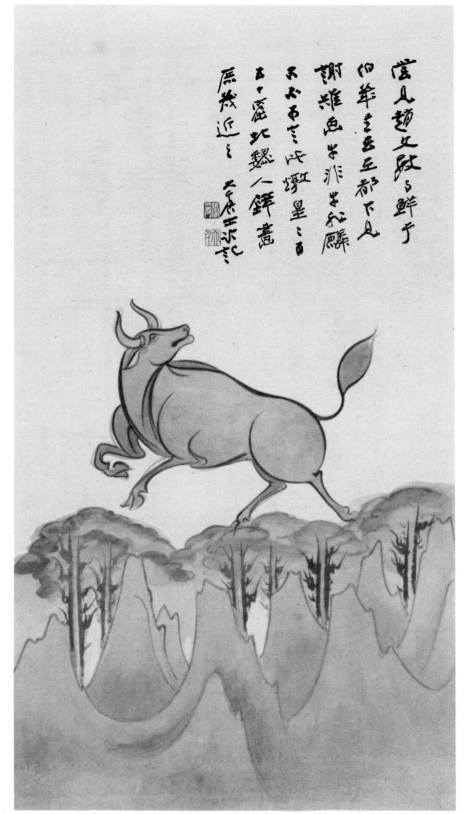

124　牛　Bull

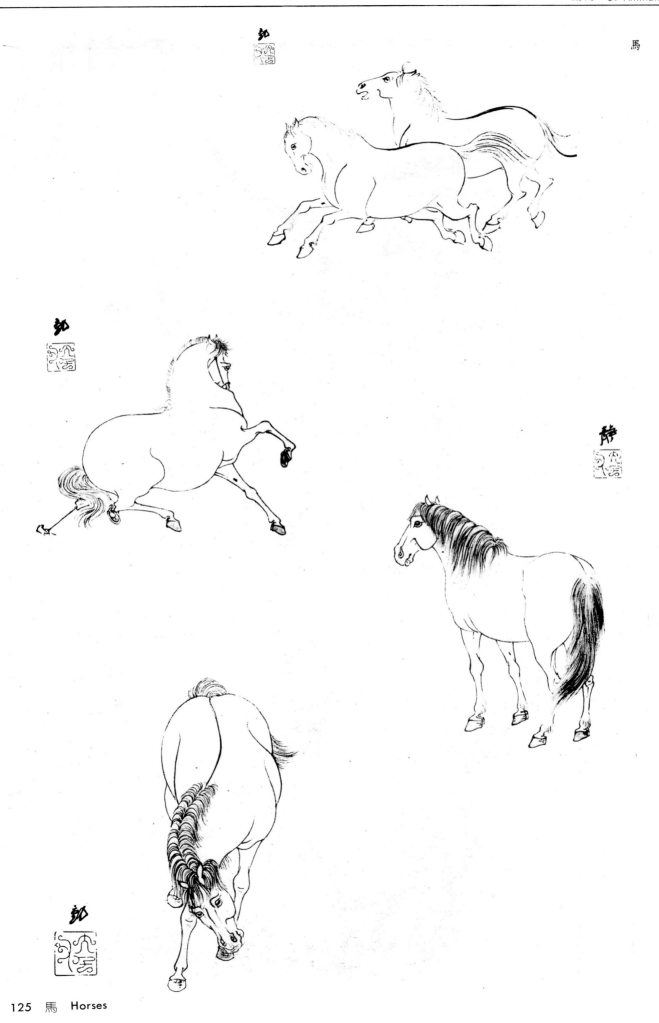

馬

125 馬 Horses

人物

　　畫人物，別爲釋道、先賢、宮闈、隱逸、仕女、嬰兒，這些部門，工筆寫意都可以。畫人物先要了解一些相人術，不論中西人概都是以習慣相法來判別人的賢愚與善惡。譬如戲劇裡，凡飾奸佞賊盜的角色，祗要一出場，略一舉動，不用說明，觀衆就可以看出他不是善類。那麼能瞉了解相人術，畫起來豈不更容易嗎？譬如畫古聖、先賢、天神，畫成了一種寒酸和醜怪的樣子，畫高人、逸士、貞烈、淑媛，畫成一副儅野和淫蕩的面孔，或者將一個長壽的人畫成短命相，豈不是滑稽？所以我一再說：能懂得一些相人術，多少有一些依據，就不會太離譜了。如果要畫屈原和文天祥，在他們相貌上，應該表現氣節與正義，但決不可因他是大夫和丞相，畫成富貴中人的相貌。這是拿視覺引動人到思想，也便是古人所講的骨法了。

　　畫人物最重要的是精神。形態是指整個身體，精神是內心的表露。在中國傳統人物的畫法上，要將感情在臉上含蓄的現出，纔令人看了生內心的共鳴，這個當然是很不容易。然而下過死工夫，自然是會成功的。杜工部說：語不驚人死不休。學畫也要這樣苦練才對。畫時無論任何部份，須先用淡墨勾成輪廓，若工筆則先須用柳炭打之，由面部起先畫鼻頭，次畫人中，再次畫口唇，再次畫兩眼，再次畫面型的輪廓，再次畫兩耳，畫鬢髮等。待全體完成以後，始畫鬚眉，鬚眉宜疏淡不宜濃密，所有淡墨線條上最後加一道焦墨。運筆要有轉折虛實才可表現出陰陽凹凸。有時淡墨線條

不十分準確，待焦墨線條改正。若是工筆着色，一樣的用淡墨打底，然後用淡赭石烘托面部，再用深赭石在淡墨上勾線，衣褶如果用重色，石青石綠那就用花青勾頭一道，深花青勾第二道，硃砂用岱赭或胭脂勾它。不論臉及衣褶的線條都要明顯，不可含糊沒有交代。巾幘用墨或石青，鞋頭用硃砂或石青或水墨都可以，看他的身份斟酌來用。畫人身的比例，有一個傳統的方法，所謂行七坐五盤三半，就是說站起的人除了頭部之外，身裁之長恰恰等於本人七個頭，新時代的標準美人，八頭身高比例之說，那知我們中國早已發明若干年了。

　　記得少年時讀西廂記，有金聖嘆引用的一段故事，眞是畫人物的度人金針，鈔在下面：「昔有二人於玄元皇帝殿中，賭畫東西兩壁，相戒互不許竊窺：至幾日，各畫最前幡幢畢，則易而一視，又至幾日，又畫寅周旄鉞

畢，又易而一視之，又至幾日，又畫近身纓笏畢，又易而一視之，又至幾日，又畫陪輩諸天畢，又易而共視，西人忽向東壁啞然一笑，東人殊不計也，迨明並畫天尊已畢，又易而共視而後，西人投筆大哭，拜不敢起。蓋東壁所畫最前人物便作西壁中間人物，中間人物，却作近身人物，近身人物竟作陪輩人物，西人計之，彼今不得不將天尊人物作陪輩人物矣，以後又將何等人物作天尊人物耶？謂其必至技窮，故不覺失笑！却不謂東人胸中，乃別自有其日角、月表、龍章、鳳姿、超於塵埃之外，煌煌然一天尊，於是便自後至前，一路人物盡高一層。」倘能細細領略這段文章，我想要畫人天諸相當不至於太難吧！畫西壁的那一位，雖然是遜畫東壁的人一籌，他還肯自己認輸，也不失眞藝人的風度。最怕是祗知別人眼中有刺，不知道自己眼中有一段梁木啊。

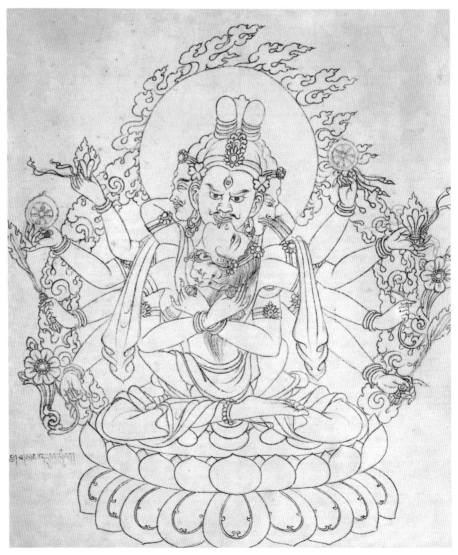

126　密積金剛　A Buddhist Deity

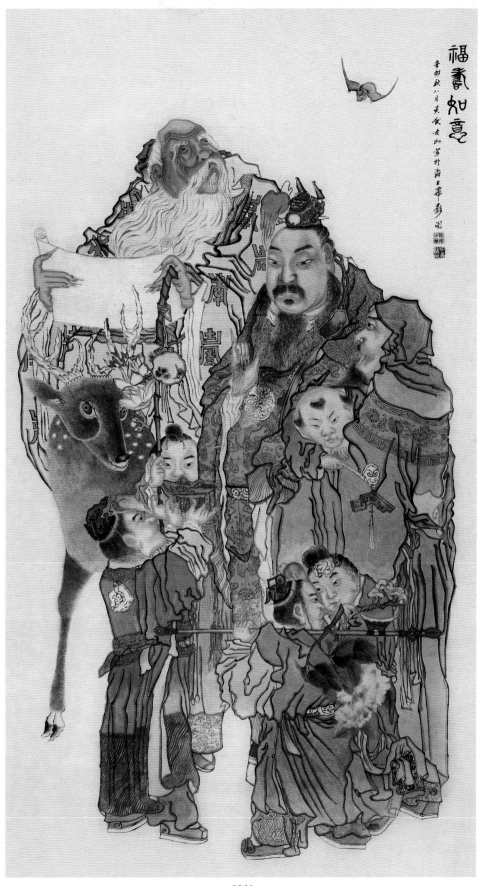

福壽如意

辛卯秋八月吳猷友如寫於海上飛影閣

友如(?－1894年)　福壽如意
紙本　立軸
福壽如意。辛卯(1891年)秋
八月，吳猷友如寫於海上飛
影閣。
友如手筆(朱)、臣吳猷印(白)
Youru(? -1894)
ging scroll, ink and color on paper
× 94 cm　66 1/8 × 37 in
B: 15,000 — 20,000

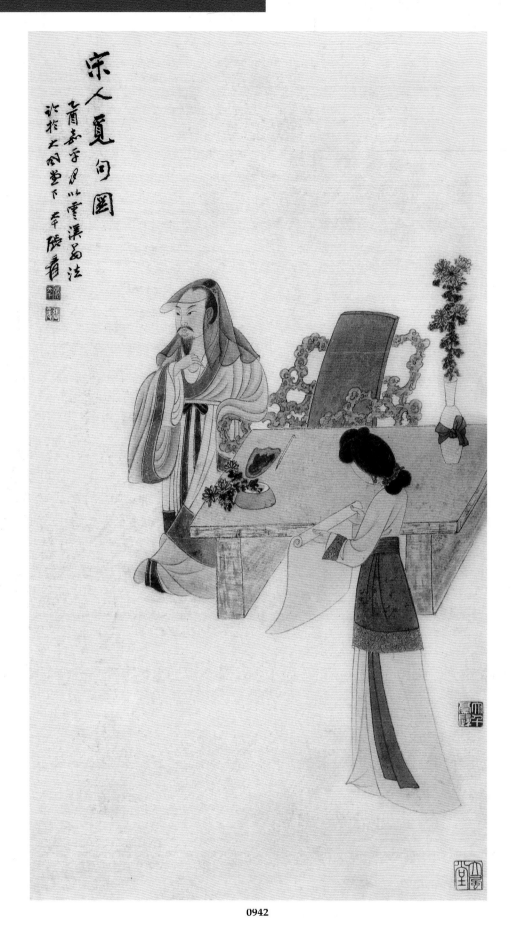

0942

書法 ✗

○三點水第三筆不應
應為大筆上挑之

0942 ✗仿品

張大千(1899-1983年)　宋人覓

設色紙本　立軸

題識：宋人覓句圖，乙酉(1945年
　　　月，以雲溪翁法，記於大
　　　下，大千張爰。

鈐印：張大千(白)、張爰(白)、大
　　　髮(白)、大風堂(朱)

Zhang Daqian(1899-1983)

Hanging scroll, ink and color on pa
92×50 cm　36×19 $^5/_8$ in

RMB: 15,000 — 25,000

○書法✗「法」字尤差，

○畫亦差：生硬

凸

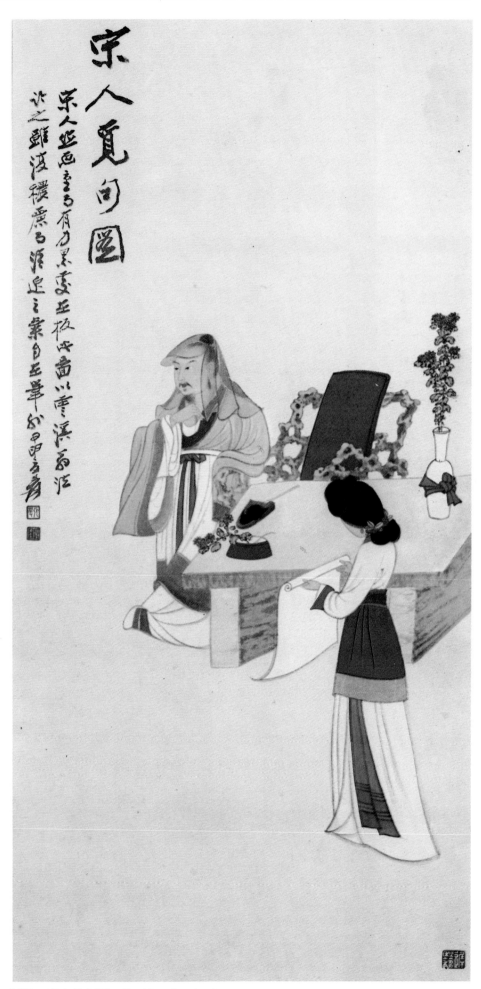

127 宋人覓句圖 Seeking Inspiration

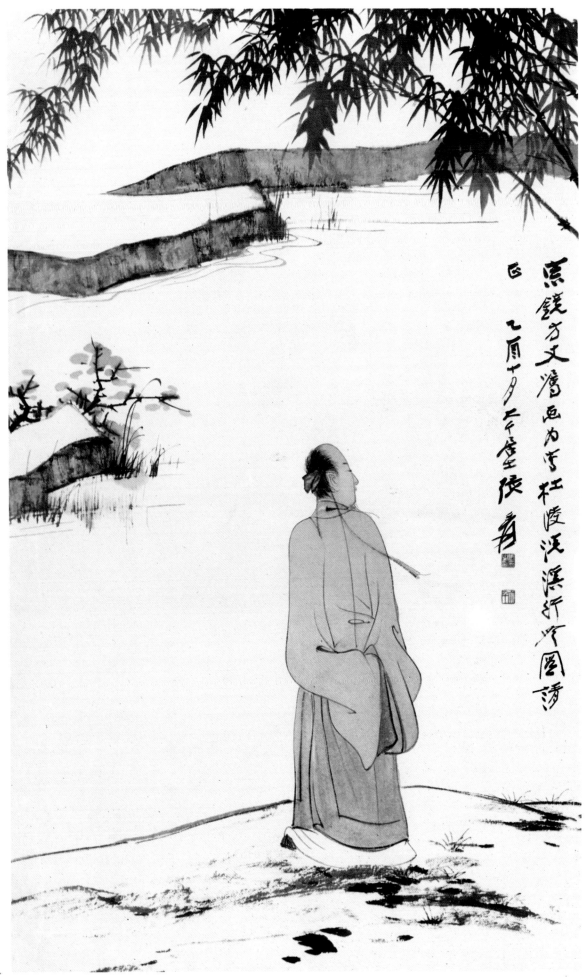

128　浣溪行吟圖　Chanting Along the Stream

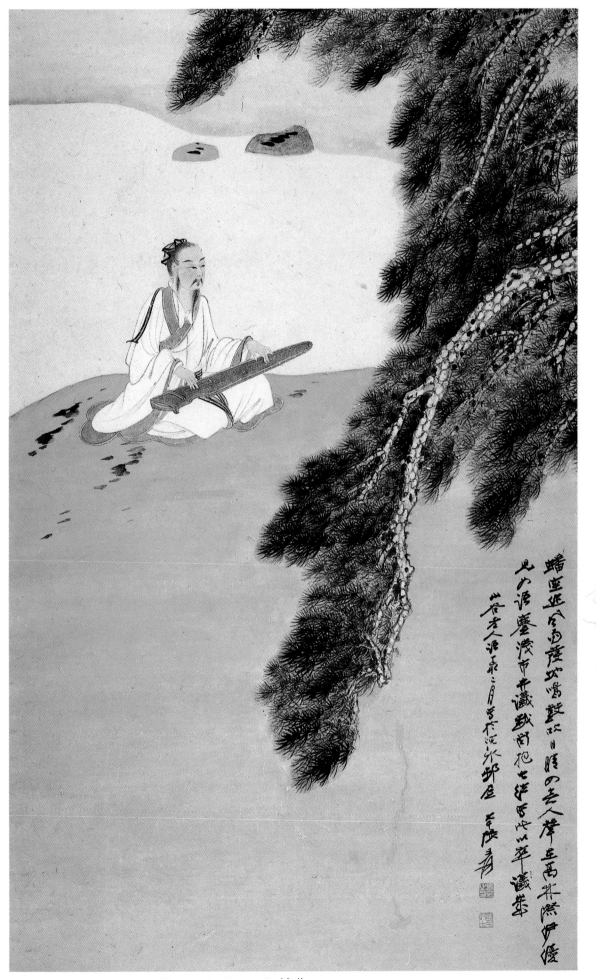

129　山老人彈琴　Zithen Playing in Mountain Valley

OF HUMAN FIGURES

Human figures are generally divided into six categories: (1) Buddhists and Taoists, (2) historical personages, (3) court and palace characters, (4) recluses, (5) classical ladies and (6) children. All these categories may be painted either in the elaborate style or in the impressionistic. The figure painter should first have a general knowledge of physiognomy which is commonly regarded in China, as well as in the West, as a criterion for judging whether a man is virtuous, imbecile, good or bad. On the stage, for instance, as soon as a villain enters, the audience can tell from his very first movement, without any explanation, that he is not a good sort. Should one be conversant with physiognomy, it would be much easier for one to portray characters. Suppose a painter gives a pauper-like or monstrous appearance to an ancient sage or a god, a venal or boorish look to a high-minded hermit, a lewd face to a virtuous woman or a noble young lady, or ephemeral features to an octogenarian, it would be ridiculous, would it not? I have repeatedly stressed the knowledge of physiognomy because its basic principles may enable the painter to characterize his subject without being too far removed from the accepted standard. For instance, while painting a picture of the patriots Ch'u Yuan and Wen T'ien-hsiang, he should bestow upon their features the expression of sterling integrity and righteousness, instead of the air of temporal pomposity, merely because the former was a minister and the latter a premier. That is the art of giving the desired impression by means of presenting an appropriate visual aspect, or what the ancients call "the

technique of bone structure".

In portraits, the most important thing is the spirit. Whereas form and attitude indicate the body, the spirit reveals the inner self. According to the traditional technique of Chinese portrait painting, the registering of emotion on the face should be subtle and reserved so that it may inspire sympathy in the heart of the beholder. That, of course, is not easy but, given painstaking efforts, it is not altogether unattainable. The great T'ang Dynasty poet Tu Fu says of his own poetry.

If words of mine surprise one not,
I'll try till death and try again.

The painter should exert himself just as assiduously.

Whichever part of human figure one may paint, one should start by defining its contour with diluted ink or, if the painting is to be in the elaborate style, with willow charcoal. The usual order of painting is as follows: (1) nose, (2) the raphe of the upper lip, (3) mouth and lips, (4) eyes, (5) outline of the face, (6) ears, hair, etc. Beards and eye-brows are to be painted after the whole body is completed. They should be trim, even-spaced and light, instead of being too dense. Over all linear strokes in pale ink, a final charred-ink line should be made.

The brush should be manipulated with appropriate twists and turns and with both direct and indirect approaches, so as to show light and shade or convexity and concavity. In case a pale-ink line happens to be inaccurate, it may be corrected with a properly executed line in heavy ink. In colour portraiture in the elaborate style, the painter should build up the

contour with light ink washes, next apply to the face pale ochre shadings, then draw deep ochre lines on the pale ink ground. In case the folds of the robe are to be defined with deep colour, they should be outlined first with indigo and again with deep indigo, if azurite or malachite is to be used. If the fold lines are to be in vermilion, they should be drawn with ochre or saf-flower red. The lines, whether on the face or the folds, must be clear-cut, instead of being vague and pointless. The headgears are usually in black ink or azurite; the crest on the head of shoes in vermilion, azurite or ink, depending on the wearer's station in life. The traditional formula for determining the proportions of human figure is contained in the maxim, "Seven for walking, five for sitting and three and one-half for folded legs." That is to say, in case of a walking figure, the ratio between the head and body is 1:7, and so on. It is interesting to note that this formula coincides with the modern standard of the head being one-eighth of the total length of the human body.

I still recall that in *The Romance of the Western Chamber,* which I read in my youth, there is an anecdote cited by the commentator Chin Sheng-t'an that may open the eyes of human figure painters. Hereunder is the story: —

"Once there were two painters who entered into a competition by painting murals on the walls in the main hall of a Taoist temple of the Celestial Emperor. It was agreed that the one should paint the eastern wall and the other the western wall and that they would not spy on

each other's work. Several days later, when the banner and canopy bearers in the van of the heavenly retinue had been finished, they inspected each other's drawings for the first time. The reciprocation was repeated at the interval of every few days, upon the completion of the wielders of yak-tail staves and axes, the wearers of tassels and tablets near the Divine Presence, and the seraphs in attendance alongside the sacred chariot. On the last occasion, the painter of the western wall looked at the eastern wall with a sneer but his rival was quite unperturbed. Next morning, when they had both finished painting the Celestial Sovereign, they again viewed each other's mural. Whereupon the western wall painter threw away his brush, burst into a loud wail and humbly kowtowed to his competitor, being too diffident to get up. The truth is: in the mural on the eastern wall the bearing of the figures in the forefront was equivalent to that of those in the middle of the procession on the western wall, that of the mid-ranking ones to that of the western tassel-and-tablet wearers, and that of the high-ranking ones to that of the western seraphs. By deduction, the western artist knew that his rival would have no choice but to assign the divine carriage of the Celestial Emperor to the seraphs. He was at a loss to see with what loftier deportment his contender could provide the Supreme Ruler, since apparently he was already at the end of his tether. That was why he could not help laughing aloud. He did not then realize that the eastern artist had conceived an almighty god with the majestic splendour of the

sun on His forehead, the serenity of the moon in His eyes, together with the dignity of the dragon and the stateliness of the phoenix — far above and out of the world. [When the mural was completed], the picture of the Supreme One on the eastern wall shone with such a breathtaking glory that His entourage appeared to be on a higher level than its counterpart on the western wall."
If one should ponder over

this anecdote, I think it would not be too difficult for him to paint the different walks of life on earth or in the kingdom above. The painter of the mural on the western wall, though having to yield the precedence to his rival, still showed a readiness to admit defeat with a good grace, in keeping with the ways of a true artist. It would be frightful, if he could only see the mote in the other's eyes without seeing the beam in his own.

130　松石老子圖　The Aged

131　撥阮圖　Flying Notes

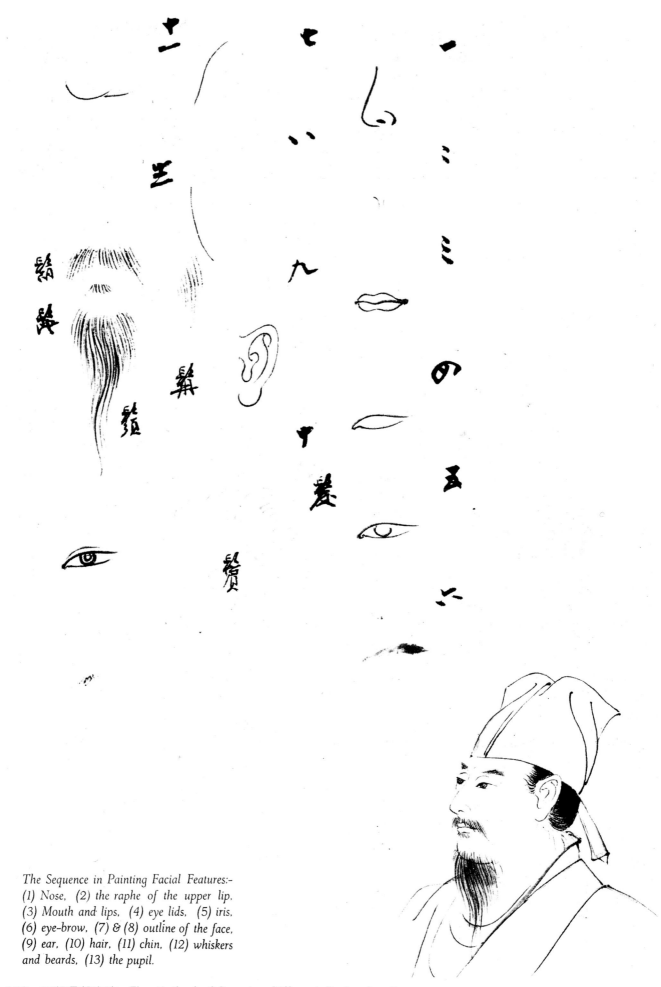

The Sequence in Painting Facial Features:-
(1) Nose, (2) the raphe of the upper lip,
(3) Mouth and lips, (4) eye lids, (5) iris,
(6) eye-brow, (7) & (8) outline of the face,
(9) ear, (10) hair, (11) chin, (12) whiskers
and beards, (13) the pupil.

132 面部各部畫法 **The Method of Drawing Different Parts of a Face**

133 五老圖 The Five Venerables

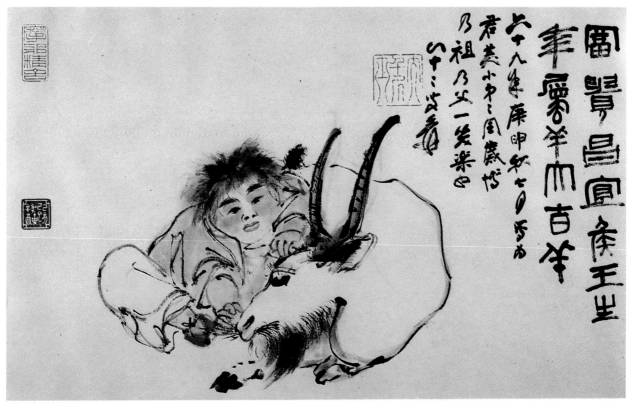

134 富貴吉祥 A Child and a Sheep

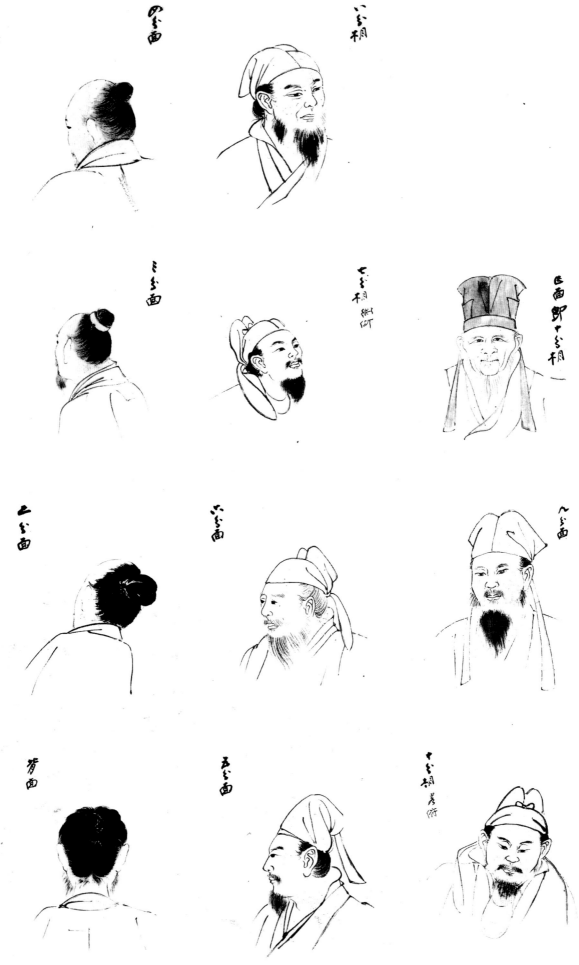

135 臉部畫法　Painting of Faces

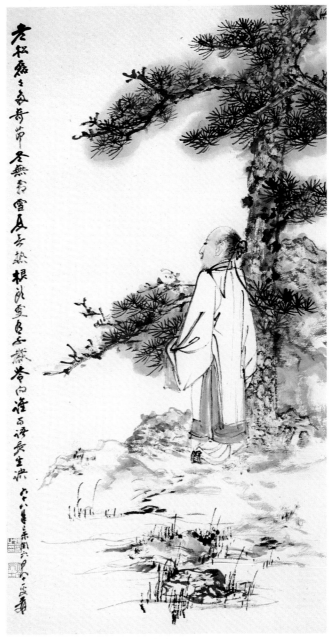

137　松下老人　The Aged by Pine

136　獨遊秋山　Lone Ranger

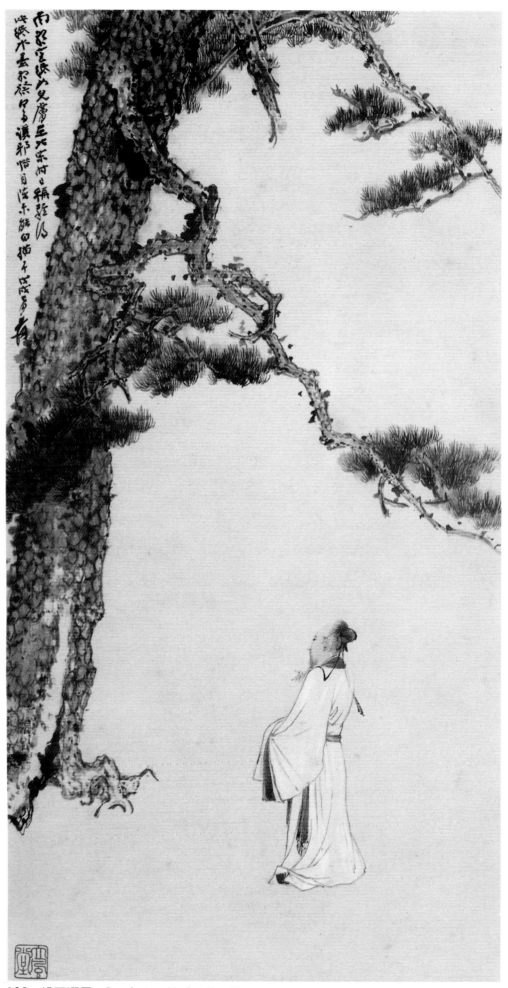

138 松下遲思　Pondering Under the Pine

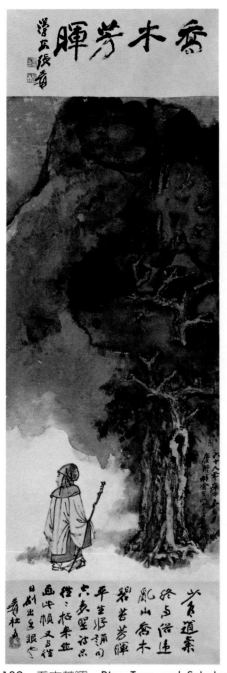

139　喬木芳暉　Pine Tree and Scholar

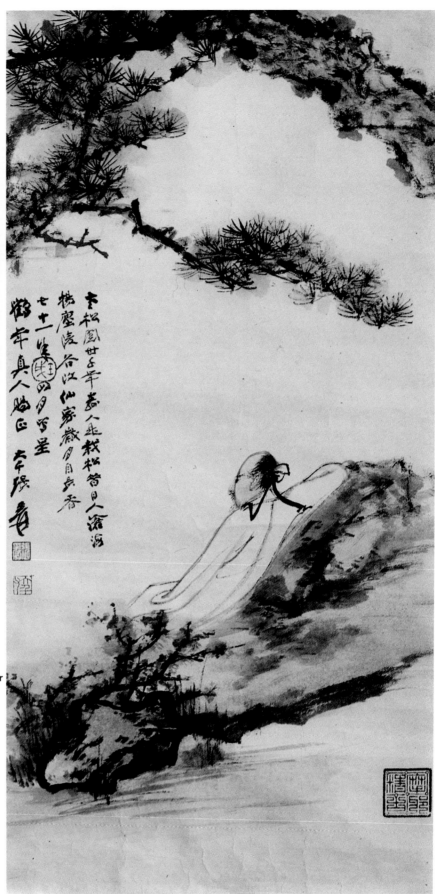

140　靜觀松　Appreciating the Pine

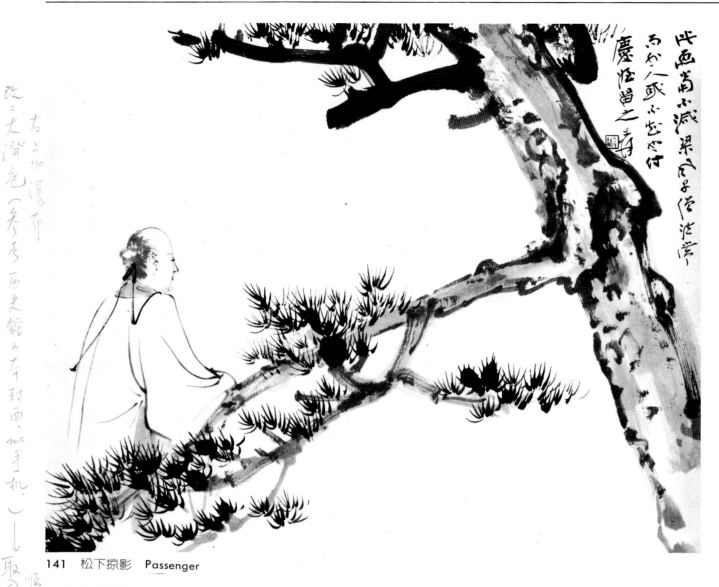

141 松下掠影　Passenger

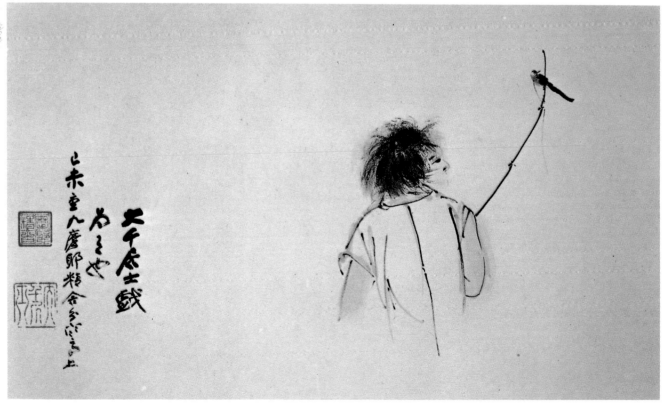

142 調禽圖　Bird Training

138

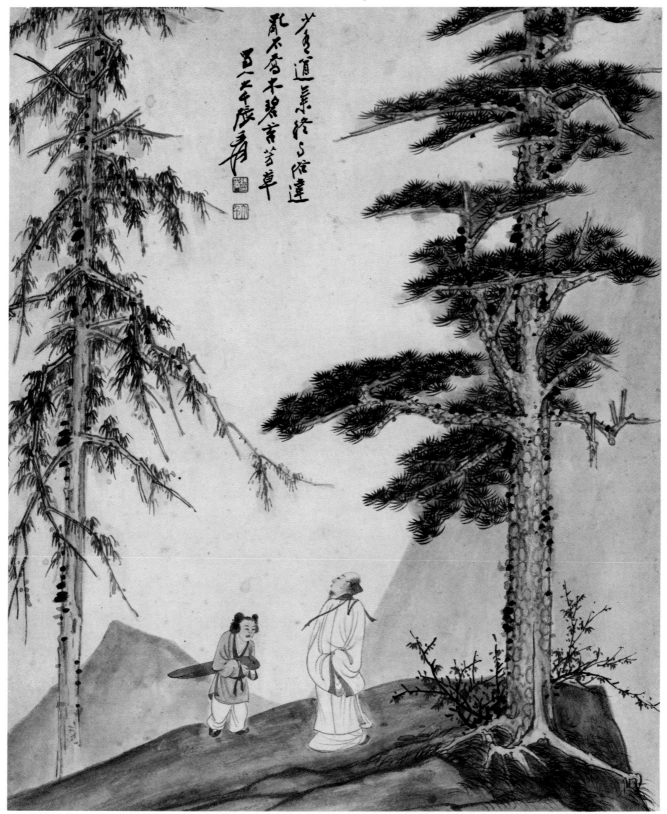

143 松下 Under the Pine

鬚髮

畫人物的鬚髮，畫得不好，好像是一團水泡的黑棉花，勉強黏在頭上。畫鬚髮唐宋人最爲擅長。方法是用濃墨細筆，依着面型方位，疏疏落落略撇十幾筆，然後再用淡墨渲染二三遍，顯得柔和而潤澤，有根根見肉的意思，自然清秀可愛。工筆仕女的頭髮，也和畫人物相同，但是不可用油烟所製的墨渲染，要用松烟墨渲染。先用極淡的逐次加濃，大約三次就可以了。松烟烏黑，油烟有光反覺不黑了。

畫佛像的頭髮，要用石青，這石青是三青，亦稱佛頭青，要二次或三次纔能填勻，後用花青重撇髮紋就可以了。

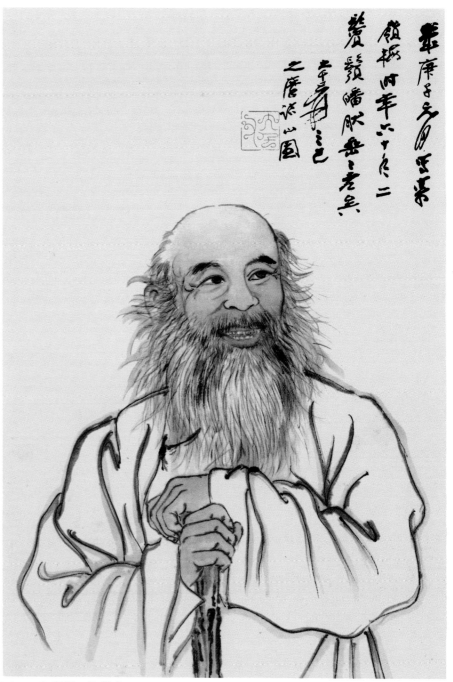

144　自畫像　Self Portrait

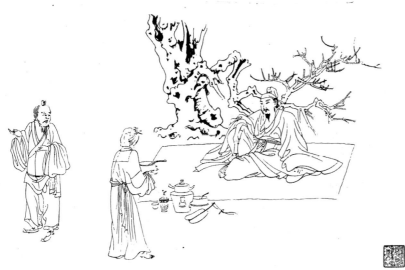

145　玉川評茶圖　Flavouring Tea

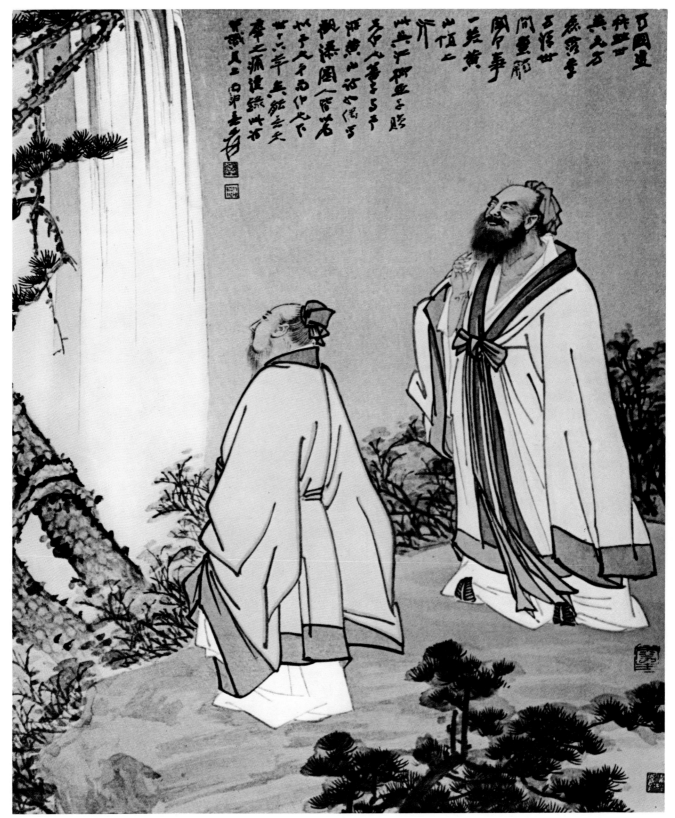

146　黃山觀瀑圖　Appreciating Huang-Shan Falls

OF HAIR AND BEARDS

The hair and beards, if not painted properly, may look like a cluster of water-soaked black cotton wool stuck to a reluctant head. The old masters of the T'ang and Sung Dynasties are most adept in the art of painting hair and beards. Their technique is to execute dozen odd fine strokes with a thin brush and condensed ink at suitable places, according to the shape of the face, then to wash them over with diluted ink two or three times. That gives the hair and beards a pliant and lustrous appearance, as though each individual one is traceable to its root, and naturally they look graceful and lovely.

The technique of painting the hair of classical ladies in the elaborate style is identical with that of painting human figures in the same manner. But the painter must use resin-soot ink, instead of that made of tung-oil soot. The first delineation is to be rendered with the ink of a very pale shade; the subsequent ones are to be progressively darker. It will suffice to repeat the brushwork three times. The resin-soot ink is jet black, whereas that made of tung-oil soot is less so, on account of its glossiness.

To paint the hair of Buddhist deities, it is necessary to use No. 3 azurite, which is also known as the Buddha-head Blue. The painter must do it with even-toned washes two or three times and then mark the traces of hair and beards with light indigo.

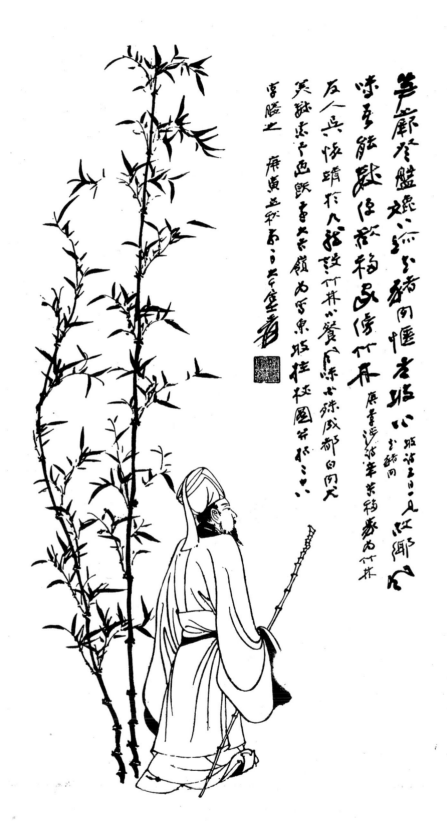

147 東坡柱杖圖 Tung Puo With Walking Stick

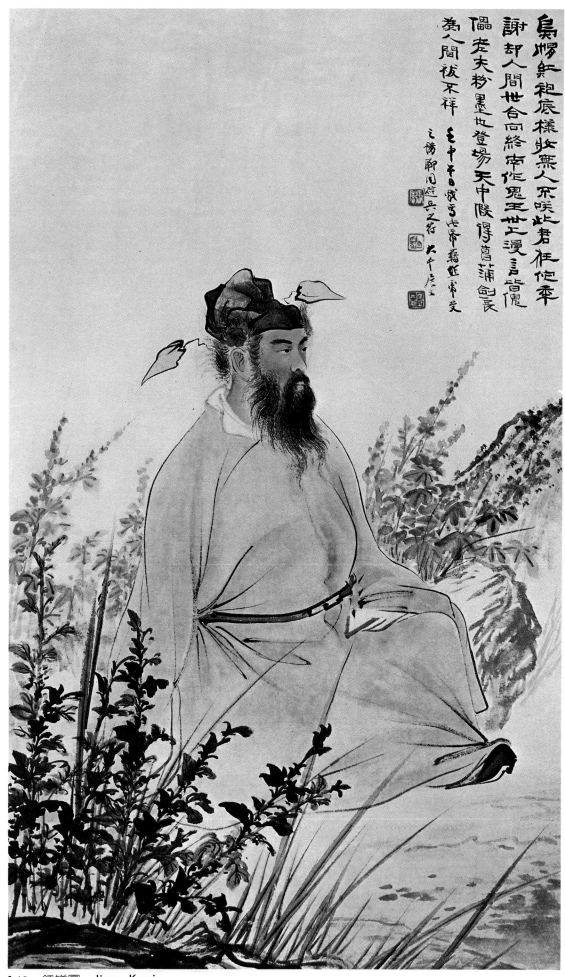

烏帽紅袍恣樣妝無人不咲此君狂但率
謝却人間世合同終南作鬼王世上漫言皆儂
儡老夫粉墨世登場天中隊得菖蒲劍長
爲人間祓不祥

壬申午日戲寫古來香攜狂肖受
三陽卿圖避兵之符　大千尼耄

148　鍾馗圖　Jiung Kweir

仕女

　　畫人物要打稿，畫仕女當然一樣的，更要加意的打稿。工筆仕女，尤不可潦草，一線之差則全面俱壞。打稿仍以柳炭扚之，等扚成以後，墨淡勾過，輕輕拂拭卽無柳炭痕跡。畫題有至難傳神的，必須反復揣摩，不嫌麻煩，三次五次的塗改，至無可議處方可落墨。仕女的容貌與服飾，要高華明麗，豐艷窈窕，各極其態。更要嫻靜娟好。有林下風度，遺世而獨立之姿，一涉輕蕩，便爲下乘。臉型五官，仍與畫其他人物一樣，先用淡墨勾線，勾準後再用淡硃砂烘托。眼眶鼻梁用赭石襯出凹凸，額鼻下顎以白粉暈它，古人稱爲三白臉。如用薄質的紙或絹，可於背後托粉更顯得厚潤些。最後用深赭重勾，點脣用硃砂，再用西洋紅分開。至於衣着，則看畫題而定富麗與清雅，衣披裙帶花紋，宜參考古人名作，如周昉簪花仕女，張萱明皇納涼圖，徽宗張萱搗練圖，或敦煌壁畫都是最好的資料。

　　重色須用礦物質的，是石青石綠硃砂等等，雄精石黃不可用，因爲這兩樣顏料久了會燒紙，祗要用藤黃和粉就行了。胭脂近世已絕，亦祗有以西洋紅代它了。白粉，古人用車碾粉，牡蠣粉（通稱珍珠粉），歷久不變。近世多用鉛粉，一遇鹽滷的氣立變爲黑，愼不可用。化學有鈦粉，永不變色，可以採用。

　　至於用配景宜梧、竹、梅、柳、芭蕉、湖石、荷塘、紅闌、綠茵，切不可用松、杉、槐、柏，等樹。古人題材有極堪揣摩的，如楊妃病齒、楊妃上馬、明皇貴妃並笛等圖，能試寫幾幅最見功力。至於背面皆極不容易施工，側面的輪廓由額至下頜凸不得、凹不得、踢不得、蹶不得、縮不得、豐不得、削不得，這些皆須十分着意意，背面那就要在腰背間着意傳她嬝娜的意態。

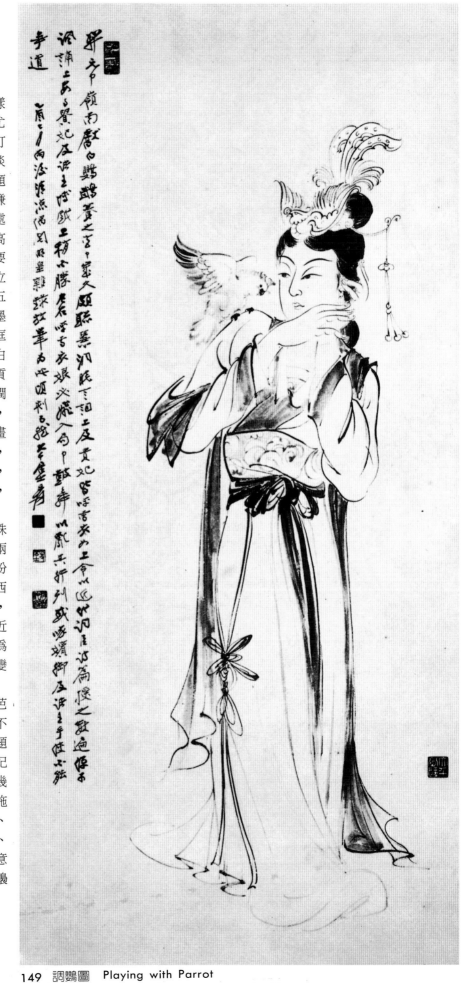

149　調鸚圖　Playing with Parrot

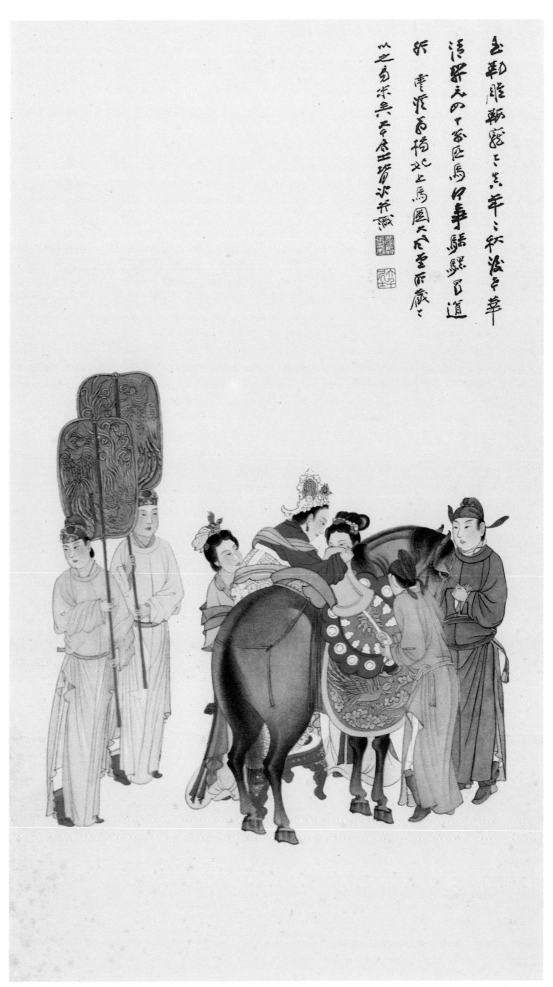

以之易米與友皆次井藏之
玉勒雕鞍寵一身年年秋後一萃
清渠元O〔…〕馬日毒驕驟呈道
環秦狂香楊妃上馬圖大尺重而藏之

150 楊妃上馬圖 Yang Fei Mounting a Horse

OF CLASSICAL LADIES

As it is imperative to make a draft when painting other human figures, so it is in the case of painting classical ladies. As a matter of fact, the draft should be made with greater care and, particularly in the elaborate style, should never be rough and offhand, for a little error in one single line may spoil the whole picture. When the willow-charcoal draft is completed and its outline marked out with diluted ink, the charcoal lines can be dusted off without leaving any trace at all.

Some boudoir themes are so difficult to interpret that the painter must exert his imagination over and over again and make no bones about striking out and correcting parts of his draft several times till it is unimpeachable, before using ink. The face of his subject, as well as the clothes and ornaments, may be either dignified, radiant, ravishing, or graceful, as the case may be. But each must be at its best and, above all, the subject should be quite and ladylike, with a retired demeanour and the attitude of one standing alone and away from the world. The slightest hint of frivolity or lechery would condemn the picture to the lower order.

The contour of the face and its features should be accurately outlined with pale ink, as in the case of painting other human figures, and be washed over with light vermilion. The eye-sockets and the slopes of the nose should be shaded with ochre to show their respective depression, while the forehead, the ridge of the nose and the chin should be high-lighted with flake white. That is what the ancients call *san pai lien,* or "the face with three white areas". If thin paper or silk is used, the painter may support those areas with a white backing to produce a smooth, three-dimensional effect. Finally, the lines should be touched up with deep ochre and the lips filled in with vermilion before being set apart with imported carmine.

As to the garments, the painter must decide whether they should be magnificent or elegant, according to the theme of his picture. For the decorative designs on the coat, cape, skirt and sashes, he must refer to the masterpieces of the old masters, such as *The Ladies Wearing Flowers* by Chou Fang, *Emperor Hsuan Tsung at a Summer Resort* by Chang Hsuan, a copy of Chang Hsuan's *The Silk Beaters* by Emperor Hui Tsung, or the murals in the Tun Huang Caves.

The mineral pigments commonly used for making heavy colours are the azurite, the malachite green, vermilion, etc. Orpiments, either transparent or otherwise, are not to be used because they will "scorch" the paper after due lapse of time. A better substitute is gamboge mixed with flake white. In recent ages, saf-flower red is no longer in production and the painter his no choice but to use imported carmine instead. For the white colour, the ancients preferred to use the powder of oyster or mussel shells, which could withstand the test of time without being discoloured. The flake white now in general use is objectionable because it will turn black when coming into contact with the vapour of salt and brine. In its place, the painter may adopt the powder of a titanium compound which

151 飛花天女 The Goddess of Dispensing Heavenly Petals

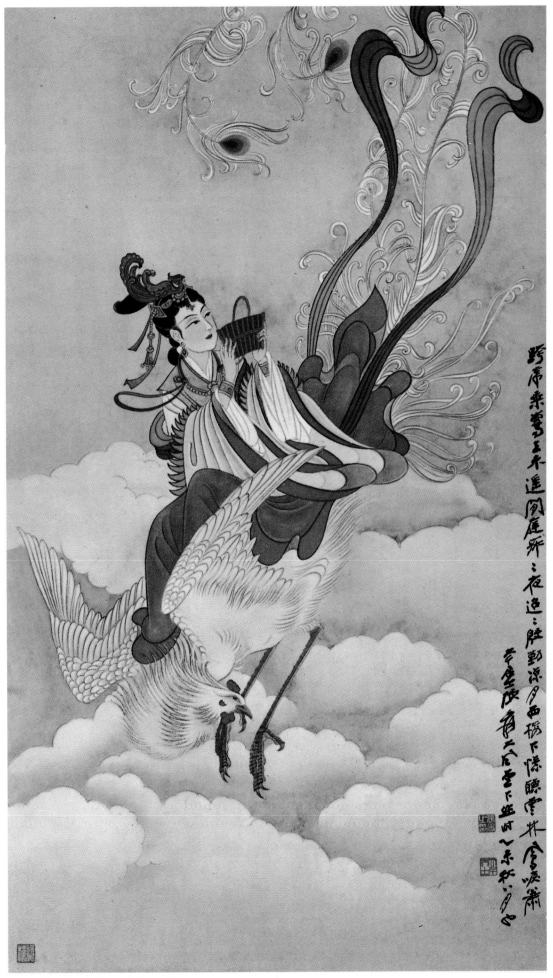

152　鳳簫圖　Playing Pan-Pipe

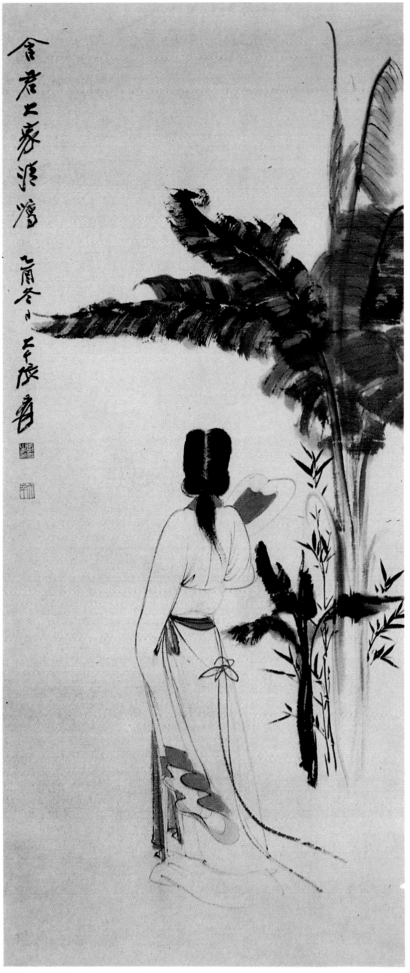

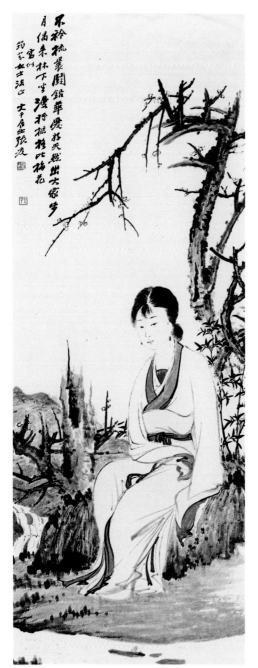

154　梅花仕女圖　Plum Blossoms and Beauty

153　芭蕉仕女　Lady by Palm

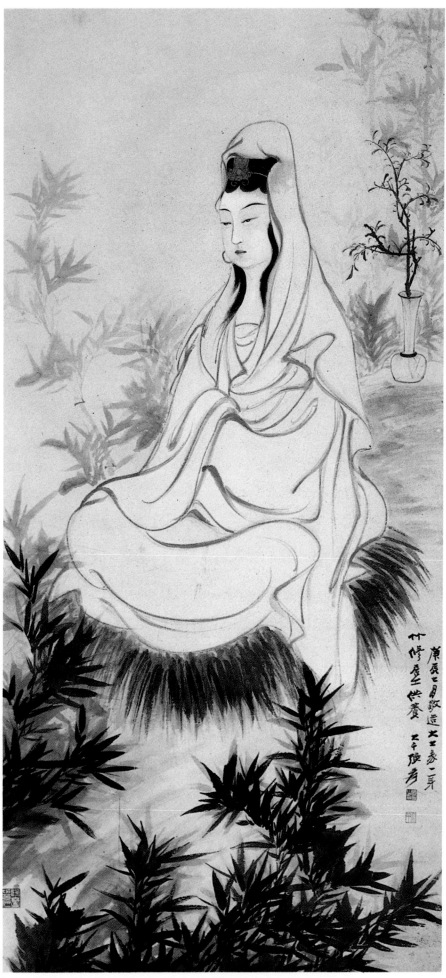

155　觀音　Feminine Form of Avalokitesvara Bodhisattva

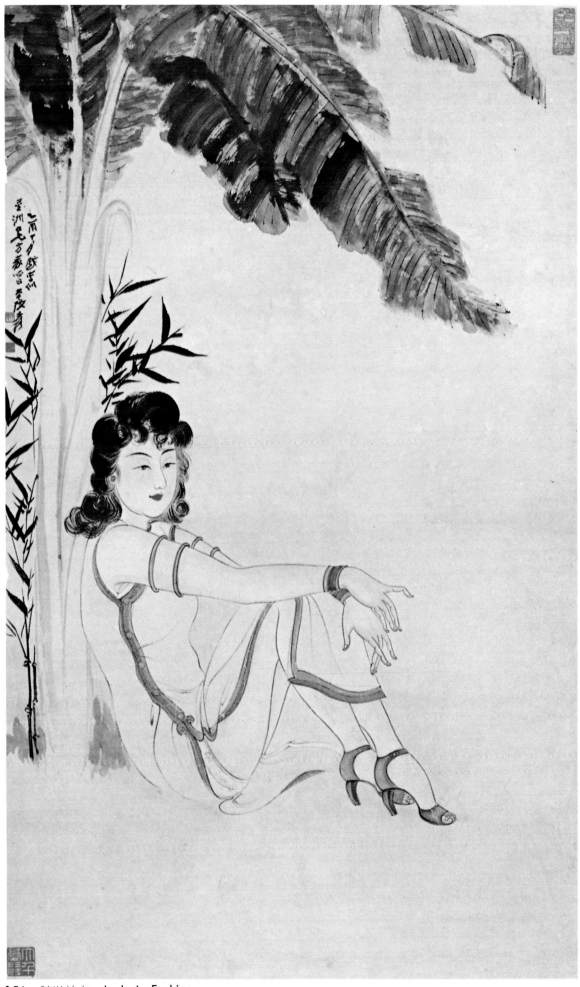

156 時裝仕女　Lady in Fashion

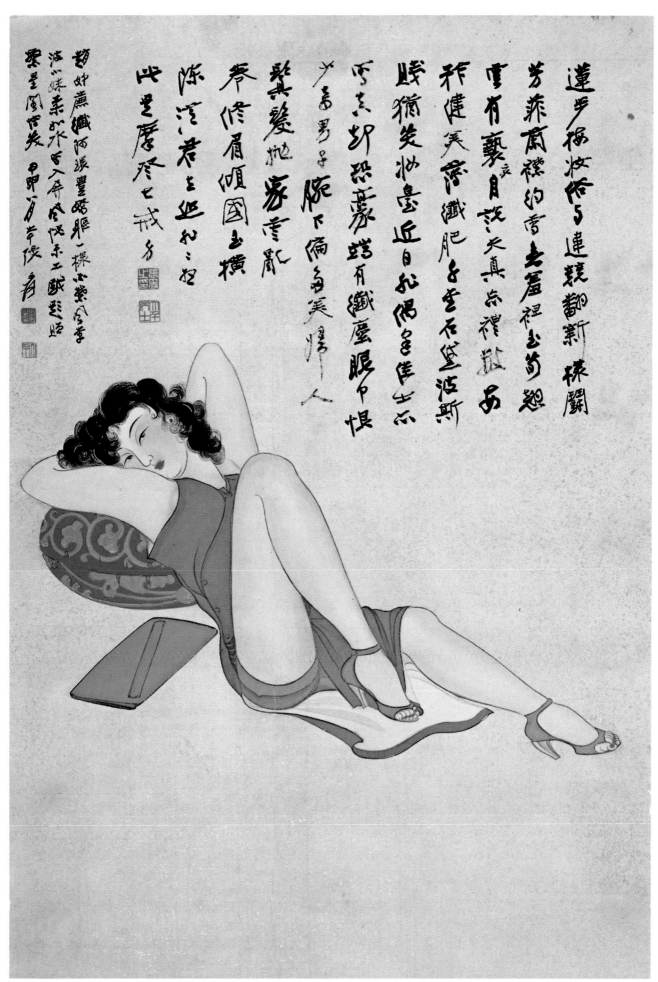

157　摩登仕女　Modern Lady

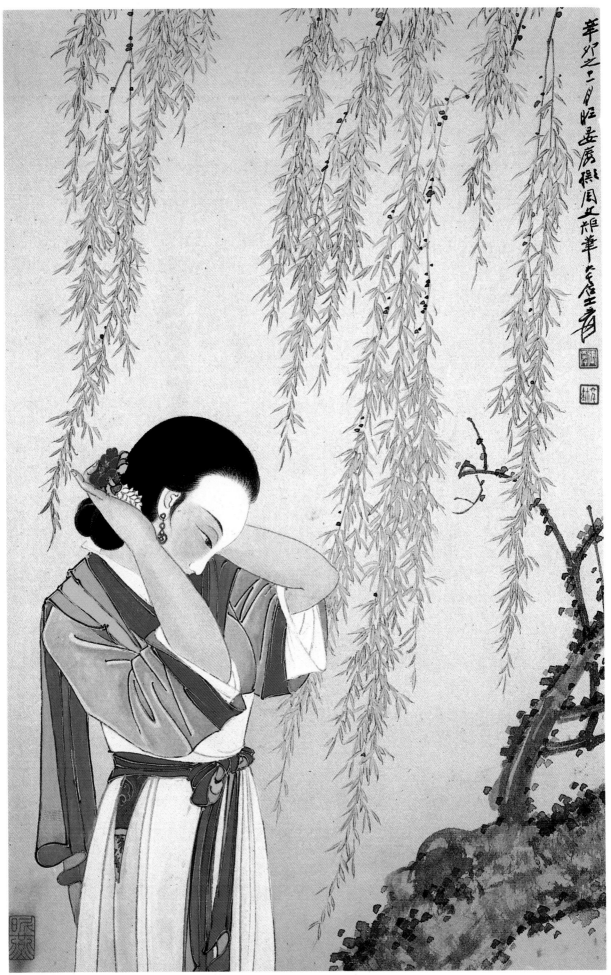

158 簪花圖　Pinning Flowers

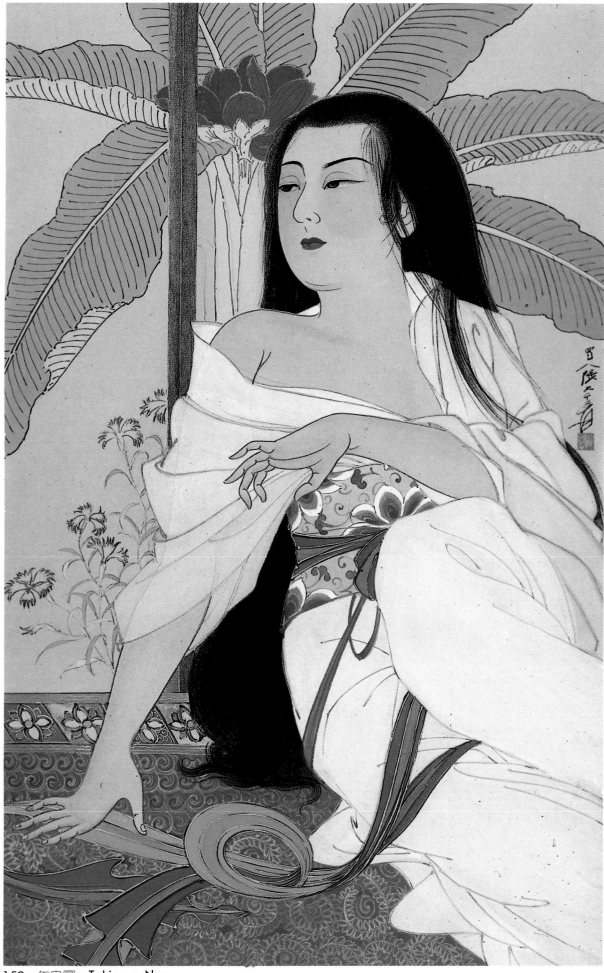

159 午息圖 Taking a Nap

點睛

　　人物最難於點睛，顧愷之嘗說：「四體妍媸，無關於神明，傳神寫照，正在阿堵中。」畫時，先描出眼眶，再勾出瞳人的輪廓，用淡墨渲染二三次，再用濃墨重勾一遍。傳神的關鍵重在瞳人的位置，就是視線的方向要對正面。尤其是畫仕女，要怎樣才能使畫中人顧盼生姿，更要隨你從那一個角度來看，總是像脉脉含情的望着你，你在右她也向着你，你在右她也向著你，正面更是不用說了。乃至將畫倒過來，橫過去，仍舊是向着你。畫中人的眼神與看畫人的眼神，彼此息息相通，洛神賦所說的「神光離合」就是這個意思了。

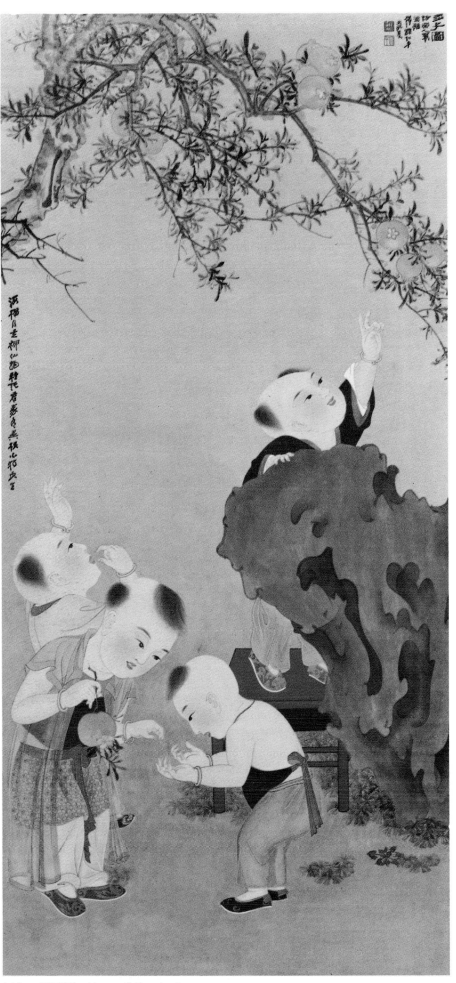

160　多子圖　Many Offspring!

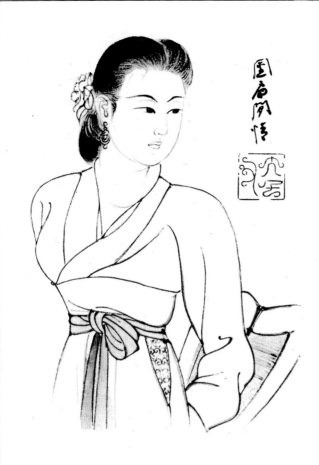

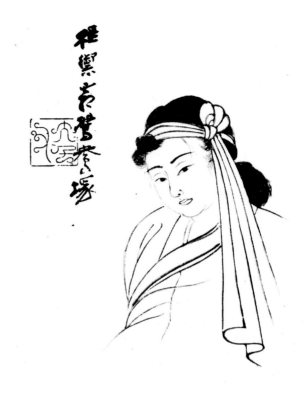

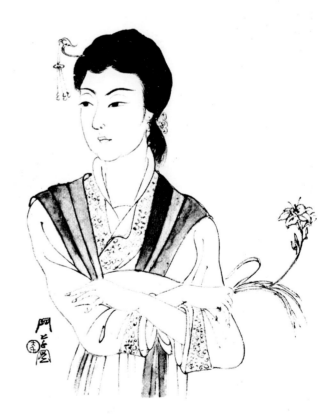

161　古典女性　Ancient Female

ON PAINTING EYES

Of figure painting, the most difficult part lies in the art of dotting the eyes. "The shapeliness or ungainliness of the limbs and the body does not concern the soul," says the great painter Ku K'ai-chih of the Chin Dynasty. "It is there (i.e., in the eyes) the painter should register the spirit and capture the likeness."

The painter should first describe the aperture of the eyes, next define the contour of the irises and fill in with washes of diluted ink two or three times, then do it once over with heavy ink. The key to giving expression to the spirit depends on the position of the pupils. That is: the vision should be directed towards the front. Particularly in the case of painting classical beauties, the artist should know how to make the glance or gaze of his subject breathe life into her graceful attitude. Viewed from whichever angle, be it from the left, right, or the front, she should seem to be looking at the viewer with sympathetic feeling. Even if the picture should be turned upside down or hung on its side, her eyes would still be riveted on the viewer, so that a spiritual communication might be established between the one in the picture and the one looking on. That is what the celebrated poet Ts'ao Chih meant, when singing to the beautiful Goddess of the Lo River: —

"Away withdraws the light
　　divine

Yet back it comes anon to
　　shine."

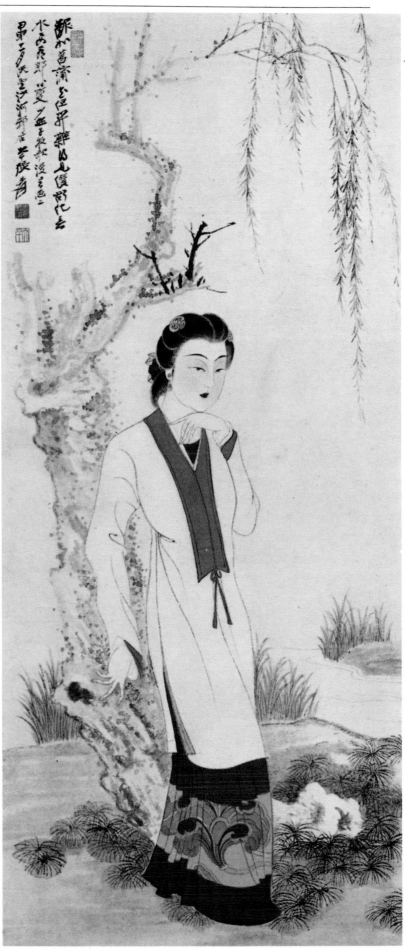

162　倚柳春愁　Spring Melancholy

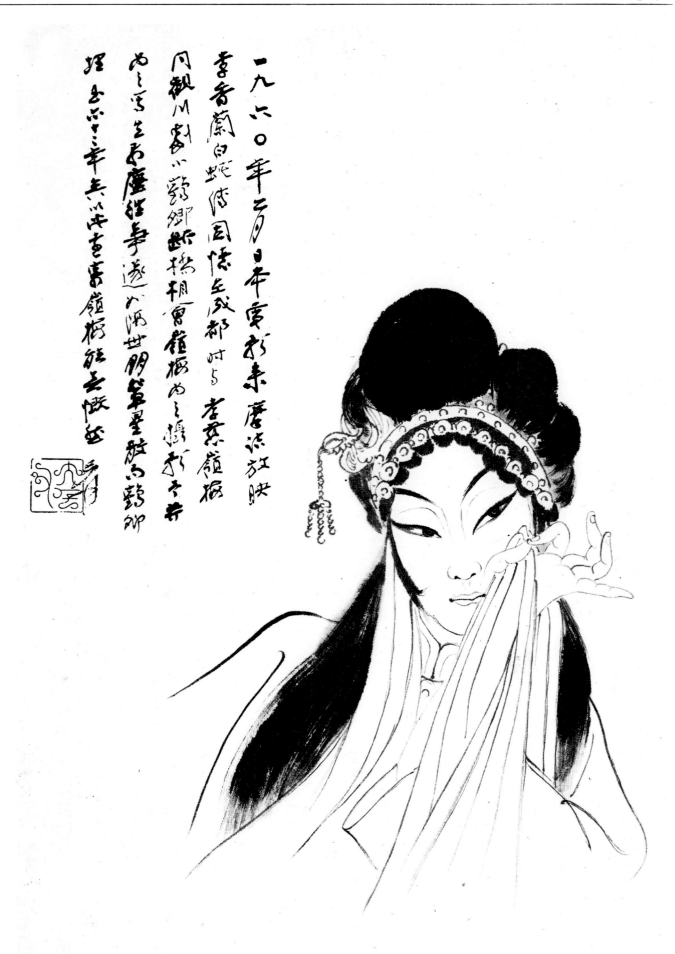

一九六〇年二月日本電影來麞溪放映
李香蘭白蛇傳因憶至成都時与
同觀川劇小艷鄉斷橋曾爲搨幅
而之寫生而廛經事遂如隔世明筆星散而鶴卿
李慕鵑撫期曾爲搨幅而之撫新寺并
埋名於市平其以平重畫鎖被能生慨如

163　小鶴卿　Hsiao Ho-Ching in the White Serpet

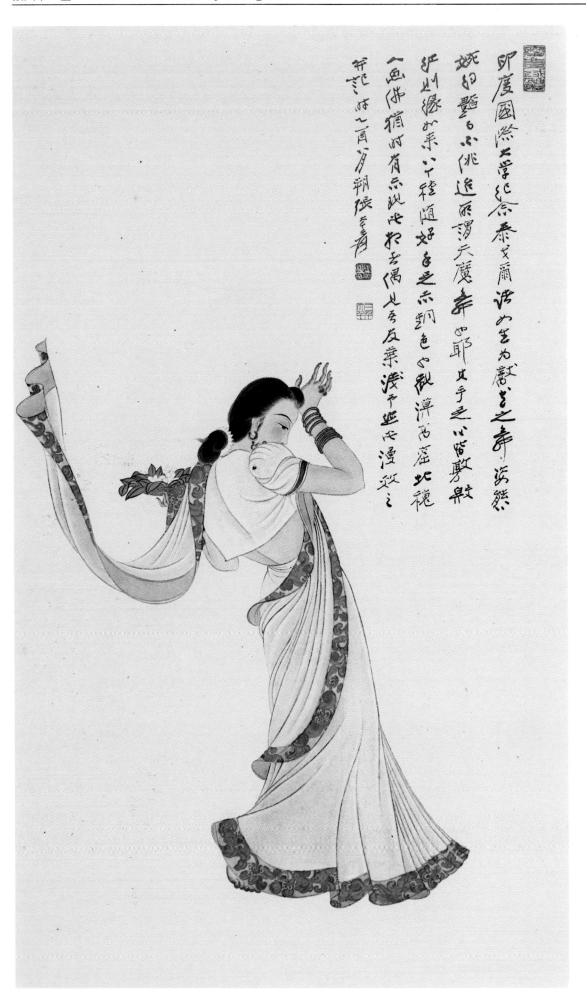

164　獻花舞　Dance of Dedicating Flowers

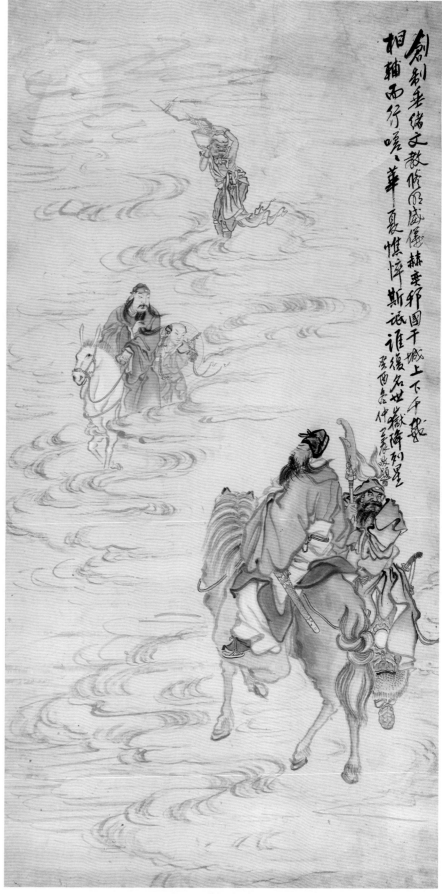

30

王震(1867-1938)

文武聖圖

紙本立軸　癸酉(1933年)作
題識：癸酉冬仲，王震敬題。
鈐印：一亭父
Wang Zhen

CHARACTER

153×77 cm　約10.8平尺
RMB:25,000-45,000

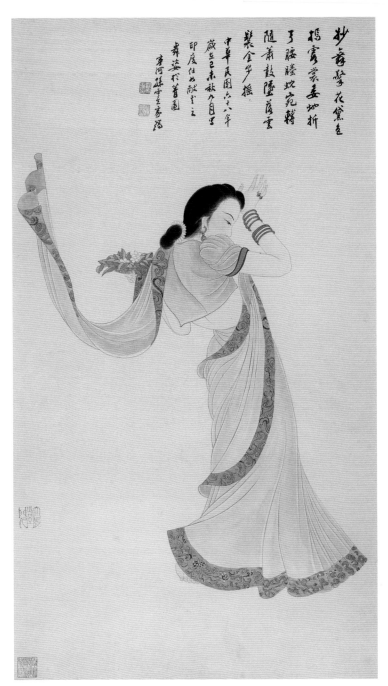

【31】

31

孙云生(1918-2000)
献花舞

纸本镜心　1979年作
题识：中华民国六十八年岁在己未秋九月写印度仕女献花之舞姿
　　　于菁园。宁河孙云生家瑞。
钤印：孙家瑞印、云生长寿、大风堂门人
Sun Yunsheng
DANCE PEOPLE
96×54 cm　约4.8平尺
RMB:45,000-65,000

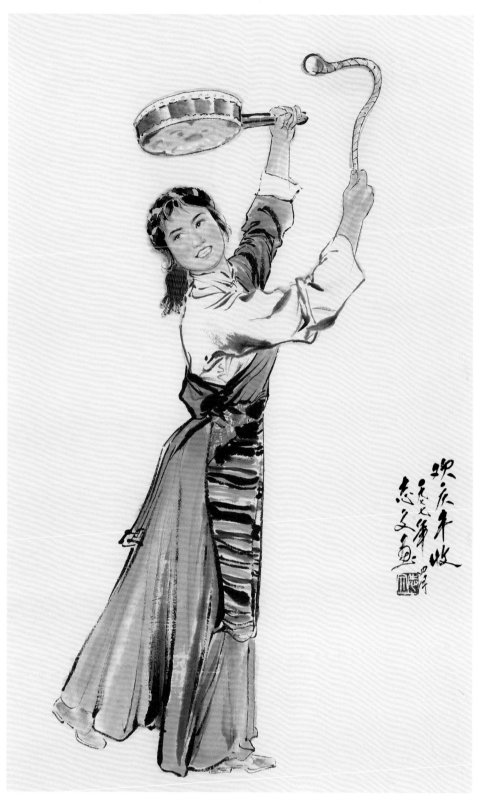

420

徐志文（b.1942）　**歡慶豐收**

設色紙本　立軸
1977 年作
款識：歡慶豐收，一九七七年四月，志文畫。
鈐印：志文（白）

Xu Zhiwen

**CELEBRATING FOR
GOOD HARVEST (1977)**

Hanging scroll; ink and color on paper

49 × 31 cm. 19 ¼ × 12 ¼ in. 約 1.4 平尺

RMB: 25,000-35,000

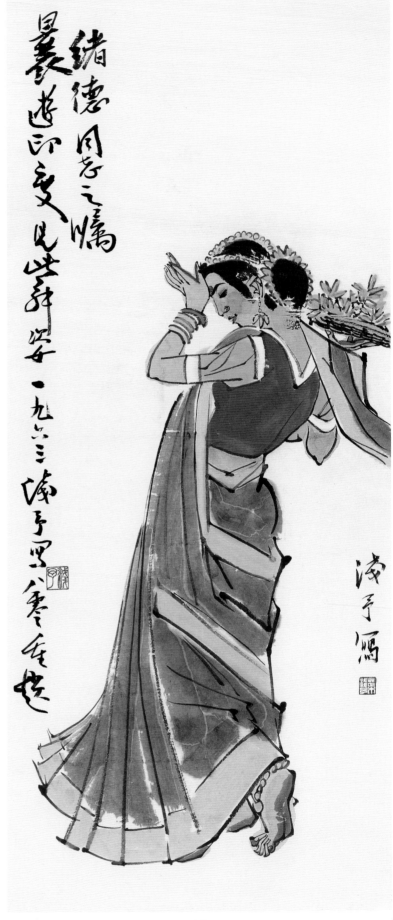

419

葉淺予（1907-1995）　　**印度舞者**

設色紙本　鏡片

1963 年作

款識：一、緒德同志之囑，曩游印度見此舞姿。
　　　　　一九六三年淺予寫，八零重題。
　　　　二、淺予寫。

鈐印：葉淺予（白）、淺予（朱）

Ye Qianyu

INDIAN DANCER (1963)

Framed; ink and color on paper

78 × 34 cm.　30 3/4 × 13 3/8 in.　約 2.4 平尺

RMB: 30,000-50,000

上海保利‧精品紛呈

◎文／高世光　圖／上海保利拍賣

上海保利2005年秋拍，訂於12月6日在上海靜安希爾頓酒店開拍，12月3日至5日預展。

此次中國書畫推出的400件拍品，包括吳昌碩、于右任、張大千、傅抱石、黃君璧、溥儒、林風眠、李可染、黃冑、謝稚柳、陸儼少、唐雲、江寒汀、黃秋園、劉奎齡、汪亞塵、關良、李苦禪、劉海粟、程十髮、劉旦宅、范曾等名家作品。

此次秋拍徵集了多件張大千精品，如1994年〈侍女圖〉、1945年〈印度天魔舞〉、1973年〈梅竹雙清〉等，已足以領略大千風采。張善孖，尤以畫虎著稱，此次上拍的〈雄風圖〉、〈虎圖〉皆屬佳構。

傅抱石此次亦有其兩件精品上拍，〈擘阮圖〉作於1945年，是時蝸居於重慶金剛坡斗室，在艱苦的環境中創作出一批如〈瀟瀟暮雨〉、〈大滌草堂圖〉、〈屈原〉、〈麗人行〉等的代表作，使他攀上藝術生涯的頂峰。〈擘阮圖〉即為這一時期人物畫的佳作，在圓折並用、粗細輕重變化豐富的勾線中，融水墨色彩於一體，營造出滿溢晉唐古韻又有現代浪漫氣質的仕女形象。〈江南春色〉作於南京時期，雖為小幅，然

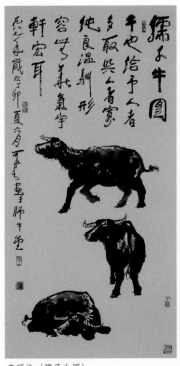

李可染〈孺子牛圖〉。

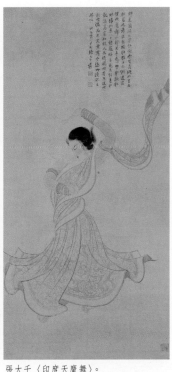

張大千〈印度天魔舞〉。

而小中見大，設色妍美，春意盎然，圖上有傅抱石夫人羅時慧女士題跋，可謂雙璧。

溥儒的拍品也十分吸引人，如〈醴泉勝景圖〉，布局謹嚴，筆墨精到，設色飽滿。此外，謝稚柳〈春山清碧〉為晚年手筆，奔放蒼勁的筆墨中，墨彩交融，呈現浪漫的意境，堪稱傑作。

還有程十髮的〈散花天女圖〉，作於1970年代。畫中散花天女，人物形象居於畫幅上方，空間感極強。線條匹配所要表現的對象，已與傳統人物勾線拉開距離，且寓意吉祥，值得細賞。

其他佳作包括李苦禪〈花鳥長卷〉，為早年作品，長達20餘米，實為難得；李可染〈孺子牛圖〉乃4尺巨幅；關良〈武松打武〉、〈烏龍院〉、〈李逵撕詔〉皆為其盛年力作；唐雲1944年〈溪邊垂釣〉，為其山水精品。

傅抱石〈江南春色〉。

南京十竹齋·精品亮相

◎文／牛瀞羚　圖／南京十竹齋

12月15日至16日，南京十竹齋2005秋季藝術品拍賣會將在南京希爾頓國際大酒店舉辦，12月13、14日舉行預展。推出「中國書畫」、「翰墨精華」、「瓷器玉器工藝品」、「中國油畫」4個專場1,200餘件拍品。

中國書畫專場，共有700餘件拍品，傅抱石〈赤壁泛舟圖〉作於1948年，筆法遒勁，揮灑頃就，舟上人物線條精練準確，疾速運筆中顯其動勢。黃賓虹〈山水〉，設色清潤素雅，構圖疏密有致、繁簡得當，用筆層次變化豐富，表現出山川的渾厚之氣。錢松嵒〈蒼松雪霽圖〉用筆蒼勁老辣，沉雄厚拙，畫面宏偉壯麗，構圖嚴謹。此外張大千〈柳蔭高士圖〉、黃賓虹〈雨逐西風圖〉、吳昌碩〈壽石富貴圖〉、齊白石〈鳳仙花〉、陸抑非〈塘沼秋風圖〉、黃君璧〈松瀑圖〉、溥心畬〈高士圖〉都值得細賞。

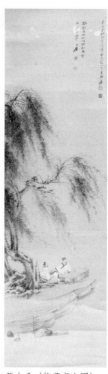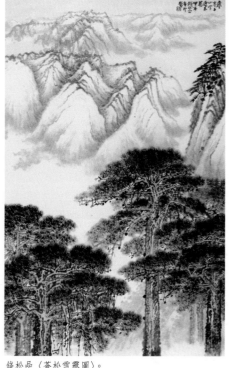

張大千〈柳蔭高士圖〉。　　錢松嵒〈蒼松雪霽圖〉。

為慶祝南京文物公司成立40週年暨南京十竹齋畫譜、箋譜刊行378週年，由南京文物公司主辦並出版《翰墨精華》中國當代50名家優秀作品展，彙集中國當代優秀中青年畫家崔如琢、馮大中、唐逸覽、喻繼高、宋玉麟、傅小石、徐樂樂、范揚、江宏偉、薛亮、常進、方駿、胡寧娜、蓋茂森、盧星堂等50餘人100餘件作品，所有作品均得自畫家本人，代表性強，內容豐富。

瓷器玉器工藝品專場品種豐富、琳琅滿目，瓷器、玉器、青銅器、硯台、印章、木雕、牙雕、鼻煙壺等共300餘件。明宣德〈青花一把蓮紋大盤〉，盤心以蘇麻離青繪一把蓮紋，盤壁繪纏枝牡丹與卷草圖案，底部火石紅自然分佈於圈足。畫意疏朗，筆法流暢，青花色澤濃豔，深入胎骨，白釉肥潤細

清道光〈鬥彩馬蹄碗〉一對（之一）。

膩。清乾隆〈青花花卉穿花龍雙耳方尊〉，器形仿先秦青銅器，自上而下繪7層紋飾，口沿與圈足均繪以回紋相呼應，頸部及瓶下部繪蕉葉紋，肩部繪雙龍纏枝蓮紋，腹部主體繪纏枝蓮托八寶紋，整體佈局疏密有致，畫工精細流暢，紋飾層次清晰，青花發色典雅鮮豔；清光緒〈粉彩百鹿尊〉，高48厘米，通體以粉彩繪山水百鹿圖，形象生動，自然逼真。此外還有清道光〈鬥彩馬蹄碗〉、清乾隆〈粉青釉獸耳鼓釘罐〉、清乾隆〈豆青白花花卉燈籠瓶〉、清雍正〈青花礬紅小杯〉一對、清道光〈仿官釉葵口碗〉一對、清宣統〈粉彩雲蝠荸薺扁瓶〉等精品。

油畫專場部分包括李超士、汪亞塵、秦宣夫、關良、周碧初、涂克、李劍晨、羅工柳、袁運生、羅中立、楊飛雲、劉小東、匡劍、韋爾申、龍力游、何大橋、石虎等名家精品。此外還將重點推出包括蘇天賜、徐明華、陸國英、丁方、張華清、沈行工等江蘇當代油畫名家的精品力作。◐

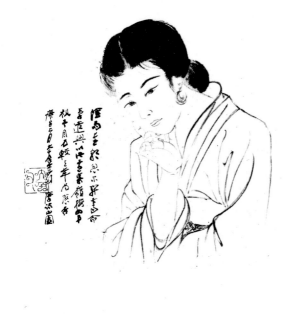

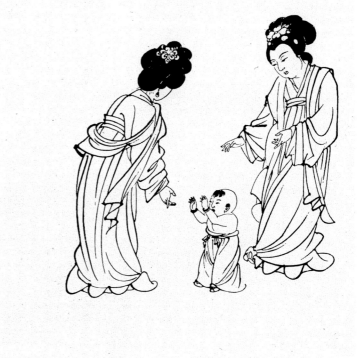

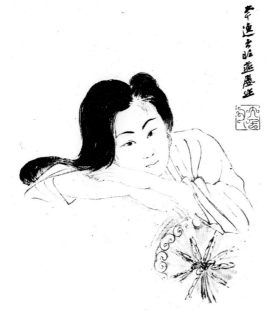

166　弄兒圖　Playing With Child

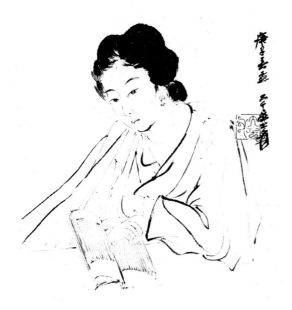

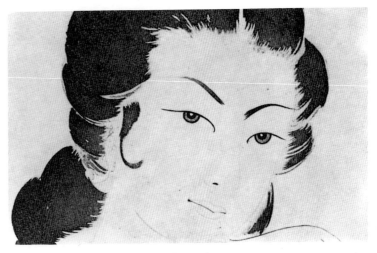

165　古典女性各態　Ancient Female

167　仕女像臉部　Female　Portrait

題畫、用印、裝裱

　　北宋以前中國畫，都與西洋畫一樣，畫成之後，祇在不顯著處，簽一個名字便了。因為這幅畫的本身是不能再着筆墨，若在顯著處題字，豈不有妨畫面的美嗎？後來文與可、蘇東坡、米元章他們幾位，都是畫、詩、書，三絕的人，於是就創出題畫的例子來，宋徽宗也是這樣的。這種風氣至元朝更盛行了。到了明朝，像宋人只在樹身石角簽名的，幾乎沒有了，祇有仇實甫一人，尚自守着老法。題畫行款，最為重要。字之大小疏密，篆隸眞行，都要和畫面相配合。至於題詩或跋，發揮畫的未盡的地方，或感慨興懷，和畫相得益彰，才是合作。董玄宰嘗說，題畫詩不必與畫配合，但期補畫之空白，適當為佳。此眞是行家語，元明以來沒有人道破，只有這位老先生提出來，功德眞是不小。題字最忌高高矮矮，前後必須平頭，若有高低參錯，便走入江湖一路，如世傳揚州八怪的李復堂、鄭板橋，千萬不可學。

　　印章也是方形的最好，圓印還可，若腰圓天然型等，都不可用。工筆宜用周秦古璽，元朱滿白。寫意可用兩漢官私印信的體製，以及皖浙兩派，就中吳讓之的最為適合，若明朝的文、何、都不是正宗。名號印而外，間或用閒章，拿來做壓角的用場。那印文要採古人成語，和畫面或本身適合的。

　　印泥是硃砂最好，硃䍲第二。硃砂紅紫，硃䍲略帶黃色，這兩種越久越覺沈着古艷。但硃砂本質重，裝在缸內，一天不攪，油就四面溢出。俗語說：「若要印色好，一天攪三攪。」卽是說硃砂不攪要走油。現在製印色賣的，大都是用洋紅，又美觀，又不走油，祇可惜歷年稍久，顏色就衰退了。

　　裝裱是我國畫必不可缺的，因為我們用的紙和絹是軟質的，畫時受了水墨和顏色的膠水浸漬，乾後就有凸凹皺痕，若不襯托，非但不如原來的樣子，還要減色。所以第一步必須要襯托。至於裝池，墨筆或淡設色，是湖水色，和淺米色的絹一色挖嵌為雅，切不可用深顏色的綾絹。深重的顏色，祇宜於裝璜宋元破爛絹本，或是磁青上的泥金畫。若工筆或金碧青綠，可用宣和裱式，就是所說三色的：玉池用湖水色絹，隔水用米色綾，天地用略深湖水綾，驚燕與隔水同一材料。玉池要用絹的緣故，是留來讓人題跋的。軸頭是紫檀、黃楊、象牙為最雅，瓷、犀便是其次了。

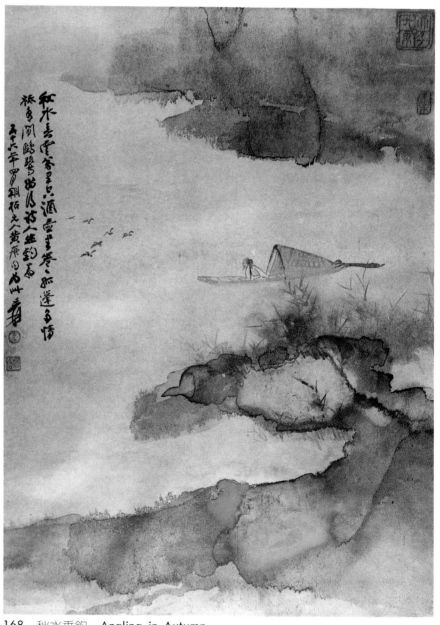

168 秋水垂釣　Angling in Autumn

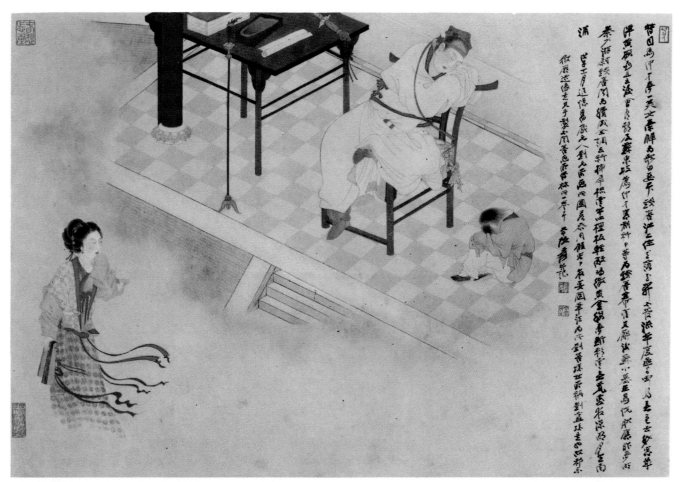

169 夢會圖　Meeting in the Dream

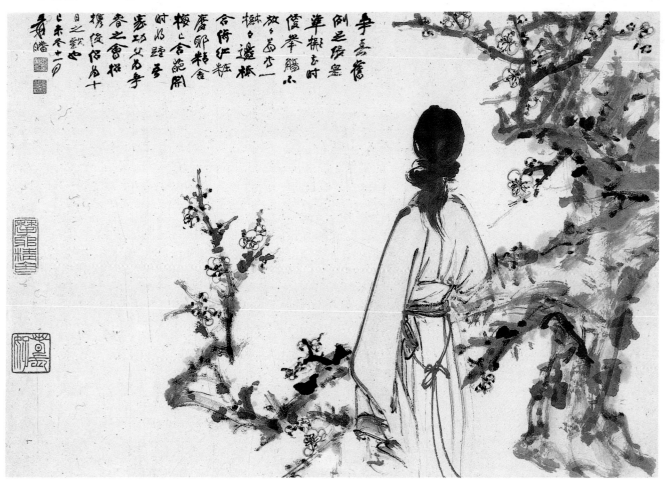

170 梅花仕女　Plum Flowers and Beauty

Before the Northern Sung Dynasty, the Chinese artist merely put his signature in an inconspicuous corner of his painting upon its completion, just as the Western artist does. For a finished picture does not admit of any additional brushwork; hence, the beauty of its composition would be marred if an inscription were made at a conspicuous place. Later, with the rise of such outstanding painters as Wen T'ung, Su Shih and Mi Fei who were at the same time great poets and calligraphers, many artists began to make inscriptions on their paintings, and so did another great painter, Emperor Hui Tsung. Having enjoyed increasing popularity under the rule of the Mongols, the practice was so unanimously followed in the Ming Dynasty that artists no longer put their signatures unobtrusively on the trunk of a tree or the corner of a rock, with the exception of Ch'ou Shih-fu who alone doggedly trod in the footsteps of the ancients.

The most important part of the inscription on a painting is the artistic arrangement of its lines as well as the dedication and the signature. The size, spacing and style of the characters must be in perfect agreement with the pictorial composition. The inscription of colophons and valedictory poems to make up for what the painter has left out or to give vent to the writer's responsive feeling or inspiration, should be mutually edifying; otherwise, it would be out of place. "The valedictory poetry," says the renowned Ming Dynasty painter Tung Hsuan-tsai, "does not have to agree with the picture entirely. So long as it fills the vacant space befittingly, it is as good as can be expected." This is truly the word of an old master that has

never been expounded by anyone else in the Yuan and Ming Dynasties. By calling attention to it, he has done a service of no mean order.

Jagged arrangement of characters is a capital fault to be avoided in making a colophon. The first character of each line must be placed symmetrically on a level with that of the others, or else the inscriber would be associating himself with the erratic. One should, therefore, guard oneself against imitating the eccentric style perpetuated by Li Fu-t'ang and Cheng Pan-ch'iao of the so-called "Eight Freaks of Yangchow."

SEALS

As to the seals, the quadrangular ones are the best. Round ones are also admissible but oval and irregularshaped ones should not be used. For paintings in the elaborate style, it is appropriate to employ seals modelled after the pre-Han archetype of archaic ideograms in bold red and massive white. For paintings in the impressionistic style, one may adopt the style of the official or private seals of the Han Dynasty or that of the Anhui and Chekiang Schools of engravers, particularly Wu Jan-chih, whose mode of expression is the most suitable. But the seals made by Wen Po-shan and Ho Hsueh-yu of the Ming Dynasty are quite unorthodox. Apart from personal seals, one may occasionally apply the so-called "idle seals" for the purpose of "weighing down" any corner of the picture frame. The characters on such seals are usually a quotation from some ancient saying that befits either the painting or the artist.

STAMP-PASTE

The best stamp-paste is made of vermilion, that made of

vermilion scum comes second. The former may be either scarlet or dark rose in colour, the latter is slightly tinged with yellow. The longer they are in use, the more they become mellowed and imbued with antique elegance. But the vermilion, being a heavy mineral, tends to settle to the bottom of the jar, if left unstirred, and its oil content will seep through to the top. So the proverb says: —

"Stir the stamp-paste thrice a
 day
And its colour will always
 stay."

That is to say, the oil content will escape from the pigment unless the paste is stirred at frequent intervals. The stamp-pastes sold by the stationers nowadays are commonly made of imported carmine, which has a brilliant red colour and is not oil-repellent but, unfortunately, its colour will begin to fade before long.

MOUNTING

Mounting is a finishing process with which Chinese paintings can not dispense. For the paper or silk used by the Chinese artists is of a flimsy texture which, having absorbed the water and glue content in the ink and pigments, is liable to shrivel up into bulges, dimples and wrinkles. If it is not supported with a backing, the painting will not only be unable to maintain its original appearance but will inevitably suffer from distortion. So, after the completion of a picture, the first step is to put a backing to it.

The next step is mounting. For paintings in ink monochrome or light water colour, it is good taste to mount them up with thin pongee of either very pale lake-blue or light rice colour. Deep coloured damask

and pongee are only suitable for mounting tattered silk scrolls of the Sung and Yuan Dynasties or paintings in milk-gold on porcelain-blue paper. Landscapes in gold and azure, blue and green, or in the elaborate style, may be mounted in the Hsuan Ho fashion, i.e., in three colours: very pale lake-blue pongee for the rectangular spaces above and below the picture frame, known as the "jade pools", rice-coloured damask for the intermediate borders, known as the "water dividers", and for the narrow, vertical twin strips (originally hanging loose) from the top, known as the "scare-swallows", and slightly deeper lake-blue for the top and bottom of the scroll. Thin pongee is preferred for the "jade pools" because they are reserved for colphons and valedictory poems. Projecting end-pieces of the roller made of black sandal-wood, box-wood or ivory are of the most elegant taste; those made of porcelain or water-buffalo horns are second best.

171　張大千印章　The Author's Seals

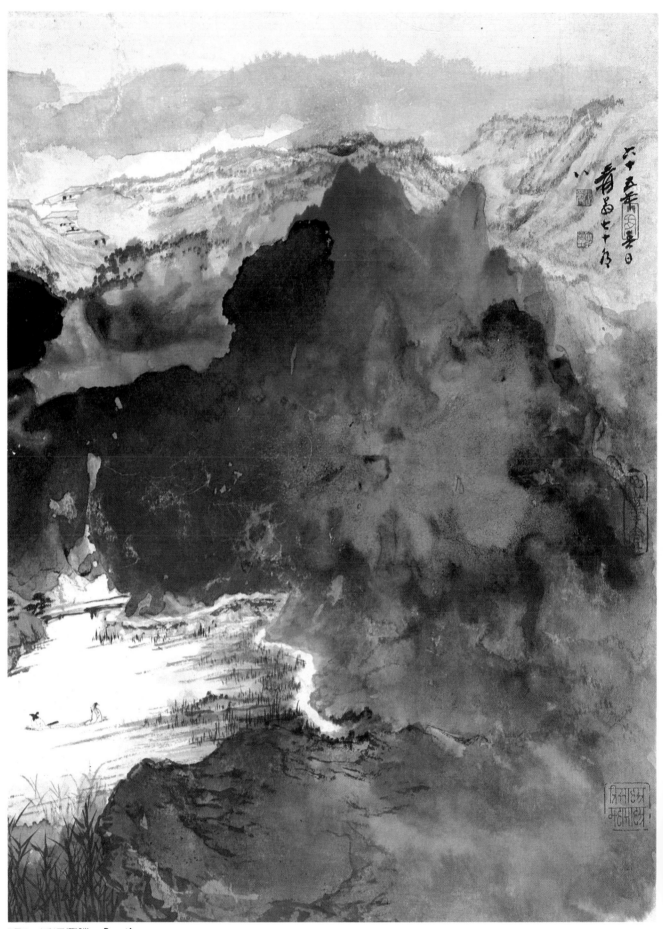

172　泛江攬勝　Boating

張大千先生與本書發行人攝於摩耶精舍。
樂恕人先生攝

出版者的話

何恭上

如果讓我選過去五十年最好的一本中文藝術書，那一定是高嶺梅先生在一九五七年為張大千先生出版的「張大千　畫」一書。這是卅年前，以米色素紙印刷，以中國古書褶頁線裝式，並附極講究的錦緞盒包裝而成的八開大畫冊。內容中英文對照，圖片解說，彩色黑白精印，皆是上乘上選。時至今日假若參加新聞局舉辦的金鼎獎，榮獲最佳印刷裝訂獎足足有餘，可見卅年前出版品傲視群書的盛況。

可惜這本優美的藝術珍書並沒有廣泛流傳，或許有海天孤本吧，曾經在港台間有人向收藏者割愛，出價美元五百元之紀錄。藝術無價，更是永恆，我深深體會其中道理。

猶記張大千先生在世時，我曾陪同旅美畫家王方宇先生到摩耶精舍拜訪，談到「張大千畫」這本書的事，當時大千先生說時代進步，很多過去未發現的問題，現在都已領略更有心得，很想再畫一本類似的畫。我相信大千先生的胸懷大志，但是摩耶精舍的訪客加上大千先生的好客，我想縱使心有餘大概力也不足吧！

一九八三年五月，我到香港拜訪高嶺梅先生，談到「張大千　畫」再版的可能性，他說當時製的版全部不在，而台灣、大陸有很多根據這本書的翻版本，粗製濫造，不能保有珍本的神韻。當時他雖然答應讓我重印，但在沒有十足把握之前，我實在不敢大意行事，以免有損這本書的高雅品質，今年歷史博物館舉辦「張大千書畫研討會」，有聲有色，也出版一本非常豪華的「張大千九十紀念展書畫集」，重新啟迪我印製這本書的契機；累積多年的出版經驗，也更讓我有信心。

雖然無法將高嶺梅先生當年魅力完全轉移，但在內容方面，香港文聯莊李昆祥先生提供不少珍貴底片，張保羅先生、王新衡先生、蘇富比公司、歷史博物館……提供難能可貴的資料，將這本書粧點得更完美。

想「畫好國畫」，不能忽略到在中國當代繪畫史上佔有一席重要地位的大千先生，他能古能今，仿畫能傳其神，創作能姿其意，將中國水墨畫技巧發揮得淋漓盡致。今有幸留其墨澤，我們心懷無比的虔敬，同時也感激高嶺梅先生。

我也能畫啊！這些書可以幫助您——畫好國畫

畫好國畫①
林湖奎繪著
金魚、錦鯉

　　中國人喜歡用「金魚・錦鯉」做為繪畫題材。金魚——象徵金玉滿堂，錦鯉——寓意年年有餘，它們都是富貴吉祥的化身。林湖奎畫魚知魚性，他從畫金魚・錦鯉個體基本技法開始，到組合技法與構圖，另附60幅完成作品。全部彩色印刷，並有題畫詩。

畫好國畫④
李奇茂繪著
走獸畫法

　　動物的傳神處，關鍵在和動態。當代走獸名畫家李先生，利用其敏銳的觀察力習見動物如牛、馬、鼠、生動地展現眼前，並分析其。在名家的指導下，必有出現！

畫好國畫②
何恭上主編
畫荷花

　　本書內容包括認識荷花、蓮花與睡蓮、荷花與神話、古畫中的荷花、畫派與荷花題畫詩等。而畫家筆下的荷花以工筆、文人、金石、沒骨、寫意、潑墨、彩墨、嶺南、寫生九種畫法來區分，介紹46位海內外當代傑出畫荷之作，方便讀者學習。全部彩色精印，附圖218張及文字說明。

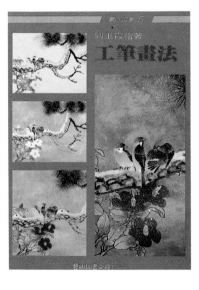

畫好國畫⑤
劉玉霞繪著
工筆畫法

　　選近佰種花卉靈鳥草再把每張畫材或花卉或禽蟲畫法步驟分解示範，不圖畫稿，也知道畫法說明一本詳細而明白的工筆畫劉玉霞女士花費三年的時者編繪，全部彩色印刷。

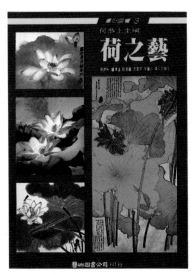

畫好國畫③
何恭上主編
荷之藝

　　荷花和牡丹是中國人最鍾愛的繪畫題材。尤其是荷花，不但搖曳生姿，風情萬種，而且象徵清高與風雅。本書從認識荷花，到張大千、趙少昂、楊善深、吳學讓、趙松泉、蘇峰男、伍揖青等大師示範，舉凡寫意、彩墨、嶺南、海派、工筆、寫生……各種荷花畫法，都提供了最易學的指引。全書均彩色印刷，附圖313張，文字說明清晰，易學易畫。

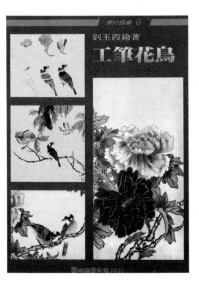

畫好國畫⑥
劉玉霞繪著
工筆花鳥

　　劉玉霞女士從喻仲林習十幾年的經驗再滲入自為習工筆花鳥畫者專門編。共分花卉畫法、禽鳥畫蟲畫法。每一單元從起稿、造型、創意、例圖、文，全部彩色印刷。

Chinese Paintings For Beginners

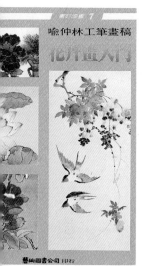

畫好國畫⑦
喻仲林工筆畫稿
花卉畫入門

喻仲林先生生前繪了二千多張課徒稿，他也曾應聘到夏威夷大學任客座教授三個月，畫了很多花卉入門的示範畫稿，我們整理出73個主題，呈獻出中國當代工筆畫最高峰大師，為下一代繪著的傳薪之作，作為我們臨摹學習之用。

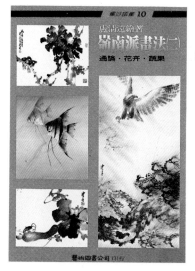

畫好國畫⑩
盧清遠編繪
嶺南派畫法㈡
草蟲・游魚・鳥雀

草蟲、游魚、鳥雀是嶺南畫派最擅長表現的題材，小小生命處處向人展現生的喜悅。除了畫法示範，尚附有每種生物的分析圖；當然，例圖的收錄也是必要的。

畫好國畫⑧
喻仲林工筆畫稿
翎毛畫入門

喻仲林有三十餘年花鳥畫經驗。其翎毛畫的特色是沒色明麗，風致天然，繁而能簡，艷而能清。本書特選出適合初學程度的畫稿，深入淺出的向您介紹各種鳥類的畫法。

畫好國畫⑪
盧清遠編繪
嶺南派畫法㈢
山水・走獸・人物

嶺南畫派筆下的山水，異於南宗、北宗畫家筆下的山水；嶺南畫派筆下的人物，也不同於梁楷、仇英；嶺南畫派筆下的走獸，也有獨特面貌。嶺南畫派山水、人物、走獸它是從日本畫技法滲入西洋畫的色彩，而展現出來所謂的嶺南風，它的技法是如何呢？本書不但有例圖，也詳細分解、示範。

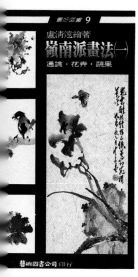

畫好國畫⑨
盧清遠繪著
嶺南派畫法㈠
通論・花卉・蔬果

嶺南畫派，融合了西洋繪畫所強調的光影技巧，為中國畫史寫下新的一頁。對這樣一個畫派，理論與實踐是同樣重要的。故本書始以「通論」，先概括地介紹嶺南派的繪畫特色；繼以十九種花卉、九種蔬果畫法示範。是嶺南派畫法入門必備之書。

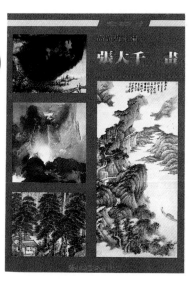

畫好國畫⑫
高嶺梅主編
張大千繪著
張大千　畫

一個時代，若能產生一位真正偉大的人物便堪額手稱慶。張大千正是我們這個時代的畫壇巨人。欲了解一個大家的畫作、思想，惟有親自身入其境去遊歷玩味一番；而從來沒有一本書，曾經那麼有系統的提供大師親口所流出的精闢論說。高嶺梅跟隨大師多年，本書的畫論、畫法、畫範，便是他一點一滴所匯集而成。這第一手資料，實不容錯失！

國家圖書館出版品預行編目(CIP)資料

張大千畫 / 張大千著. -- 再版. -- 臺北市：藝術圖書，2013.07印刷
　面；　公分. --(畫好圖畫；12)
ISBN 978-957-672-124-3(平裝)

1.中國畫 2.繪畫技法

　　944.3　　　　　　　　　　　　　　102012617

張大千　畫

張大千繪著・高嶺梅主編

法律顧問 ⊙	北辰著作權事務所　　蕭雄淋律師	
發 行 人 ⊙	何恭上	
發 行 所 ⊙	藝術圖書公司	
地　　址 ⊙	台北市羅斯福路 3 段 283 巷 18 號 4 樓	
電　　話 ⊙	(02)2362-0578・(02)2362-9769	
傳　　眞 ⊙	(02)2362-3594	
郵　　撥 ⊙	郵政劃撥 0017620-0 號帳戶	
E－Mail	artbook@ms43.hinet.net	
http://www.artbookho.com		
南部分社 ⊙	台南市西門路 1 段 223 巷 10 弄 26 號	
電　　話 ⊙	(06)261-7268	
傳　　眞 ⊙	(06)263-7698	
中部分社 ⊙	台中市潭子區大豐路 3 段 186 巷 6 弄 35 號	
電　　話 ⊙	(04)2534-0234	
傳　　眞 ⊙	(04)2533-1186	
登 記 證 ⊙	行政院新聞局台業字第 1035 號	
印　　刷 ⊙	欣佑彩色製版印刷股份有限公司	
定　　價 ⊙	480 元	
再　　版 ⊙	2013 年 7 月 30 日	

ISBN　978-957-672-124-3